The Color of Ivory

The Color of Ivory

Polychromy on
Byzantine Ivories

Carolyn L. Connor

Princeton University Press
Princeton, New Jersey

Published by Princeton University Press, 41 William
Street, Princeton, New Jersey 08540

In the United Kingdom: Princeton University Press,
Chichester, West Sussex

Library of Congress Cataloging-in-Publication Data

Connor, Carolyn L. (Carolyn Loessel)
 The color of ivory : polychromy on Byzantine
 ivories / Carolyn L. Connor.
 p. cm.
 Includes bibliographical references and index.
 ISBN 0-691-04818-5 (alk. paper)
 1. Ivories, Byzantine. 2. Polychromy. I. Title.
 NK5872.C66 1998
 730′.09495—dc21 97-23914
 CIP

This book has been composed in Galliard Oldstyle

Princeton University Press books are printed on acid-
free paper and meet the guidelines for permanence
and durability of the Committee on Production
Guidelines for Book Longevity of the Council on
Library Resources

Printed in the United States of America

10 9 8 7 6 5 4 3 2 1

Designed by Bessas & Ackerman

For Margaret E. Frazer

Contents

List of Illustrations

Black and White Figures

Acknowledgments

This book is dedicated to Margaret Frazer, formerly of the Department of Medieval Art at The Metropolitan Museum of Art in New York. Under her guidance I spent a memorable year as a J. Clawson Mills postdoctoral fellow pursuing the initial research that eventually led to this book. She first shared my conviction that seeing coloration on ivories was no insignificant detail and arranged for me to have regular access to the ivory objects on display and in storage. Without her sustained enthusiasm and support there would never have been an Ivories Project. Other members of the Department of Medieval Art served as mentors and facilitated my research well after the fellowship year and in numerous ways; my special thanks go to William Wixom, Charles T. Little, and Barbara Boehm. I wish also to thank the department's technical assistant, Martin Fleischer, for his help with many photography and microscopy sessions in the catacombs, and for his practical advice. Over a period of years vital technical analyses of pigments found on the ivories were carried out by Mark T. Wypyski and A. Diana Harvey at the Sherman Fairchild Center for Objects Conservation at the Metropolitan, under the leadership of Edmund P. Dandridge.

As the project took off, so did I. Visits to twelve museums around the world took place over a five-year period, from 1989 to 1993, and resulted in the body of evidence needed to run the project. The collecting of data in these major museums was made possible by scholars, curators, and museum directors worldwide. Their courtesy, cooperation, and curiosity were truly inspiring. Many went out of their way to be helpful, from borrowing equipment at considerable personal inconvenience, to providing welcome afternoon tea. Although I owe each of them an individual tribute, space permits me only to list them here: Paul Williamson (Victoria and Albert Museum, London); Gary Vikan (Walters Art Gallery, Baltimore); David Buckton (British Museum, London); J. E. Poole (Fitzwilliam Museum, Cambridge); Edmund C. Southworth (Liverpool Museum, Liverpool); Susan Boyd and Stephen Zwirn (Dumbarton Oaks, Washington); Danielle Gaborit-Chopin and Jannic Durand (Musée du Louvre, Paris); Alain Erlande-Brandenburg, Clarisse Duclos, and Pierre-Yves Le Pogam (Musée de Cluny, Paris); Michel Amandry, Mathilde Broustet, and Irène Aghion (Cabinet des Médailles, Bibliothèque Nationale, Paris); Arne Effenberger and Petra Sevrugian (Museum für Spätantike und Byzantinische Kunst, Berlin); Vera Zalesskaya, Yuri Piatnitsky, and Marta Kryshanowskaja (Hermitage Museum, St. Petersburg).

Financial support and research resources for the project were provided by the Metropolitan

Museum of Art, the Institute of Fine Arts of New York University, and in particular the University of North Carolina at Chapel Hill, where a research leave as a Hettleman Fellow at the Institute for the Arts and Humanities, a Junior Faculty Development Award, and a University Research Council Grant made possible both time for writing and funds for the extensive travel needed to gather evidence for the project.

For reading versions of the manuscript, my largest debt of gratitude goes to Nancy P. Ševčenko, whose precision, clarity of vision, and wide knowledge contributed greatly to this book. I wish also to thank my colleagues in the Classics Department at Chapel Hill, Georgia Machemer, William West, Edwin Brown, and George Houston for readings and critiques of individual chapters and for their thoughtful suggestions from their various perspectives; I am especially grateful for the generous help and insights of the late John Herington. Other colleagues in Classics, Art, History, and Religious Studies, both here and at our neighbor, Duke University, likewise contributed valuable advice along the way: Laurie Maffly-Kipp, Sarah Shields, John Younger, David Ganz, Gerhard Koeppel, Philip Stadter, Sara Mack, Jaroslav Folda, Dorothy Verkerk, Sarah Immerwahr, Kenneth Sams, and Donald Haggis. My research assistants Dan Green, Carmen Beard, and George Demacopoulos have been untiring in their efforts. I am grateful to my anonymous readers with Princeton University Press for their suggestions, and in particular to the Art History Editor, Patricia Fidler, who helped review and move this book toward publication. Finally, I wish most of all to thank my husband Bob, not just for his critiques of the chapters, but especially for extending moral support to and having confidence in this endeavor, as in all my work.

The Color of Ivory

Introduction

When the tomb of the boy-king Tutankhamen was opened in 1922, the sumptuous grave goods discovered inside included objects of painted ivory. Among them was a wooden chest fitted with ivory panels carved in relief, some depicting the king in scenes of everyday life, others with animals fighting and chasing one another within borders of stylized flowers and palmettes (pl. I). The colors were still vivid with strong contrasts: a reddish-brown for flesh, details of clothing, and background; dark brown for some animals; a bluish-black for hair, jewelry, bands on clothing, and flower petals; and yellow for cartouches of hieroglyphic writing; kilts, drapery, and some areas of background appeared to have been left the natural color of ivory.

Polychromy comes as no surprise in Egyptian art, with its painted tombs and mummy cases, and lavish use of gold and precious and semi-precious stones in jewelry, but this chest is of particular interest because it demonstrates that in Egypt as early as 1325 B.C.E. ivory was not only carved but also painted in a variety of colors.

Although it is now widely recognized that ancient and medieval art in a range of materials and media was often colorful, it still remains to be demonstrated that Byzantine ivories were also originally polychrome. New studies of a sampling of Late Antique and Byzantine ivories show not only that these beautifully carved pieces were once very colorful, but also that the pigments that can still be detected on them are likely to be original. While much valuable work has been done on the style, iconography, groupings, and techniques of ivories, now an additional consideration must be taken into account, the important aspect of their coloration. This book explores a new and fascinating dimension of the art form of carved ivory, assessing observable and recorded evidence of color, as well as the cultural implications of the coloring of ivory. The resulting change in perception affects not only the way we see ivories, but the rest of Byzantine art, and even artistic production of all periods.

While we can readily see that mosaics, frescoes, illuminated manuscripts, enamelwork, and silk textiles were brightly colored in Byzantium, it is harder to visualize monumental sculpture and architecture from which pigment has almost entirely disappeared as polychrome. And it is even more difficult to imagine that color was applied to objects carved out of ivory. Indeed, it seems almost reprehensible that such a beautiful substance should be altered by added color. The reasons for this assumption are complex. Some scholars have argued, for example, that to paint ivory would be to confound two distinct art forms—painting and sculpture. Earlier in this century, scholars who studied Byzantine ivories

occasionally asserted, although without detailed argument, that ivories were originally painted.[1] Over the last few generations, however, the notion of ivory as a "pure" form of sculpture, intended to show only the natural color of the material, has taken a firm hold on the scholarly imagination. Of late, whatever evidence that did exist has been neglected, and no systematic study has been undertaken. The notion of ivory as a polychrome art form has proved difficult for some to accept.

The question of polychromy on Byzantine ivories has been neglected largely because today most such objects range in color between white and aged tan, or what we consider the natural color of ivory. Furthermore, the beauty of the carving of this exquisite material is immediately evident. Ivory boxes, plaques for attachment to furniture, icons, book covers, panels that were hinged to form diptychs or triptychs are rightly admired for the soft, lustrous sheen and subtle grain characteristic of elephant ivory. On their intricately carved surfaces are human figures, animals, pictorial scenes, and ornamental motifs reflecting in style and technique a tradition rooted in the ancient Near East and in Greco-Roman antiquity. The subjects, whether secular or religious, include imperial portraits, mythological figures, and biblical narratives and are profitably studied for their iconography.

Several years ago, when examining the collection of Late Antique and Byzantine ivories, dating from the fifth to the twelfth century, in the Metropolitan Museum of Art in New York, I encountered an unexpected sight. While my initial interest was in a close examination of the styles and techniques of carving on a particular group of pieces, I could not help noticing faint traces of color on them. Under a microscope, it was apparent that the surface had once been ablaze with

color. On continued microscopic examination, it became evident that almost all the ivories in the collection bore some traces of coloration: red, blue, green, gold, black; some colors were even visible to the naked eye from outside the display case. In most instances, however, only observation under a microscope revealed that they once had been brightly colored. On turning to catalogues to see how these traces were described, I found that occasional mention was made of traces of color on individual pieces, but no one, it appeared, had ever systematically collected and evaluated the evidence for polychromy or fully examined such important questions as: Is the color original? How much of the surface was colored? Can one speak of a color scheme or pattern of coloration on ivories? Why did the Byzantines add color to their ivories? How do the colors on ivories compare to those found in other media? From these initial observations and questions came the present book.

The treatments of ivories by various scholars were, to be sure, of help in formulating this study, although from the turn of the century on, the subject of coloring ivory has received little serious consideration or detailed analysis.[2] Evidence of color is mentioned by some scholars, but even in the monographs on which we all rely, the issue of polychromy is hardly raised; attention is focused on carving technique, object types, inscriptions, and iconographic features.[3] After the Second World War a number of important publications on ivory emerged, but these showed even less concern than the earlier studies with the issue of ivory's original appearance.[4] Recently published, highly informative handbooks have dealt with the medium and its craftsmanship, and although incidences of partial gilding of ivories are noted, the occurrence is not investigated.[5] In current scholarship, the preoc-

cupation with the beauty of the material continues: "Late antique and Byzantine craftsmen obviously rejoiced in the gloss as in the grain of ivory, exposing the latter not only as a modeling device but also as a decorative element in its own right."[6] Most recently the cultural context of ivories has been discussed in exciting new ways, with features such as signs of wear and abrasion explained and interpreted; but although the importance of close observation is repeatedly stressed, the aspect of color is still not given adequate treatment.[7] When bright colors do appear on ivories they are assumed to be the result of an "eighteenth- or nineteenth-century 'medievalizing' impulse."[8] Based on earlier scholarship, the need for clarification and understanding of the issue of polychromy on ivory is clear, for color represents an unexplored dimension of this fascinating medium.

The idea of colored ivory is difficult for some to accept, in part because in many languages the word "ivory" is used to describe a color, a virtual synonym for "off-white." That an object made of this substance often took on a very different coloration in its finished state proves problematic. Moreover, since biblical times ivory has been a symbol of luxury. Throughout antiquity and the Middle Ages to the present, it has always been relatively scarce, expensive, and eagerly sought—a precious medium with high intrinsic value as a raw material, a prized possession when artfully carved. To obscure or change its surface by coloring it, even slightly, would seem to some wasteful, almost sacrilegious, or perhaps a case of extreme ostentation. To obscure the "gloss and the grain" interferes with the paradigm that has grown up and is now dominant: that ivory objects should be ivory-colored.

The full implications of this paradigm are hard to assess. Ivory is known to warp, expand and contract, and crack as it encounters variations in humidity or temperature. Thus anything applied to the surface is fugitive and does not adhere well. There is even reason to fear that curators and owners of Byzantine ivories may with some frequency have seen to it that traces of color were "tactfully removed" by cleaning with swabs, brushing, or even by the use of solvents and bleaches.[9] That traces of color should be visible only on close observation or under the microscope, then, should not be surprising. The study of color on Byzantine ivories therefore involves not only an exercise in detection but also different types of approaches, as we shall see in pursuing various avenues in the following chapters.

Close observation and microscopic analysis are the core of chapter 1 of this book. I was fortunate to obtain access to a test group of one hundred Late Antique and Byzantine ivories in twelve museums around the world.[10] A quantitative study became possible when the findings were entered into a computerized database. Ninety-five percent of the ivories examined had traces of polychromy. With refinements and sortings of the evidence, it was possible to attempt answers to some of the questions posed above, and even to reconstruct the original color schemes of several pieces.

The need for scientific analysis of the colors observed on ivories was evident from the start, and thanks to the interest and cooperation of the staff of the Sherman Fairchild Center for Objects Conservation at the Metropolitan Museum of Art in New York, I initiated a series of analyses. The first were conducted on the pigments found on pieces in New York, and later ones on a piece in the Hermitage in Saint Petersburg, Russia. These were chosen because they represented instances in which painting or repainting had left

sufficiently concentrated traces from which to obtain tiny samples, for traces usually are too minute or too generalized to collect a sample without an intrusive procedure like scraping. Sample analysis was done through scanning electron microscopy (SEM) using energy dispersive X-ray spectrometry, and polarized light microscopy. Once the materials analyses identified a group of pigments actually found on the ivories, the next step was an investigation of the history, sources, and usage of these pigments. The painting stage of ivory production, as it turns out, was far from a summary decision by the artist. In chapter 2 we enter into the process of identifying pigments and their sources, and of exploring their artistic and cultural associations in the ancient and medieval worlds.

Contrary to our expectations, many ancient cultures painted, stained, or gilded their ivories. Examples of polychromed ivories survive in Egyptian, Assyrian, Anatolian, Cretan and Mycenaean, classical Greek, Etruscan, and Roman contexts. By collecting the archaeological evidence from excavation reports and museum catalogues, it is possible to assess occurrences of polychromy over two and a half millennia. The diverse treatments of the medium have one feature in common: polychromy. To pursue firsthand observation of a representative selection of surviving ancient ivories would require another lifetime, so in the interests of feasibility, the research for chapter 3 was done in the library. The correspondences between documented survival of color traces on ancient pieces and on the Byzantine pieces in the test group show that applying color to ivory is not an idea that suddenly sprang up in Late Antiquity; it belongs to a tradition that goes back to the most ancient times.

What do the literary sources say about the painting of ivory? In chapter 4 I deal with literary sources that provide corroborative testimony about the appearance of ivory in antiquity and the Middle Ages. Numerous ancient and medieval authors refer to ivory, its appearance, juxtaposition with other materials, and relative value compared with other precious objects. Homer, for example, draws a comparison between the color on an ivory cheekpiece and the blood flowing from an arrow wound in Menelaus's thigh.[11] Much later the Greek traveler Pausanias (2d century C.E.) provides another approach to the question of the appearance of ancient ivory in his descriptions of the famous chryselephantine statues of classical antiquity, works in gold and ivory which have now entirely disappeared. These colossal statues once set the standard for sculpture in other media, from life-size architectural sculpture in marble to small terracotta figurines and carved ivories. The written sources on ivory extend as late as Cennino Cennini, whose handbook of around 1390 attests the continued practice of dyeing, painting, and gilding ivory objects throughout the medieval period. Craftsmen even record their "tricks of the trade" as well as the production of dyes and their application to ivory. Here a variety of details about the appearance and coloration of ivory contributes to our overall understanding of the use of polychromy.

The final and most perplexing question is: Why did the Byzantines paint their ivories? Since the texts show how widespread was the practice of coloring ivory throughout antiquity and the Middle Ages, one must give credit to the persistence of tradition, but there is more. The texts also hint at a value system in Byzantium whose response to color differs widely from that which prevails in our culture. Without some understanding of this system, it is difficult for scholars to make the conceptual leap into an appreciation of what color meant from the Byzantine stand-

point. What dictated the nature of the Byzantine aesthetic? Brightly colored objects, images, and media are characteristic of Byzantine culture: icons, manuscripts, mosaics, frescoes, enamels, silks. To deny that they are interconnected reflects a mechanistic view of art, for polychromy on ivory stands in relation to all these media and to the individual color schemes of their imagery. Symbolic values, associations, and tastes help explain the coloring of ivory in Byzantium. By defining the rationale behind the practice of coloring ivory, we reintegrate it with its brilliant cultural and aesthetic context.

To explore provenance of individual pieces might prove useful in recovering the diverse careers of Byzantine ivories when they left Byzantium. But to be able to determine provenance back further than a century or so is very rare, usually impossible, and in any case would hardly yield statistical evidence on which to draw conclusions about later treatments with color. Some ivories came to Europe in crusaders' saddlebags, some were given as imperial or Church gifts, some were part of the dowries of Byzantine women married to Westerners. We know some were reused on book covers in the medieval West. Unfortunately, the chances of deriving from provenance information that would usefully relate to questions of color or when it was applied (or reapplied) are minimal, and so this question is best left to others to pursue, in individual cases in which records can be found.

Fifty years ago Gisela Richter showed that ancient Greek sculpture had been regularly painted and identified for the first time the pigments used.[12] The evidence had long been available, but the obvious inference had not been drawn in earlier scholarship. The reason her ideas met with resistence at first is that much of modern taste comes out of revisionist ideas from the Renaissance and Enlightenment, such as Winckelmann's notions of purity and sculptural ideals. But we can hardly blame the Renaissance for the unwillingness of recent generations of scholars to take seriously evidence as important as color on an art form. Do we see only what we want to see? Do we adapt the facts to the theory, rather than the other way around? Recent studies have tended to isolate ivories from the rest of Byzantine art, linking them instead with the alleged formal purity of ancient sculpture. This position, however, has become less and less tenable, in part because of the progress in research in other fields, not only ancient sculpture but also Western medieval sculpture. For example, a recent book on the Romanesque ivory, the Bury Saint Edmunds Cross, or Cloisters Cross, shows it was originally brightly painted.[13] Recent studies of Gothic ivories show polychromy was part of the original visualization of the medium.[14] Polychromy therefore fits into the broader context of medieval culture, and it should come as no surprise that Byzantine ivories were once colorful.

This book does not claim to be comprehensive, but it does attempt to open up some new perceptions and lines of inquiry in the study of ivories, and to begin the process of reintegrating Byzantine ivories with their artistic and cultural context. In revising the paradigm for Byzantine ivories, this study aims at broadening the criteria upon which our judgments of art are based and suggests some fresh ways of seeing.

Chapter 1

Color on Byzantine Ivories

The impetus for this study of color on ivory was the surprising sight I encountered when examining several ivory plaques in the Metropolitan Museum of Art in New York. Three intricately carved plaques illustrate episodes in the Old Testament story of Joshua's conquest of the Promised Land. They once served as the decorative covering of a wooden box along with framing strips made of bone (pl. II).[1] One shows the ambush of soldiers of Ai by the Israelites; another, the captive king of Ai before Joshua; and the third, suppliants from Gibeon before Joshua. The panels are small enough to fit easily into the palm of the hand, measuring only 13 × 6.6 cm, 8.5 × 5 cm, and 9 × 6 cm, respectively, and each .5 cm thick. While faint suggestions of color are visible to the naked eye on these otherwise tawny white ivories, microscopic examination at 30× power revealed numerous traces of bright colors: red, blue, gold, and green. These pieces proved to me that at least some ivories were once polychromed.

The Joshua Plaques have been thoroughly studied and published by Adolph Goldschmidt and Kurt Weitzmann, who rightly compared them with the well-known illuminated manuscript of the tenth century, the Joshua Roll (Vat. gr. 413).[2] Weitzmann addresses the iconography, inscriptions, and style of both manuscript and ivories but never discusses color. However, upon

my repeated and close examination of the plaques, there proved to be enough polychromy preserved to reconstruct their former color scheme. In the reconstruction, the "suppliants plaque" looks strikingly different from the largely monochrome relief we see today and, in fact, resembles a colorfully painted manuscript illumination (pls. III, IV). The background of the ivory was blue, the beveled edge of the frame red, the tunic of the nearest suppliant green, while that of the farther one was speckled green; the soldiers' helmets and Joshua's cuirass were gold, Joshua's cloak and footstool red; the boots were also red, and the pupils of eyes and incised letters of the inscription black. A photograph of the plaque taken under ultraviolet light shows a comparable pattern of polychromy (pl. V). In ultraviolet reflectography, the residues of pigments fluoresce differently in areas that were painted different colors. A photograph therefore shows formerly painted areas as varying somewhat in hue among one another, reflecting their former diverse colors.[3] The same range of colors appeared in the strips of carved bone accompanying the plaques. The strips were decorated with green leaves and gold, red, and blue medallions and rosettes, alternating with profile heads. The traces of pigment can be seen in a photograph taken with a micro lens (pl. VI).[4] On the basis of these observations and reconstructions, it was possible to imagine an entire box, of which these plaques and border pieces composed part of the decoration, as brightly colored.

Following up on these initial discoveries, I launched a project of systematic collection of data obtained through microscopic observations of ivories, with the intent of determining the frequency with which traces of color appeared on ivory objects, and characterizing and describing these traces as precisely as possible. The technique for conducting this research developed with the process of collecting data. For example, red pigment had several appearances. In the Joshua ivories it was concentrated and formed dense, localized spots, whereas on other pieces scattered pale red crystals were the only indication of coloration on the surface; in yet others a dark brownish discoloration would turn out, on high magnification and under intense lighting, to consist of many tiny grains of red material or pigment suspended in a vehicle, perhaps wax or resin or varnish. Gradually the distinctions among types of color traces became familiar, which then determined the system of classification. Before embarking on a wider study, it was first necessary to determine which ivories might be profitably examined, and then to gain access to them.

The selection of pieces for examination was determined by several criteria: chronology, geography, object types, and cases of known or suspected traces of polychromy. The chronological range of material for the project fell into logical groupings, represented by objects on display at the Metropolitan Museum. There, the Late Antique, Early Christian, and Byzantine ivories are exhibited alongside other types of objects and media of the same periods. Most ivories in this gallery were geographically localized in the Latin- and Greek-speaking lands around the Mediterranean in the period between approximately 400 and 1200 C.E., with likely centers of production ranging from Rome, Milan, and Alexandria, to Constantinople; the majority are believed to have been made in Constantinople. Typical objects included diptychs, panels, icons, caskets, and pyxides. Ivory was apparently available and worked during two distinct periods, for the objects on display clustered in either the Late Antique/Early Byzantine period of the fourth

through sixth centuries, or the Middle Byzantine period of the ninth through twelfth centuries.[5] To extend the study to Carolingian, Ottonian, Anglo-Saxon, Romanesque, or Gothic ivories would have meant dealing not only with a wider area geographically and a much larger body of evidence, but also with a whole different set of questions connected with their cultural contexts. Furthermore, some ivories from these periods have recently been studied addressing issues of color, providing material to which we can usefully refer for comparisons.[6] In the interests of coherence and feasibility, I decided that ivories of the Late Antique through Middle Byzantine periods, representing the full range of object types, and, whenever possible, those already mentioned in catalogues as having traces of polychromy, would form the test group.

Materials and Methods of Analysis

Perhaps the best analogy for the Ivories Project would be the systematic compilation of evidence that a field archaeologist undertakes. The fieldwork in this case consisted of gathering data in twelve museums, and involved firsthand observation and microscopic analysis in all cases. The use of a binocular microscope yielding 10× to 40× power was requested. Although microscopes varied in quality and magnification capability, it was possible to approximate the same kinds of analyses of all objects. Descriptive data for each piece was recorded while it was under the microscope. Various solutions were found to problems of viewing, as in the case of large pieces, such as open triptychs, or pieces in fragile settings or in poor condition that had to remain on their carrying trays. In many cases, I also examined pieces under ultraviolet light using a handheld UV lamp.

Lighting was the most problematic aspect of the fieldwork. Color is a function of light, and at high magnification a very focused, bright light has to be trained on the object in order to see anything at all. Unless the light can be gradually strengthened, increasing the powers of magnification means a dimmer and dimmer field. The ideal type of lighting is therefore from a fiberoptic lamp with two nine-inch necks, each with a beam at the end that can be precisely directed, then brightened or dimmed. Using this system it is possible to direct one beam into a crack while lighting the general area around it with the other, or the two beams can be angled, or set to converge for intense lighting of one spot. It is important to use this type of "cold" light that can be trained on an object indefinitely without causing it to heat up, which could lead to expansion and contraction of the surface, and to eventual cracking.

The process of observation is painstaking and time-consuming. The first stage is to examine the piece closely with the naked eye—front, back, and sides—to get an idea of its overall condition and to assess the most likely places where color traces might be found. Next comes a systematic scanning of the surface at 10× power. Faces, drapery, background, frame, and back are all scanned for variations in hue. At this stage it is often possible to catch a glimpse of the sparkle or transparency of pigment crystals, a bright dot of localized pigment, or the glint of gold. It is best to manipulate the object, that is tip and turn it, so that undercut areas, corners, cracks, or folds can be examined for trapped particles of pigment. Before any notation is made, there must be clear and certain indication of the presence of the color, its location, the precise character of the pigment, and the exact shade. This process of scanning, focusing, verification, and

notation requires from one to three hours for each piece. Its rewards will be experienced by those who are prepared to examine microscopically any of the hundreds of Byzantine ivories still awaiting analysis for traces of color.

Classification of Information in the Database

The evidence of color traces collected through observation has been tabulated in the Database (See appendix A, pages 84–87), referred to as DB with the assigned object number, in discussions of individual pieces. The classification system in the database bears explanation.

Variations in the appearance of coloration were categorized according to the following principles. Under variable magnification the remains of pigment have different appearances; for example, sometimes a reddish-brown smear at 10× power turns out at higher magnification to be a cluster of tiny particles of red pigment. This evidence of former coloring of the surface is referred to in the database as localized color (lc). If, on the other hand, one detects isolated particles of pigment, sometimes opaque but often seen as semitransparent crystals, this constitutes a different kind of evidence, referred to as crystals (cr). This may or may not indicate the color of that part of the surface, for individual pigment crystals could have moved around the smooth surface of the piece when it was handled or cleaned, and become lodged in a new location and reattached, for example, when the piece was varnished. But when a number of these isolated crystals are observed over a general area, say, on a piece of drapery, a decorative border, or a crease next to a frame, this again constitutes localized color (lc). This is the type of evidence required for reconstruction of the color scheme.

Another type of coloration is stain (st), which appears both to the naked eye and under the microscope as covering a particular area, giving it a general cast of one hue. It is important to distinguish the evidence of stain, which is coloration that has permeated the ivory's fabric, from traces of paint, which is pigment coating the surface. Staining can occur as the result of steeping or dipping an entire piece in dye until it takes on an overall hue that is different from its natural color; the terms staining and dyeing are therefore used interchangeably in describing pieces that appear to have had this treatment. Staining can also occur as a by-product of something else, such as the residue of a paint, paint vehicle, or the binder for gilding; in this case it can be very difficult to tell the difference between paint and stain, for one occurs as a result of the other, and both may be present. Staining and dyeing therefore are used to describe the observable result rather than the probable but difficult-to-ascertain original treatment involved.

The most frequent type of ivory staining is red, but it can also be brown or green. In the case of red staining, an entire piece might have a general brownish or reddish-brown cast, either with or without occasional tiny particles of red pigment appearing scattered over the piece or concentrated in some areas. Observation of edges or cracks reveals even more clearly whether the coloration has been absorbed by the ivory as the result of soaking in a dye solution. In the Nicomachorum Diptych leaf (DB no. 64; fig. 1a), for example, the cracks in the brownish-red ivory allow one to see the lighter-colored interior, which has not been reached by the stain. When pigment has been applied to the surface, worn off, and left a residual stain, more narrowly defined areas are usually affected, such as the drapery of a

figure, or a border, with a given area appearing a different coloration from that surrounding or adjacent to it; this stain is probably an indication of former painting. In either case, the coloration would be recorded on the database as localized stain (lc,st).

Another type of coloration is residue (rs), a buildup or accumulation of what might or might not be pigment. This would be a dense enough clustering of either one or several pigment crystals caught in a medium such as dirt, wax, or varnish, so that they no longer have a clearly identifiable hue but are simply muddy in appearance. Usually this type of residue is brown, but sometimes it is greenish-black; the lumpy or grainy residue from the taking of plaster casts of ivories is white.

Gold is the easiest type of coloration to recognize and identify precisely. In scanning, even at low magnification, the metallic gleam of a tiny, flat flake of gold leaf (fk) stands out, especially if one is constantly changing the angle of the beam of light. Although the remnants of gold leaf often appear as small, isolated flakes, they also are sometimes preserved over a small localized area, like a relief capital, or on a warrior's helmet, or on the openwork of a canopy, indicating that these features were originally gilded. In this case the evidence would be recorded as localized (lc). A small dot or fleck of a color other than gold might also appear as a fleck (fl).

Another type of polychromy often detectable with the naked eye is encrustation (ec). This occurs as a dense, opaque, black or red fill in the engraved letters of an inscription or in the pupils of the eyes of figures or animals. In many cases encrustation has mostly fallen out of an inscription or indentation in the surface, leaving a few dense, grainy traces to reveal that the letters were once encrusted.

The pigments detected are indicated in the database in six columns: Red, Gold, Blue, Green, Black/Brown (bl/br), and Other. As this selection implies, the chromatic range encountered in multiple observations was surprisingly limited. Among the hundreds of observed instances of polychromy, the vast majority were of the five colors tabulated in the database, and usually the same shades of those colors. Few pastels or evident combinations of pigments were detected. More will be said about the range of colors in chapter 2.

The database tabulates the ivories by DB number and by museum or collection. Listed under each museum are the ivories examined, by subject or name, inventory or accession number [Index Number] (when known), and object type. This object type classification does not attempt to differentiate usage; for example, panels that served as icons are not differentiated from plaques that might have served as enclosing wings on such icons. All are classified simply as plaques (Pl). But if an assemblage of pieces survives intact, such as a diptych or triptych, or as a casket with ivory plaques fastened to it as revetment, or even if it has been ascertained that a plaque came from a box or casket, then the category is abbreviated accordingly: Triptych (Tr), Diptych (Di), Consular Diptych (Cd) or Casket (Ck). The type of round liturgical box known as a pyxis forms a separate category (Py). Any plaque that has been identified in its catalogue entry as a piece of furniture revetment has been placed in that classification (Fr). Finally, two major periods have been distinguished for convenience: Late Antique (LA), for pieces dated in the fourth through sixth centuries; and Byzantine (B), for Middle Byzantine pieces dated in the ninth through twelfth centuries.

Summary of Findings from the Database

The database tabulates findings from observations of one hundred ivories in twelve museums; this represents the total number of pieces observed, not only those with traces of polychromy. The most basic results are the following. Of the 100 ivories examined, 95 had traces of color: 76 pieces had red, 63 gold, 52 green, 44 blue, and 18 black or brown; 40 had additional types of coloration, such as orange or pink pigment, or various types of residue including chalky white encrustation. Those that had no color traces were very clean and white, often with a chalky consistency to their surfaces, perhaps the result of bleaching or cleaning.[7] In 57 cases in which gold appeared, it was accompanied by another color, rather than being the sole coloration. In 53 of the 95 instances of pieces with coloration, three or more colors survived on the same piece.

Localized color, or color traces that are attached to the surface of ivory over a defined area, is a frequent occurrence, and most often applies to red or gold. Of the 76 cases where red was found localized, 46 took the form of a stain that covered and seemed to permeate the surface, and 30 had red crystals or flecks on the surface. The other common type of localized color was gold, or thin gold foil (gold leaf) that was applied to the surface of the ivory with an adhesive agent, perhaps oil, resin, or glair, as in manuscript illumination. Of the 63 pieces on which gold was detected, 44 had traces over a wide area of the surface; in the other 19 instances an isolated piece or random flake of foil was detected. In 18 cases both red and gold could be seen as localized over different areas of the same piece. Localized color was found in 125 instances (sometimes more than one color was found localized on the same piece), indicating that the ivories were

dyed, painted, and gilded a variety of colors. Finally, it is worth emphasizing that on 53 pieces, three or more colors survived, either in localized areas or as isolated traces. In only 8 pieces was red the only color detected, and in only 5 was it gold. From this we can conclude that ivories were not usually given a single color or touches or highlights of color, but were genuinely polychrome in appearance, with color applied to different areas in a variegated scheme.

Since our project includes evidence from two periods separated by about three hundred years, the sorting of evidence by period helps determine whether there were distinctive patterns of coloration on the various types of ivory objects produced within each period, e.g., was coloration of ivory more or less common in the Late Antique versus the Byzantine period? Of 36 pieces classified as Late Antique, 28 of them (77.7 percent) had red color traces, 18 had gold, and 30 had two or more applied colors. For the Byzantine period, of the 64 pieces in the test group, 48 (75 percent) had red coloration, 45 gold, and 51 had two or more colors. Red is therefore either the most popular or the most durable coloration used in both periods. In these two periods there was a preference for polychromy as opposed to painting or dyeing with a single color.

A breakdown of pieces from both periods by object type is also informative. In the 18 diptychs or leaves of diptychs of the Late Antique period, 14 had traces of color: 13 had gold, 13 green, and 9 blue. Of the 8 pyxides from this period, 7 had pinkish-red or red coloration, and three included other colors. Among two Late Antique plaques identified as furniture revetment, both had localized red and gold as well as traces of blue and shades of other colors.

In the Middle Byzantine period we are dealing with different types of objects. For example,

there were 19 caskets or isolated plaques that were once part of the revetments of caskets. Of these, 14 had red paint, 12 had gold, and 11 had blue and/or green. The largest object category comprises 45 pieces, which are hard to divide into meaningful subgroups: diptychs, triptychs, or plaques that once served as components of these or as icons. Of these, 35 had red coloration, 33 gold, 27 green, and 20 blue.

To sum up, 95 out of 100 pieces have some color traces, and 53 have traces of at least three colors. From these sortings it is clear that all types of ivory objects were colored, in both the Late Antique and Byzantine periods, with no limitation on the number of colors used, except in the case of the pyxides, which appear to have been painted or dyed primarily red. References to specific pieces or case studies demonstrate that there was a consistent iconography of color for certain types of objects.

Case Studies

Among the finest surviving diptychs are the antique-inspired panels representing Asclepius and Hygieia, dated around 400 C.E., in the Liverpool Museum (DB nos. 23 and 24; pl. VII).[8] These large, heavy panels, measuring 31.5 by 14 cm, and 1 cm thick, have rich, lustrous surfaces of a warm, tawny to brownish-yellow color. They were examined using a high-quality microscope at 40× power, which yielded immediate results; traces of red, orange, gold, and green pigments were clearly detectable. A large piece of bright red-orange pigment adhered to Asclepius's robe, while numerous green crystals appeared in the folds of his cloak. Judging from the number of gold flakes caught in the varnish around the outer contours of the figure, it is likely the background was gilded. Hygieia's cloak

also had remnants of green coloration in the folds, and there was orange-red pigment in her hair. Red and gold appeared on columns and wreaths of the setting, and gold was localized in several areas of the background. Green and red flecks and crystals appeared in the border but without clear localization. We can imagine these two panels with the red-haired figures draped in green, seen against a gold background with red and green in the frames (pl. VIII). The overall deep brownish color of the plaques is probably the result of red dyeing (pl. VII).

Another admired diptych from the same period, the Symmachorum-Nicomachorum Diptych (DB nos. 42 and 64; fig. 1), has one of its leaves in the Victoria and Albert Museum in London and the other in the Musée de Cluny in Paris. Suspicions of forgery for the London panel have now been laid to rest.[9] The large leaves (30 by 12.4 cm, and 1 cm thick) depicting draped women performing sacrifices are carved in a style strongly reminiscent of Augustan classicism. The Symmachorum plaque, which to the naked eye looks very white and shiny, had a substantial amount of green pigment in the palmette frieze around the border. Green crystals also appeared in folds of the garments, while flecks of gold adhered to the background. There was also a good deal of white, chalky substance visible under the microscope, probably residue from the process of taking casts.

The Symmachorum panel's companion piece in the Cluny Museum survived being thrown into a well during the French Revolution, from which it was retrieved years later.[10] The broken and badly cracked Nicomachorum panel is brownish-gray to the naked eye; under the microscope, however, thirty-six positive identifications of polychromy were made. For example, the chiton of the woman had numerous flecks of

green, also red and gold, while the cloak slung around her hips had many red color traces and also some gold flakes. Red appeared around the *tabula ansata* and in the engraved letters; the pine tree sprays also showed remains of red pigment. There were many gold flecks on the background, and the ornate border of the frame had numerous red and bright green crystals adhering to the surface with occasional gold flecks. The brownish cast to the surface appeared more reddish on close examination, especially around an area of abrasion on the right; here the substance looks distinctly dyed. More specifically, where the ivory has cracked, sheering down along her right side and especially on her right knee, one can see inside the crack that both sides of the ivory are reddish down to a little below the original surface, i.e., the reddish color does not penetrate very deeply. Thus, contrary to expectation, this badly damaged panel gives us extensive evidence of color. The difference in color between the two leaves of the diptych has been thought to result from, in the case of the Symmachorum leaf, its being subjected to more light, and in the case of the Nicomachorum leaf, its "long subterranean residence."[11] It appears probable, however, that while the excellent preservation of the Symmachorum leaf led to its use for casts and to extensive cleaning or bleaching, the fragile Nicomachorum leaf was treated more gently and thus retained more traces of pigment. Likewise, the brown color is not entirely the result of its subterranean existence; more likely the tint is owed to the remnants of red stain. The two valves of the diptych thus present complementary evidence, in spite of the different conditions to which they were subjected over time. They seem to have been similar in their general color schemes to the Asclepius and Hygieia panels, which also appear to have been dyed red and

which, like these, show traces of green on garments, gold on backgrounds, and green and red in frames and decorative elements.

The consular diptychs dating to the fourth, fifth, and first half of the sixth century make up a precisely dated and technically distinguished group. Among the fourteen panels or pairs of panels examined, thirteen were painted, and, in all but two cases, with two or more colors. Red was found localized on the majority of the thirteen. The Diptych of the Consul Anastasius, of the year 517, in the Cabinet des Médailles in Paris, is a good representative example (DB no. 69; fig. 2). The Louvre catalogue includes in the entry on this diptych: "Ivoire d'éléphant autrefois orné d'incrustations; traces de peinture rouge" (elephant ivory formerly decorated with encrustations; traces of red paint), one of the few instances where polychromy is mentioned.[12] In both leaves the consul sits almost identically enthroned beneath a gabled pediment and holds mappa and scepter; in the areas below are scenes from the theater on the left leaf and the hippodrome on the right. In spite of thick varnish covering the surface, red and green crystals can still be discerned. For example, red appears on the ground near the legs of the throne, on the ground of the central medallion on the left leaf, and on the frame and the baluster around the hippodrome scene. Green crystals appear on the ground below the horse's belly, in the wings of the putti, and generally on the ground of the lower scenes. Blue was encrusted in a crease of the consul's robe, on the *tabula ansata,* and in the groove of the frame; a white deposit appeared over much of the surface. Sufficient instances of localized green appeared in the ground to reconstruct the color of the background as green. Beyond this, enough red and blue were detected to indicate a three-color scheme for the piece. The

pattern of findings on the whole group of dip-tychs indicates that consular diptychs sometimes were painted and sometimes dyed, and when dyed red they were regularly further embellished with painting in red, blue, green, and gold.

Ivory objects from the Middle Byzantine period also fall into several categories. One unique tenth- to eleventh-century piece represents perhaps the most extreme example of colored ivory of any period, the so-called Troyes Casket. It is made of pieces of solid ivory and appears to have been stained red in its entirety; gilding can also be detected.[13] The color varies in intensity but covers all parts of the surface, including the motifs of horsemen and hunters and decorative motifs on the ends; its color is what we would call shocking pink, even in worn areas. In contrast, a well-known piece that has been the subject of detailed study but on which color has not been recorded is the plaque in the Cabinet des Médailles with the coronation of Romanus and Eudocia (DB no. 68; fig. 3).[14] After inspection with a microscope at 20× power, red was recorded in twenty-one separate instances, sometimes as crystals and sometimes localized as spots or stain or in clusters, as, for example, on the footstool and underneath the projecting relief of Christ's robes. In spite of obvious wear, especially in the faces of the figures, there was clear evidence of polychromy. Crystals of bright green appeared on a "jewel" of the dais, bright blue-green on the ground at the upper right, on Romanus's loros, on Christ's robe, and on the footstool, and bright blue on a crease of Romanus's sleeve. It is unusual to be able to distinguish so clearly two shades of blue, not as mixtures of pigments but as crystals of different mineral substances. While much has been said about the technically brilliant carving of this piece, the richness of the imperial ornaments, the elegance of modeling and propor-

tions of figures, and, of course, the figures' identities, it has gone unnoticed that this piece, like the Troyes Casket, was once bright red, with touches of other colors.[15]

The Romanus II and Eudocia Plaque is not a unique example of an ivory depicting an imperial crowning. Another is the famous plaque showing the crowning of Constantine VII Porphyrogenitus by Christ in the Pushkin Museum in Moscow, dated around 945 C.E. Since it is known that this scholar-emperor took a strong interest in the arts and was himself a painter, we can surmise that this finely crafted plaque commemorating his coronation would have had to meet high standards. In style the piece is classically refined and delicate, and despite its relatively small size and damaged state, the gravity of this symbolic event can still be detected in the sensitively depicted gestures and expressions. The enhancement of such an imperially associated piece through dyeing is also appropriate. Even a casual observer immediately realizes that it was once bright red.[16]

A third coronation scene appears on the well-known "Leo Scepter" in Berlin (DB no. 57), dating to the late ninth or the early tenth century, showing the crowning of Leo VI by the Virgin on one of its two carved sides.[17] This sculpture appears to the naked eye to be a deep reddish-brown, and under the microscope it is apparent that there are various shades of red and red-orange pigment crystals covering the entire surface. In addition, there is a bright blue-green crystal on the ornament of the left arch in the background of the crowning scene; the color is the same unusual blue-green shade as on the Romanus and Eudocia Plaque, and there is a large green crystal on Paul's book on the reverse. On the side with Christ and the Apostles, which is darker red and also in better condition than the

side with the crowning of Leo, gold is found on Gabriel's halo, and there are gold flecks scattered over the surface and in indentations. Thus, in three instances with similar iconography of the crowning of an emperor or empress, the ivories depicting the event are painted or stained a bright red in their entirety; that is, their overall coloration suggests that they were soaked in a red dye. In addition, traces of red pigment were detected on some of their surfaces. The iconography of color on these three ivories thus reflects the symbolic content: the crowning of the Byzantine emperor and empress by Christ or the Virgin Mary. Even the name of one of the emperors, Constantine VII Porphyrogenitus, stresses his legitimacy as emperor through color, since the title means "born-in-the-purple."[18]

Another piece connected with the three plaques that show imperial Byzantine crownings is the plaque in the Musée de Cluny depicting the crowning by Christ of Otto II as Holy Roman Emperor along with the Byzantine princess Theophano (DB no. 67; fig. 5), dated 982–83.[19] Although its attribution to a Constantinopolitan atelier is not secure because of its somewhat inferior technique, there can be no doubt that it was modeled on an imperial plaque such as that showing Romanus II and Eudocia (fig. 3). On close examination with a microscope this plaque turned out to have traces of red in the letters of the inscription and in the border next to the frame, as well as on the columns and baldachin. There were also numerous traces of gold, which appeared on Christ's garments, on Otto's crown and footstool, on Theophano's loros, on the background, on the frame, and on the columns and baldachin. A bright green crystal appeared on Otto's chlamys. The plaque appears to have been heavily gilded.

Ivory boxes or caskets constitute another important category of Middle Byzantine objects. Indeed it was the Joshua panels from a rosette casket that precipitated the current investigation.[20] Two designs predominate among some fifty examples in museums around the world: an oblong shape with sliding lid and a slightly taller type with a truncated, pyramidal lid.[21] A particularly fine example of the former type is the Veroli Casket in the Victoria and Albert Museum in London (DB no. 41; fig. 6), dated to the tenth century.[22] Measuring 40.5 × 11.5 × 15.5 cm, it survives intact and is reveted with panels and strips made entirely of ivory on which are carved in a classically inspired style mythological motifs and scenes. The issue of color has never been mentioned in prior scholarship on this piece, and to the naked eye it is, in fact, creamy white in color. Under the microscope, however, twenty separate instances of color or areas of color were recorded on brief observation. Green appears in the background of the panels and gold on the medallion heads in the border strips. On the lid, with its scenes of Europa and the bull, stone throwers, Heracles playing the lyre, centaurs and dancing maenads, there were sufficient traces of color to partially reconstruct the color scheme. For example, green appears not only on the background, but on the garland worn by Europa's bull; red and blue appear on drapery, as in the stone throwers and dancers; eyes are filled with black encrustation; the panther skin worn by the centaur was gold as were the boots of the stone throwers; the bevel of the border was red. Green appears on the petal ornament in the rosette border and gold on all the medallion heads. Two recently acquired ivory plaques in the Louvre, very likely from the same casket, can be associated with the carver or workshop that pro-

duced the Veroli Casket; they too have clear evidence of red, blue, and green polychromy (see DB no. 81).[23] The evidence from the eleven caskets included in the study varies, but in eight cases polychromy, including gilding, was detected. From the signs of wear it is clear they were used and handled extensively, which might account for the uneven preservation of color.

The Harbaville Triptych in the Louvre is of exceptional beauty and makes an indelible first-hand impression on the observer (DB no. 79; figs. 7, 8; pls. IX–XI). This tenth-century triptych is in an excellent state of preservation and has numerous traces of polychromy that are visible to the naked eye.[24] The central panel, 24 cm high and 14 cm wide, depicts Christ enthroned between the Virgin Mary and St. John, with Apostles and warrior saints arranged in registers below and on the insides of the wings. On the outsides of the wings are church fathers, and on the back is a cross with arms terminating in large rosettes and surrounded by stars, trees, and inhabited vegetation. The carving is in high relief, and the style is crisp and highly ornamental, with subtly modeled figures of naturalistic proportions—a prime example of art of the so-called Macedonian renaissance. Red and gold are clearly visible on the inside of the triptych and are most evident in the halos of the central figures of Christ, Mary, and John the Baptist and in the ground around the medallions with angels (pl. IX). On close inspection it can be detected that the Virgin's robes were gold, as was Christ's throne, and red was applied around the contours of their halos. Inside the left wing, the engraved names of warrior saints Theodore Tiron and Theodore Stratelates were painted red, and their halos were also outlined in red (pl. X). A similar color scheme can be seen on the outside of the

closed triptych wings. On the back, the cross has clear traces of localized gold, and the rosettes and surrounding stars and vegetation have so much localized gold preserved that it is clear the surface must have been entirely gilt (pl. XI). Red is painted over the gold in the grooves of the frame and in the trees, and the cross has traces of blue along its left arm. In the interior and on the wings, faces have localized gold preserved on them as well. The red, when viewed at 20× power, again appears to be applied over the gold, which entirely covers the surface. There is red on the throne back and boots of the warrior saints. Green pigment appears on the lower border and blue next to the fibula of St. Procopius and on the tablion of St. Arethas. Letters are filled with red encrustation, and there is a light-colored, grainy fill or thick encrustation in the interstices of the latticework of the throne. Blue appears localized on the ground behind the warrior saints. There are numerous traces of localized green on the frame. This triptych was once ablaze with color, with gold covering extensive parts of the piece, red in the inscriptions and on borders of garments and ornaments; details were picked out in red, blue, and green over the gold. The kind of value system that would require this seemingly irrational layering of color over gold, and the use of gold for the Virgin's robes, a highly irregular occurrence, will be taken up in chapter 5.

In the final phase of work on the Ivories Project I had the opportunity to observe two ivories that are almost identical and were probably produced in Constantinople at the same time and by the same workshop; they are currently in Berlin and St. Petersburg. A panel representing the Forty Martyrs of Sebaste is at the Museum für Spätantike und Byzantinische Kunst in Berlin (DB no. 58; fig. 9), while its counterpart, the

center panel of a triptych, is in the Hermitage Museum in St. Petersburg (DB no. 84; pls. XII–XIV). The forty seminude martyrs are shown shivering and freezing to death in a lake, while Christ, enthroned, hovers with angels in the sky above. A juxtaposition of these two pieces is revealing in a number of ways. To the naked eye the Berlin panel looks pristine and milky white, but under the microscope colors stand out.[25] There are clear traces of localized red in loincloths, posts of the throne, footstool, bathhouse, monograms, and in the bevel of the frame; blue appears on the ground under the throne and wherever relief was undercut behind figures; there are traces of green on angels' robes and on the vegetation under the martyrs' feet, and gold on the frame, aureole around Christ, cushion of the throne, and door of the bathhouse.

The St. Petersburg Triptych, like the Berlin panel, is in very good condition, and the center panel showing the freezing martyrs is almost identical in all details except for the addition of a figure seen just disappearing into a little bathhouse. The most striking dissimilarity is the abundance of very bright blue in the background of the principal scene; this blue also appears on the wings in the background of depictions of eight warrior saints (pl. XII). Heavy blue paint appears on the ground down to just above the heads of the martyrs and in the inscription, around which the ground has been rubbed clean. A lighter blue band frames the aureole around Christ. Gold stars are painted sprinkled over the blue sky; inscriptions that have been painted over in blue are picked out in gold as well. Gold is also clear and abundant on boots, swords, shields, garments, halos, and loincloths (pls. XIII and XIV). Several large green crystals were detected on garments of the warrior saints and in

the upper border, while a pinkish-red appears on Christ's cloak and in the upper bevel. On the closed leaves of the front of the diptych is a cross with arms terminating in rosettes; on the cross are traces of gold. The interior of the diptych has such bright paint that one must assume it was repainted, while the back and front were not and simply retain faint traces of original paint. The interior was presumably repainted consistent with remnants of color visible before the repainting. While the Berlin panel was probably cleaned in order to regularize its appearance when the pigment started to flake off, the St. Petersburg Triptych met a different fate and was partially repainted, producing the strikingly different effects we see today.

In order to pursue the question of the makeup of the blue on the St. Petersburg Triptych, pigment samples were taken by a conservator. When these were analyzed in the United States, they turned out to be similar in chemical makeup to the blues on several tenth-century ivories in the Metropolitan Museum: the blue was natural ultramarine or lapis lazuli. The implications of these pigment tests will be discussed in detail in the next chapter. Thus the Forty Martyrs Panel in Berlin, on which only tiny remnants of color survive, turned out to have clearer and more varied indications of polychromy than its brightly painted twin in St. Petersburg. On the other hand, although it is somewhat anomalous, the St. Petersburg Triptych indicates the startlingly bright effect many ivories must originally have produced.

A distinct category of Middle Byzantine ivories is constituted by small panels depicting narrative scenes beneath canopies with openwork columns and baldachins; they often appear as the central panels of triptychs. One of the best preserved is in the Louvre, the Nativity Triptych

(DB no. 82; fig. 10), which is only 12 cm high and fits in the palm of one's hand. Under the pierced, *à jour* baldachin is carved in high relief and intricate detail the scene of the Nativity, accompanied, as is customary in Middle Byzantine art, by the Annunciation to the Shepherds and first bath of the infant. In the wings are the Entry into Jerusalem, the Descent into Hell, and the Ascension in double registers. The recent catalogue entry on this piece classifies the material as "ivoire pourpré."[26] And rightfully so, for on examination using a microscope, the surface appeared covered with red and reddish-pink crystals, with localized red on the ground and large crystals of orange-pink and bright red in the canopy, leaf clusters, and frame, and in the wings. Large green crystals and bright blue ones appeared in the canopy and on the ground. The cross on the closed cover also had tiny red crystals overall and blue pigment in the ground around the terminal rosettes. One positive identification was made of gold. All eyes of figures were encrusted with black, and a heavy, chalky white residue could be seen over the whole surface. The color scheme in this plaque was evidently similar to the imperial plaques discussed earlier, with stain covering the entire piece and details picked out in blue and green and gold.

Another "canopy" panel is the surviving center panel of a triptych in the Metropolitan with a scene of the death, or Koimesis, of the Virgin; Mary lies on a bed surrounded by apostles while Christ holds her soul to be transported to heaven by angels (fig. 11).[27] The ivory measures 17.7 × 14 cm. The scene is set under a canopy similar to that in the Paris Nativity. In this piece the entire brownish-red surface had evidence of gilding: on flesh, hair, halos, drapings of the bed, frame, and footstool. There was also a green encrustation in grooves and creases of drapery, with bright green

pigment in the area of damage; remains of a lapis blue and of red show they were applied over the gold. While polychromed, this represents a very different color scheme from the Paris Nativity plaque.

A third example of a "canopy" triptych is the surviving center panel of a triptych in Berlin representing Christ's Entry into Jerusalem; it measures 18.4 × 14.7 cm and is excellently preserved except for one gap in the *à jour* canopy (fig. 12). Although no color is visible to the naked eye, this panel too had a varied color scheme. Localized red appeared on the bevel of the border, on the leaves of canopy ornament, and in the letters. Red and much gold appeared on the baldachin, with localized gold also on the background. Green appeared in trees and bright blue-green crystals on the robes on the ground beneath the ass, and on robes of the children. Random red, blue, and light green crystals appeared on the ground around the figures. There was a chalky white material in the interstices of the openwork of the baldachin. These three panels with narrative scenes conform to the same palette as all the other pieces examined. Occasionally unusual colors like yellow or blue-green crop up, but for the most part the colors seem to be remarkably consistent and their patterns of application, or survival, similar. Recognizing these colors time after time results in the envisioning of a palette of very bright colors juxtaposed with the metallic gleam of gold, like jeweled enamelwork, or mosaic tesserae made of glass, or the bright pigments and gold leaf found in illuminated manuscripts. In fact, the ivories with narrative scenes have been referred to as a "painterly group," owing to their stylistic and iconographic similarities to manuscripts.[28] Now we can go one step further and say they are not only "painterly," but painted.

The evidence of color tabulated in the database shows that the palette of the surfaces of the ivories represents a repeated and consistent selection of the same bright colors: red, blue, green, and gold. Indeed, the brightest possible shades of these colors seem almost to compete with one another on these pieces. There is little evidence for pastels or ocher shades like yellow or brown. Sometimes the application is more naturalistic, as in the use of green for trees or ground—for example, in the Entry into Jerusalem panel or the Forty Martyrs panel in Berlin—but there is no discernible evidence of modeling. The color is sometimes more symbolic or abstract, as on the Harbaville Triptych, where much of the surface is covered with gold, and on the coronation panels, where entire pieces are dyed red. The recurrent use of this palette will be better understood after a discussion of the makeup of the pigments themselves.

Chapter 2

Colors, Pigments, and Pigment Analysis

 Ninety-five percent of the microscopically examined ivories of the test group bore traces of color, indicating they had once been painted or dyed. One of our initial questions was: How likely is it that the color is original? This chapter moves from visual observations of color to pigment analysis done in the laboratory. Pigment analyses done on samples taken from several Byzantine ivories in the group indicated pigments that were used in the ancient and medieval world—cinnabar, lapis lazuli, and malachite, among others. No nineteenth-century or later synthetic pigments were found. When we examine the sources of these pigments, methods of refinement, and concerns of the craftsmen who used them, the implications of applying color to ivory become more intelligible. It remains for analyses to be done on ivories that appear to have been dyed; sampling ivory imbued with the reddish-brown stain characteristic of dyed ivory must be postponed until a less intrusive process is developed. Texts from several periods help demonstrate what the coloring of ivory entailed in practical terms.

Defining the Colors

As noted in the preceding chapter, the colors observed on the ivories in the study group were remarkably consistent in their range of hues and

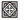

individual shades. Those encountered most frequently were bright red, green, blue, and gold, and, for the most part, the same shades of those colors. This seemed a surprising coincidence in pieces that were probably made in different locations over a span of at least seven hundred years. My visual observations were therefore systematized according to the tripartite system used in Munsell's analyses of color, which identifies color in terms of three attributes: hue, value and chroma (H/V/C).[1]

Munsell's *Book of Color,* with its color chips that reproduce all possible hues with their value and chroma progressions, offered a system by which to clearly classify my observations of polychromy on ivories. By juxtaposing my notations made while each piece was under a microscope with the color chips, I chose analogues among the chips for each of the colors observed on the ivories. Accurate visual observation of color, as in any kind of art historical or archaeological analysis, is not a mechanical process but requires developing sensitivity to gradations of color. One also needs to compensate for varying conditions, such as lighting, quality of microscopes, and overall condition of pieces.[2] Most reliable in this process was the principle of recognition. Even slight differences in the appearance of a color one has seen previously are just as striking as similarities; for example, a bright red crystal might turn out on increasing the magnification to be more orange than red. The color would therefore be differentiated from other samples recorded as simply red, and would be noted as orange-red. Based on this method of observation, I calculated the following Munsell definitions for the colors on the ivories:

Red:	2.5R 5/12 to 5R 5/14
Pink:	7.5RP 5/12

Red stain:	10 RP 5/12
Orange:	7.5R 5/12
Gold:	10YR 8/10
Green:	2.5G 6/12 to 5G 6/10 to 7.5 G 6/10
Blue-Green:	2.5 BG 6/10
Blue:	2.5 PB 4/10 to 5PB 4/12

Several inferences can be drawn from these data: for example, that green had the most variations. This may be explained by the fact that green usually appeared as crystals, and the crystals were often large and semitransparent, but occasionally they appeared as opaque patches or localized stain. The differing structural characteristics of the green pigment were responsible for producing slightly different chromatic impressions. Red and different shades and structures of red make up the largest group of identifiable colors: red crystals, red stain, pink, and orange-red. Red also had a chroma or intensity of 14, which was higher than any other color. No color observed was a true purple in Munsell terms, but the blue observed was Munsell's purple-blue; also, red stain and pink were defined as red-purple on the Munsell scale. It is clear from the calculated definitions of colors that we are dealing with a very saturated palette, for most colors had a Chroma factor of at least 10 if not 12, putting them near the top of the scale of possible intensity.

The consistent palette of high intensity shades might suggest that the artisans who painted the ivories simply preferred these colors, or that these were the only colors available, possibly all obtained from a common source. One would still expect to find more originality in mixing or adding new colors, such as pastels. Instead, the same shades were used repeatedly on ivories of both the earlier and later periods of production, and they were usually used not alone, but in conjunction with one another. This consistency can

be better understood when we turn to the pigments that produced these colors.

Pigment Analysis Results

Analyses were done in the Department of Objects Conservation at the Metropolitan Museum on several pieces with sufficient traces of color to take the necessary minute samples. The following five objects were tested: the three Joshua Plaques at the Metropolitan and their bone borders (pls. II, III, VI), the "Oppenheim Casket" (pl. XV), also in the Metropolitan Museum, and the Forty Martyrs Triptych in the Hermitage Museum in St. Petersburg, Russia (pls. XII–XIV); the Oppenheim Casket with its roundels of Apostles seen against red and blue grounds, and lid with a gilded figure of enthroned Christ surrounded by roundels with St. John the Baptist, Mary, and two angels against red and blue backgrounds (see detail in plate XV), has been recently cleaned and now appears as white.[3] Although the Oppenheim and St. Petersburg ivories may have been partially repainted at an unknown date, they are representative of the varied coloration detected on a substantial number of ivory objects, as discussed in chapter 1. Excerpts from the reports on these pieces are informative.

Diana Harvey's report on the Joshua Plaques noted:

Surfaces show traces of green, red and blue pigments as well as gold foil. . . . Pigments include red, blue and green, as well as possibly a brown and a black. With the exception of the brown and black, all colors were sampled for examination under the Scanning Electron Microscope by means of energy dispersive X-ray spectometry (EDS) with the following results: The blue pigment was identified as

Ultramarine blue. Polarized light microscopy confirmed that it is natural ultramarine. The red pigment was identified by EDS as mercuric sulphide. Mercuric sulphide (HgS), the principal ore of metallic mercury, is known as either cinnabar or vermilion (also called artificial cinnabar) depending on its source.[4] If the pigment was obtained by crushing and grinding the natural ore, it is termed cinnabar. If the pigment is formed by combining mercury and sulfur, using either of two processes known respectively as the dry process (sublimation) or the wet process, it is known as vermilion. Although the two terms are often used interchangeably, and although all three types of mercuric sulphide are chemically the same, microscopical examination reveals certain differences. Natural cinnabar and dry-process vermilion may be distinguished from wet-process vermilion because the latter consists of regularly shaped, evenly sized, very finely divided particles that are characteristic of precipitates. The former display a range of sizes and shapes, being rather coarse and granular with distinct fracture faces. (Note: the manufacture of vermilion by the wet process was not discovered until the 17th century.) Natural cinnabar and dry-process vermilion are more difficult to distinguish from each other. Apart from being coarser if not too finely ground, natural cinnabar may have inclusions and other mineral impurities from the original ore that would not be present in dry-process vermilion. However, the natural ores often have a very high degree of purity, so that inclusions are not always present. (Note: The manufacture of artificial cinnabar or dry-process vermilion was known from as early as the 8th–9th century A.D., if not earlier, and seems to have been very common by the Middle Ages.)[5] In this particular case, polarized light microscopy revealed that the pigment consists of either natural mercuric sulphide, i.e., ground cinnabar, or dry-process vermilion. The green pigment was identified by EDS as a copper com-

pound. Polarized light microscopy indicated that the green pigment consists more specifically of malachite and terre verte. What appeared to be brown and black pigments were examined using only polarized light microscopy and were found to be mixtures of malachite, terre verte and cinnabar.

The gilding on the border elements tends to be directly on the ivory surface. On the rosettes of the medallion borders, the gilding is often covered by a layer of the blue pigment which in turn is often covered by a layer of the red pigment. Although it is impossible to definitively determine the original color pattern of the plaques and borders from the remaining traces of pigment, various possibilities may be suggested, including that all of the rosette medallions had red over blue over gold backgrounds, while the bust medallions had red over gold backgrounds.[6]

Sampling by Mark Wypyski confirmed the results obtained by Diana Harvey. When he then compared samples of the same colors on the Joshua Ivories with blue and red from the Oppenheim Casket, the blues and reds from the two objects were found to be the same pigments with minor variations. The following are extracts from Mark Wypyski's report:

Samples of the blue, red and green pigments from the plaque and border of the Joshua Ivories (17.190.135–137), and blue and red from the [Oppenheim] Casket Ivory (17.190.238) were examined by energy dispersive X-ray spectrometry to identify and compare the elements present in the different pigments. The blues and the reds from the two objects were found to be essentially the same with some minor variations.

All three samples of blue pigments showed large amounts of sodium, aluminum, silicon and sulfur, indicating that the pigment in all three was ultramarine. Also seen in all three was some potassium and calcium, along with traces of chlorine, titanium and iron. These elements may be from the original stone matrix of the ultramarine, showing that it is natural and not artificially made ultramarine, which would be consistent with a medieval date. The sample from the [Oppenheim] Casket Ivory in addition showed a large amount of lead (probably lead white) and a trace of phosphorus, neither of which was seen in the blues from the Joshua Ivories.

The reds from all three contained large amounts of mercury and sulfur, and appear to be vermilion. Lead also appeared in all three samples, probably as lead white. Also seen in all three reds were aluminum, silicon, potassium, calcium, iron and a trace of titanium. In the [Oppenheim] Casket Ivory, however, there were higher proportions of these other elements, especially iron, and [this] may indicate the addition of red ochre as well as vermilion. Also seen in this sample and not in the Joshua Ivory samples was some magnesium and phosphorus.

Samples of green from the Joshua Ivories were also examined. All four samples contained mainly copper and lead, along with chlorine, magnesium, aluminum, silicon, phosphorus, potassium, calcium, and iron. The samples taken from the upper and lower layers on the border and plaque pieces were essentially the same, with some variation in proportions. The green here could be a copper chloride salt, copper resinate, or could be a copper carbonate such as malachite or verdigris, and may also be mixed with some terre verte.[7]

Schematic diagrams, generated by Mark Wypyski, show the distribution of pigments on the bone borders of the Joshua Plaques (see appendix B). Green pigment traces appear in the leaf decorations between roundels with heads and rosettes. In the backgrounds of heads and rosettes are found traces of blue, red, and sometimes blue and gold, red and gold, or red, blue and gold. Several pigments were thus used in close proximity or even in layers. Unfortunately,

it is no longer possible to be certain about the former color scheme.

Further pigment analyses were done in 1992 on blue samples from the Forty Martyrs Triptych in the Hermitage in St. Petersburg.[8] The analyses were again done through EDS, again at the Metropolitan, and the results were compared with the earlier results from the Joshua and Oppenheim Ivories. Mark Wypyski's report of 1992 notes:

Both blue samples [from the Forty Martyrs Triptych] were found to contain large amounts of sodium, aluminum, silicon and sulfur. This is probably due to the presence of the pigment ultramarine, a sodium aluminum sulfur silicate mineral (lapis lazuli). Also detected in both samples were large amounts of potassium and calcium, as well as small amounts of magnesium and chlorine, and traces of titanium and iron. These elements may be from the original stone matrix of the lapis lazuli from which the ultramarine was made, indicating that these are samples of natural ultramarine (synthetic ultramarine was made beginning in the nineteenth century). A trace of lead was also seen in sample I, probably from some lead white pigment, but not found in sample II.

The overall compositions of these two blue paints appear to be similar to those examined from two medieval ivories at the Metropolitan Museum of Art in July 1990, the "Joshua Ivories" and the "Casket Ivory." The only real difference was the large amount of lead found in the blue from the [Oppenheim] "Casket Ivory," which was probably present in the form of lead white pigment.[9]

A chart by Mark Wypyski allows comparison of elements in the five samples of blue pigment that were tested:

EDS Elemental Analysis of Blue Paint Samples: Summary of Results (June 1994)

Weight %	Na	Mg	Al	Si	S	Cl	K	Ca	Ti	Fe	Pb
Joshua											
Plaque	11	3	18	44	7	1	7	9	<1	<1	—
Border	12	3	18	42	7	1	5	11	<1	1	—
Oppenheim	13	3	18	36	6	<1	5	5	1	<1	11
40 Martyrs											
Blue I	13	4	18	40	7	1	8	8	<1	<1	1
Blue II	10	2	17	40	7	1	10	12	<1	<1	—

In conclusion, the overall results of pigment analyses indicate a consistent group of pigments: the blue is ultramarine blue or most probably natural lapis lazuli; the red is dry-process vermilion, or natural cinnabar; the green is malachite, or verdigris and terre verte; the gold is gold foil; black and brown on the Joshua Plaques were a mixture of cinnabar, terre verte, and malachite.

As more ivories with surviving traces of colors are analysed in the years to come, a clearer picture will emerge of the pigments used to paint them. Studies of pigments used in illuminated manuscripts indicate use of the same pigments as found in the test group and further contribute to our knowledge of medieval artists and their materials.[10] Pigments used on sculpture and monu-

mental decoration in stone in Byzantine times might also help complete the picture of artistic practices and uses of colors. All the pigments in the tested ivories were in use in the medieval period and also later. If the bright colors of the Oppenheim and St. Petersburg Forty Martyrs pieces are in part the result of repainting, then the painters utilized costly red and blue pigments and gold in accordance with medieval practice. The consistency with which those same colors appear on pieces that were microscopically examined suggests that the same pigments were used in the many unanalyzed examples recorded in the database. A brief look at the sources and history of these pigments will elucidate their probable usage and connotations in the ancient and medieval world.

Sources and History of the Pigments

Since the artisans who painted the ivories were often responsible for buying and refining their pigments, it would be useful to know where and through what processes they were obtained.[11] Most colors, whether to be used for painting manuscripts, sculpture, or walls, were ground in the same way.[12] Natural materials were first milled dry with mortars and pestles to break up large pieces of pigment. The next stage was fine grinding, for which the ideal stone was considered to be Egyptian porphyry because of its hardness; marble was also used. A flat porphyry stone or split pebble was used as a muller. To develop the richest color from some pigments fine grinding was necessary. This also helped produce a paint that flowed smoothly. For example, vermilion improves in color if ground very fine, while malachite turns pale unless ground lightly. Colors were usually milled dry and then mixed with water to form a paste; this paste was then

ground further as needed. The pigments identified through our analyses are discussed by a number of authors: Theophrastus, Dioscurides, Pliny, and Vitruvius for ancient pigments, and Theophilus, Heraclius, Cennino Cennini and Dionysius of Fourna for medieval ones.

Reds

Cinnabar (sulphide of mercury), or minium, was found in silver mines, and among its sacred associations in antiquity was its use on holidays to color the face of the statue of Jupiter (Pliny, *N.H.* 33.36). Cinnabar is mentioned by the fourth-century B.C.E. Greek writer Theophrastus, but it is thought that cinnabar was known in Greece as early as the sixth century B.C.E.[13] According to Pliny, the best cinnabar came from Spain and also from the country beyond Ephesus (*N.H.* 33.37).[14] The most famous cinnabar mine was in Almaden, Spain, and the price of this cinnabar was fixed by Roman law at 70 sesterces a pound, which was considered extremely costly (*N.H.* 33.40).[15] Cinnabar was the only source of bright red known to the ancient world.[16] Confusion between cinnabar and minium is evident in Dioscurides (1st century C.E.), who in his *De materia medica* identifies them as different substances; while he localizes minium to Spain and cinnabar to Africa, he attributes the costliness of cinnabar to its limited use in painting (*De mat. med.* 5.109).[17] Dioscurides concurs with Pliny on the scarcity and costliness of the substance.

Vitruvius, writing in the first century C.E., contributes to our knowledge of details of the refining process of minium in his *De architectura:*

Minium or vermilion . . . is said to have been discovered in the Cilbian Fields of Ephesus. The material and its treatment is sufficiently wonderful. For

what is called the ore is first extracted. Then, using certain processes, they find minium. In the veins the ore is like iron, of a more carroty colour with a red dust round it. When it is mined, and is worked with iron tools, it exudes many drops of quicksilver, and these are at once collected by the miners. . . . When the ore is dry, it is bruised with iron rammers, and by frequent washing and heating, the waste is removed and the colour is produced (*De arch.* 7.8.2–7.9.1).[18]

Artificial cinnabar, or dry-process vermilion, is described in a text dating from around 800 B.C.E. and was apparently already in great demand in the eighth century.[19] The manufacture of vermilion was probably invented between the third and the eighth century B.C.E. and consisted of the marrying of mercury and sulphur. This was done by depriving low-grade cinnabar of its sulphur content to make mercury. The mercury was then resynthesized with sulphur as vermilion. The longer the mixture is ground the brighter the color becomes.[20] Among works that have previously been analyzed for the presence of cinnabar or vermilion with positive results are: Egyptian Fayum portraits of the first through third centuries, Roman and Pompeian wall paintings, and the fourteenth-century frescoes at the church of Kariye Djami in Istanbul.[21]

The colors found on the ivories of our study group, red, blue, green and gold, constitute the core of the medieval palette about which the eleventh-century writer Theophilus Presbyter and the late-fourteenth-century Italian painter and writer Cennino Cennini are well informed.[22] Theophilus, in his treatise *De diversis artibus (On the Various Arts)*, deals in Book I with the materials and art of painting, including how to make the various pigments.[23] The process of making vermilion is straightforward:

If you wish to make vermilion, take some sulphur of which there are three kinds—white, black and yellow. Break it up on a dry stone, and add to it two parts of quicksilver, weighing them on the scales. When you have carefully mixed them, put them in a glass jar, cover this on every side with clay, stop up the mouth so that no vapour can escape, and put it on a fire to dry. Then place it in a burning fire and, when it begins to get hot, you will soon hear a cracking noise inside caused by the quicksilver combining with the burning sulphur. When the noise has stopped, remove the jar at once, open it and take the colour (*De div. art.* 34).[24]

Cennini refers to several reds: vermilion, red lead, hematite, lac, dragonsblood, and cinabrese. He suggests that vermilion is best bought at the druggist's, for its manufacture is "too tedious to set forth in the discussion." However, he offers practical advice on how to recognize the best vermilion:

Always buy vermilion unbroken, and not pounded or ground. . . . Examine the unbroken lump of vermilion, and at the top, where the structure is most spread out and delicate, that is the best (Cennini, *Libro dell'arte*, XL).[25]

The influence of vermilion was significant, for in its pure state it was always a powerful color of high intensity, which provided an accent or standard of brightness best seen juxtaposed with other bright colors. The expense of vermilion is well attested and stemmed from the complicated process of its manufacture.[26]

Blues

Ultramarine blue, while regularly including silicates and pyrites and other colorless mineral impurities, is richer in color than azurite and more

expensive; in ancient times this blue (the blue from "across the seas") was imported from Persia ready-made rather than as the raw material, lapis lazuli.[27] The principal quarries were in Badakshan, now Afghanistan.[28] When powdered, the stone is hardly blue at all, but gray; complicated measures had therefore to be invented to refine it to exactly the right degree for use as a pigment.[29]

The blue pigment most commonly used for painting in Greco-Roman antiquity was a manufactured blue called Egyptian blue, a copper silicate. However, Vitruvius makes an allusion to "armenium," which, he states, shows by its name the place where it was found; this may have been ultramarine or lapis lazuli found in Armenia.[30] Due to the high cost of importing the raw material and the complicated process of extraction, good quality ultramarine was as expensive as gold.[31] Byzantine use of ultramarine is demonstrated in the striking bright blue backgrounds of the painted scenes in the New Church of Tokalı in Cappadocia, dating to the mid-tenth century.[32] The high artistic quality of the frescoes is parallel to the use of the most expensive materials. For example, gold and silver leaf appear on the halos of Christ and the Virgin—a unique instance for wall painting.[33] Ultramarine blue is used not only in the background of the scenes, but also for the draperies of many figures.

Cennino Cennini wrote the fullest account of the refining of lapis at the end of the fourteenth century.[34] This consisted of pounding it into a fine powder, which was mixed with turpentine, mastic, and wax; after being heated and strained, it was used to color lye, which was then reduced. The reason for its high cost is apparent from the method. Although a low-cost ultramarine was invented in France in the eighteenth century, it is possible to distinguish this from genuine ultramarine because foreign elements are naturally present and intermixed with the genuine product while the modern imitation is very "pure."[35] From ancient times the intrinsic worth of ultramarine blue as well as its bright color made it appropriately juxtaposed with gold: "And let some of that color [ultramarine blue], combined with gold which adorns all the works of our profession, whether on wall or on panel, shine forth in every object."[36] The use of ultramarine blue in Byzantium and the West from at least the tenth century on indicates that this precious substance, so difficult to acquire and refine, must have been the luxury pigment par excellence.

Greens

Malachite occurs in nature as a stone with a range of green shades, and although some of the finest malachite is used as a semiprecious stone in jewelry, it does not have great intrinsic worth. It is made into a pigment by grinding and washing, which results in colors ranging from a pale green to a bright grassy green, opaque in character and crystalline. Vitruvius makes only a passing reference to malachite: "Malachite (*chrysocolla*) is imported from Macedonia; it is mined in places which adjoin the copper mines."[37] In discussing substitutes for certain pigments Vitruvius says: "Malachite (*chrysocolla*) is dear, and those who cannot afford it steep blue dye with the herb which is called weld and obtain a brilliant green."[38] Dioscurides affirms that there were three sources for malachite (*chrysocolla*): Armenia, Macedonia, and Cyprus.[39]

Pliny describes the laborious process of making artificial green or verdigris (*aerugo*) from the salts of acetic acid or copper acetates:

There are several ways of making it; it is scraped off the stone from which copper is smelted, or by

drilling holes in white copper and hanging it up in casks over strong vinegar which is stopped with a lid. The verdigris is of much better quality if the same process is performed with scales of copper . . . (*N.H.* 34.26).[40]

Verdigris is also called *aeruca* by Vitruvius, who describes the process of obtaining it:

At Rhodes they place a layer of chips in a large vessel, and pouring vinegar over them, they then put lumps of lead on the top. The vessel is covered with a lid lest the vapour which is enclosed should escape. It is opened after a certain time and the lead is found to be changed into cerussa [lead acetate]. In the same way, by using plates of copper, they obtain verdigris or aeruca [basic copper acetate].[41]

Theophilus discusses obtaining verdigris in chapters 35 and 36 of his *De diversis artibus*. The process is very similar to that described by Pliny and Vitruvius, and the color obtained is called salt green (*viridum salso*) or Spanish green (*viridum Hispanico*).[42]

Part of the process of making a green pigment from malachite is described by Cennino Cennini:[43]

A half natural color is green . . . and it is called malachite. This color is rather coarse by nature, and looks like fine sand. For the sake of the color, work it up very, very little, with a light touch; for if you were to grind it too much, it would come out a dingy and ashy color. It should be worked up with clear water; and when you have got it worked up, put it into the dish; put some clear water over the color, and stir the water up well with the color. Then let it stand for the space of one hour, or two or three; and pour off the water; and the green will be more beautiful. And wash it this way two or three times, and it will be still more beautiful.[44]

This is distinguished, however, from verdigris:

A color known as verdigris is green. It is very green by itself. And it is manufactured by alchemy, from copper and vinegar. . . .Work it up with vinegar, which it retains in accordance with its nature. And if you wish to make a most perfect green for grass . . .; it is beautiful to the eye, but it does not last.[45]

Another green pigment, terre verte (green earth), is dull, transparent, and soapy like clay, with a great range of hues, from bluish-gray to dark brownish-olive. Pliny mentions that it can be used as a substitute for malachite.[46] According to Cennini, "The more you work it up the better it will be . . . "; it was also used like bole, a red color applied to wooden panels as the base for gilding. Cennini notes: "I know the ancients never used to gild on panel except with this green."[47] It has been suggested that some of the green found on ivories was the preparation for gilding.

Gold

Gold foil or leaf consisting of gold beaten into thin, paperlike sheets has been used to embellish numerous media. Its intrinsic value does not need to be demonstrated, and its sources were numerous; however, the process of preparing and applying it to surfaces relates to its use and appearance. Gold can be beaten and rolled until it is so thin as to be virtually transparent. In a thin state it naturally adheres to any surface to which it is applied.[48] However, mordants were probably used, such as the oil or garlic juice described by Cennini.[49] Gold can also be applied as a powder and then polished, but it never has the sheen that gold leaf acquires, especially after polishing or burnishing. There is ample testimony to the methods used to make gold leaf.

Pliny explains the different grades and uses for gold leaf:

Nor is any other material more malleable or able to be divided into more portions, seeing that an ounce of gold can be beaten out into 750 or more leaves 4 inches square. The thickest kind of gold leaf is called Palestrina leaf, still bearing the name taken from the most genuinely gilded statue of Fortune in that place. The foil next in thickness is styled Quaestorian leaf. . . . On marble and other material incapable of being raised to a white heat gold is laid with white of egg; on wood it is laid with glue according to a formula. . . . Gold in our part of the world—not to speak of the Indian gold obtained from ants or the gold dug up by griffins in Scythia—is obtained in three ways: in the detritus of rivers, for instance in the Tagus in Spain, the Po in Italy, the Maritza in Thrace, the Sarabat in Asia Minor, and the Ganges in India (*N.H.* 33.19.61–62).

Eraclius, writing probably in the twelfth century, includes in his treatise on "The Colours and Arts of the Romans" references to color and ivory. Chapter 9 is "Of gold-leaf, how it is laid on ivory," implying this was a standard practice:

You will decorate carvings in ivory with gold-leaf. Now hear in what manner this thing is done. Seek to obtain the fish which is called "huso," and keep its air-bladder liquefied by being boiled in water, and with this mark over the place where you wish to lay the gold; and you will thus easily be able to fasten it to the ivory.[50]

Theophilus also gives considerable attention to gold leaf. In the twenty-third chapter of Book I, he describes the reddening of velum through combining squares of velum with pieces of gold in a pouch and then beating the layers into thin leaf.[51] The white of an egg is recommended to cover the surface for which the leaf is intended. In Cennino Cennini's *Handbook* the quality of both mordant and gold is stressed: "And remember that the gold which you lay upon mordants, particularly in these delicate works, wants to be the most thoroughly beaten gold, and the most fragile, that you can secure; for if it is at all stiff you cannot use it so well."[52] Gold leaf was applied by means of a mordant made of oil or varnish or another adhesive agent. Although the agent for making gold adhere to ivory has not been identified in the pieces tested to date, we assume that one of these medieval methods was probably used.

The colors detected on the pigment-tested ivories are representative of the colors found on the ivories throughout the study group. It is evident that not only were these bright, pure colors individually, but that when juxtaposed they harmonized to produce a balanced palette. They responded to one another, without one overpowering any other, and produced a uniform jewel-like richness of effect. These colors were produced by pigments—vermilion or cinnabar, lapis lazuli, malachite, terre verte, verdigris—and the metal gold, which were difficult to obtain and to refine or prepare, and were therefore of high material value. Commenting on the lavishness and expense involved in the use of bright colors, Vitruvius says:

For who of the ancients is not found to use minium as sparingly as the apothecary: But at the present day whole walls are covered with it everywhere. To it is added malachite, purple, Armenian ultramarine. And when these are applied, apart from any question of skill, they affect the vision of the eyes with brilliance. Because of their costliness they are excluded in the specification, so that they are

charged to the client and not to the contractor (*De arch*. 7.5.8).[53]

Theophilus introduces his work on the various arts saying: "[Y]ou will find in it whatever kinds and blends of various colours Greece possesses."[54] Theophilus's perception that Greece (by which he means the Greek-speaking, i.e., Byzantine, world in general) was the source of the colors for painting acknowledges his reliance on the Byzantine tradition.[55]

Greco-Roman practices for obtaining and refining pigments were inherited by the Byzantines and used by craftsman in the later medieval West.[56] Gradations of value were measured not just in terms of the rarity of pigments but in the comparative purity and intensity of the colors produced. The use of such pigments, obtained and refined at great care and expense, must have enhanced the value of objects to which they were applied. It is also clear that these bright pigments had high intrinsic value and were considered luxurious and precious, and that combining them with one another yielded the most satisfying results. To color ivory with bright pigments or to dye it was thus an expensive alternative to leaving it uncolored. The dyeing of ivory has not been examined in this chapter because of the difficulty of taking a sample and testing it. Most ivories that appear to have been dyed retain only a brownish-red cast, unlike parchment manuscripts, of which several sixth-century examples survive, which retain a deep brownish-purple color throughout. The Codex Rossanensis is an example of such a purple codex (Rossano, Calabria, Il Duomo di Rossano). The agent used to stain parchment and ivories is unknown, though Tyrian purple, made from the murex shellfish, was used to dye woolen and silk cloth from ancient through Byzantine times and after.[57] It was extremely costly and would have been a coloring agent analogous to the precious pigments described above if it had been used on ivory. By whatever means ivory was colored, this was undoubtedly a standard practice, as we can now see, based on the weight of accumulated evidence. In addition, the makeup and history of the pigments themselves show adherence to ancient practices. An examination of the archaeological evidence will enable us to pursue the origins of the tradition of coloring ivory—for it dates back far beyond the earliest pieces in our test group.

Chapter 3

The Ancient Tradition of Polychrome Ivories

The practice of covering and combining ivory with precious substances antedates the findings from our test group and extends far back in time. There were various techniques in which ivory was juxtaposed with valuable woods, semiprecious stones, and gold in Greco-Roman times, and even earlier, in the ancient Near East and Egypt. The treatment of ivory in more remote prehistory also includes coloring, but for the purposes of this study, records of excavated ivories or catalogue descriptions of pieces in museums and collections provide adequate evidence of the antecedents of Byzantine ivories. Not only was ivory used as inlay or itself inlaid with colorful substances, but its surface was regularly treated in various ways. It was overlaid with gold, painted, and dyed. Several polychrome techniques can be discerned in a brief survey of ancient ivories by period or civilization.

Only in the last sixty-five years has archaeological exploration gradually revealed the vast quanitities of carved ivory produced in the ancient Near East. Sir Austen Henry Layard's excavations of 1845 at Nimrud unearthed a few dozen ivory fragments, and W. K. Loftus's discoveries there in 1854 enabled him to establish the existence of a whole school of ivory carving, but it was not until after the fall of the Ottoman empire that the Near East was opened for scientific

exploration by international teams of archaeologists.[1] By the 1920s, new deposits of ivories had been discovered ranging chronologically from temple objects at Abydos in Egypt of the third millennium B.C.E. to ivory-revetted furniture from the palaces at Nimrud of the ninth and eighth centuries B.C.E. Ivories numbering in the tens of thousands, excavated in the 1940s and 1950s, have only begun to see publication.[2] The ongoing accumulation of evidence substantiates the well-known biblical and Homeric allusions to luxury items in this precious material. Indeed, it has been asserted that the ninth and eighth centuries B.C.E. alone should be called the "Ivory Age in the Levant."[3]

While ivory is rapidly assuming its rightful place as a major medium of ancient art, research has yet to focus on the original appearance of ivory in this "Ivory Age." Excavated pieces are often so badly deteriorated that little remains of their original surface. Having been broken in excavation or discolored by the earth, they also often show the effects of burning. To be sure, a few, like the painted ivory box found in the tomb of Tutankhamen, retain their original appearance since they were buried and preserved under ideal conditions. Others that were sheathed or combined with gold or other more durable substances can be reconstructed, giving us at least a partial idea of their original appearance. In others, traces of surface polychromy survive sporadically, giving nonetheless the barest indication of its original extent and character.

Most descriptions of ancient ivory artifacts, including those of rare cases of pieces that survive in reasonably good condition, have been preoccupied with styles of carving and with iconography. Occasionally the shades of the material are mentioned, from gray or tan to beige or creamy white, but most reports note simply that the material is ivory. Others record traces of paint or gilding adhering to the surface, but do not mention their precise location. In the case of inlaid or encrusted ivories, the colors of the glass, paste, or semiprecious stones are usually noted, but formal qualities almost always take precedence. Color, if mentioned at all, is rarely discussed, making it therefore very difficult to assess their original appearance.

While it would be a monumental task to collect and analyze firsthand a representative sampling of ancient ivory artifacts to record instances where color was detectable, there are sufficient cases in which catalogue descriptions either mention color or gilding, or publications include color plates that clearly show preserved coloration. Recent publications with fine color reproductions sometimes make obvious what has been omitted in earlier descriptions—that some ivories clearly were dyed, painted, or gilded. By various means it is still possible to obtain an idea of the appearance of ancient ivory. In a summary of descriptions and photodocumentation of evidence, it becomes rapidly apparent that there was an ancient tradition of polychromy. We thus see the evidence of our test group in a new light, in relation to a long-standing ancient tradition.

Egyptian Ivories

Although it is difficult to ascertain the prehistoric origins of the practice of painting or dyeing ivory objects,[4] the ancient Egyptians had a ready supply of ivory, both elephant and hippopotamus, in the Nile Valley. Elephants still roamed in Upper Egypt, Syria, and India in the second millennium B.C.E.; Egyptian pharaohs even went on occasion to hunt elephants in Syria.[5] The use of ivory for carving a great variety of objects took hold early in Egypt, and by c. 4000 B.C.E. Egyp-

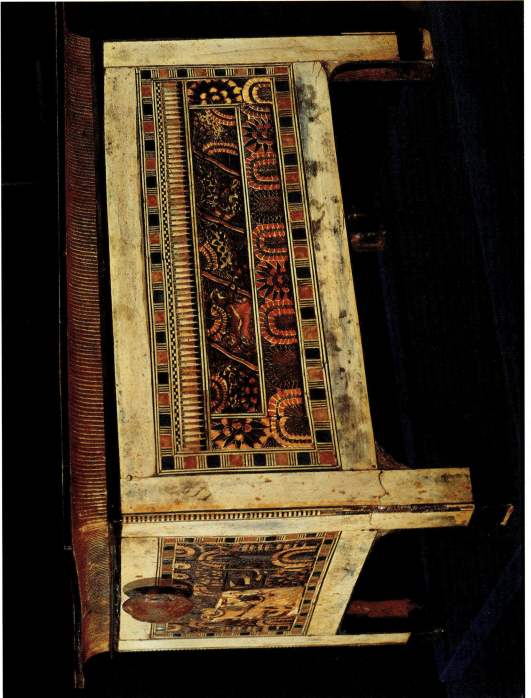

I. Chest veneered with ivory, from the tomb of King Tutankhamen. Cairo, Egyptian Museum

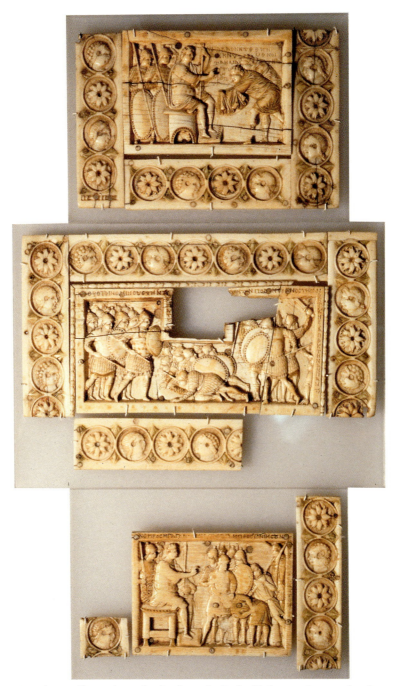

II. Plaques illustrating episodes from the *Book of Joshua*, and rosette border strips. Suppliants from Gibeon before Joshua (top); Ambush of Soldiers of Ai by the Israelites (middle); Captive King of Ai before Joshua (bottom). New York, The Metropolitan Museum of Art

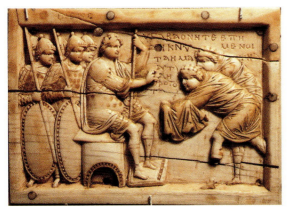

III. Suppliants from Gibeon before Joshua, plaque. 6 × 9 cm. New York, The Metropolitan Museum of Art

IV. Suppliants from Gibeon before Joshua, plaque, color reconstruction (see pl. III)

V. Suppliants from Gibeon before Joshua, plaque, ultraviolet photograph (see pl. III)

VI. Rosette border strip, detail of plate II

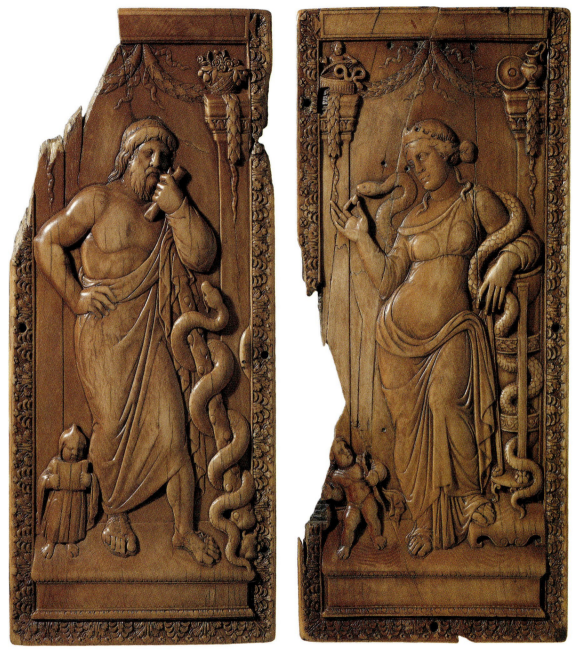

VII. Asclepius and Hygieia Diptych. 13.5 × 14 cm. Liverpool, Liverpool Museum

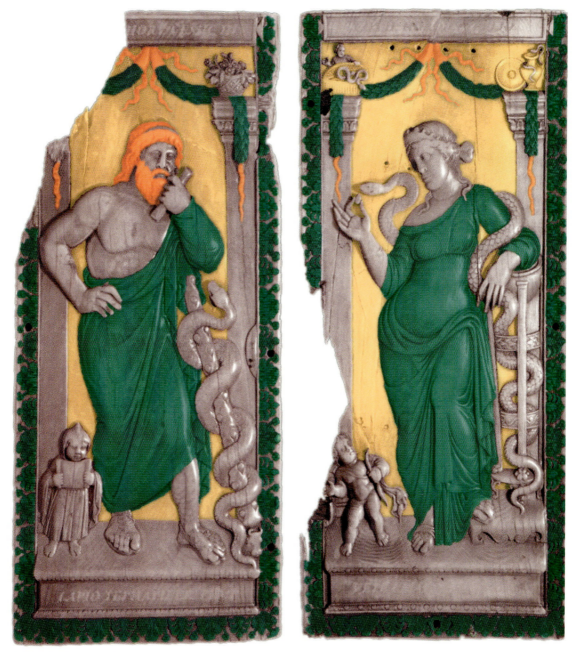

VIII. Asclepius and Hygieia Diptych, color reconstruction (see pl. VII)

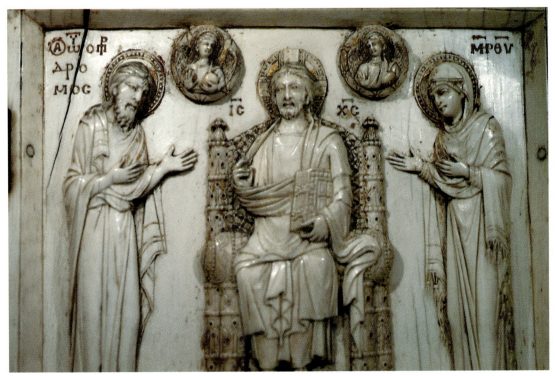

IX. Deesis, detail of the Harbaville Triptych (see fig. 7)

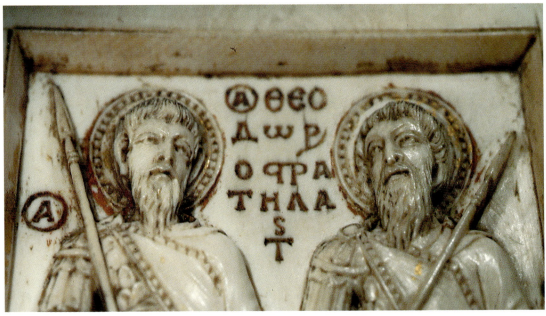

X. Warrior Saints, detail of the Harbaville Triptych (see fig. 7)

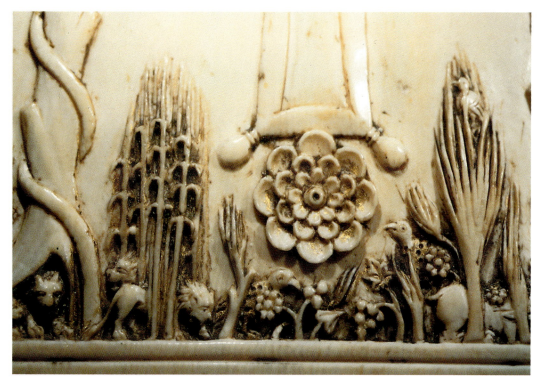

XI. Vegetation inhabited by animals, detail of the Harbaville Triptych (*back*, see fig. 8)

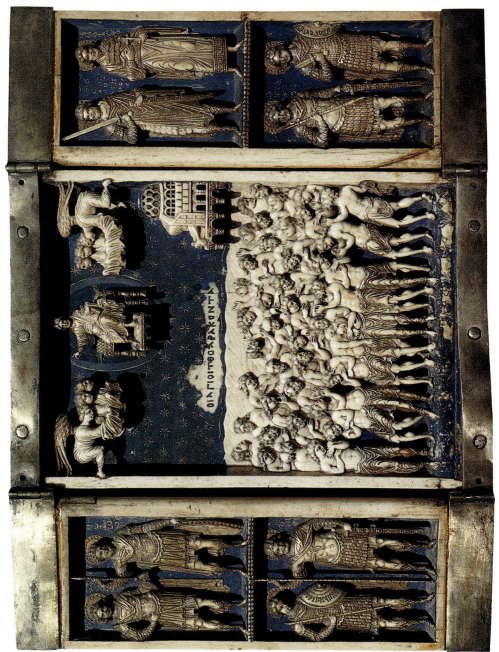

XII. Forty Martyrs Triptych (*open*). 18.5 × 24.2 cm. St. Petersburg, Hermitage Museum

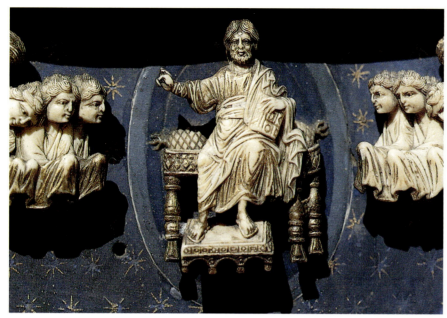

XIII. Enthroned Christ with Angels, detail of the Forty
Martyrs Triptych (see pl. XII)

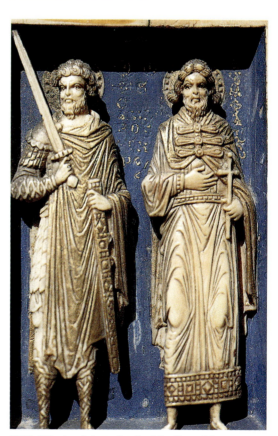

XIV. Warrior Saints, detail of the Forty Martyrs
Triptych (see pl. XII)

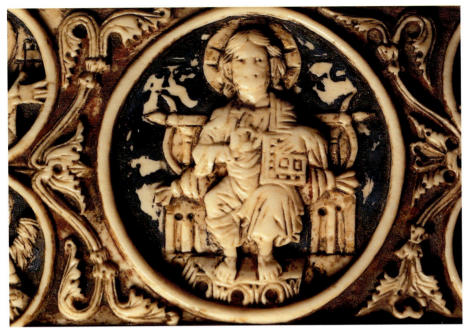

XV. Christ Enthroned, detail of the lid, Oppenheim Casket. 6.7 × 18.4 × 9.8 cm. New York, The Metropolitan Museum of Art. (Since this photograph was taken, the piece has been cleaned and the red, blue, and gold polychromy removed.)

XVII. Border, detail of diptych leaf (see pl. XVI)

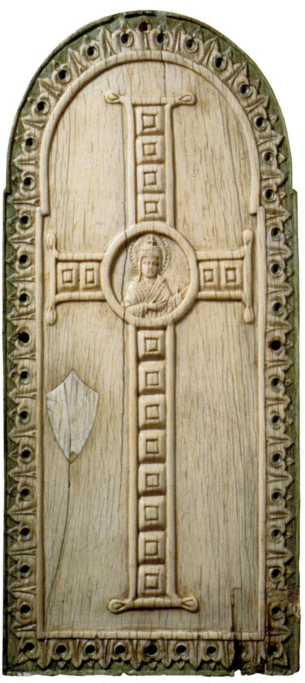

XVI. Emperor Medallion within Cross, diptych leaf. 28.8 × 13.3 cm. Washington, D.C., Dumbarton Oaks

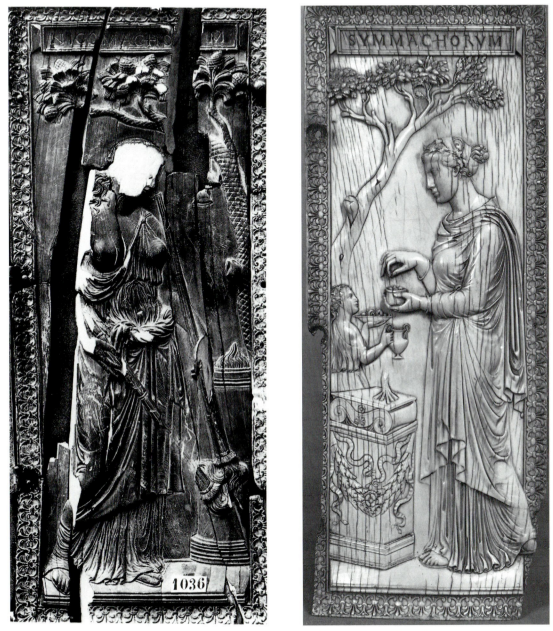

1. Symmachorum-Nicomachorum Diptych. 29.9 × 12.4 cm, each valve. Paris, Musée de Cluny (Cl.17048), and London, Victoria and Albert Museum

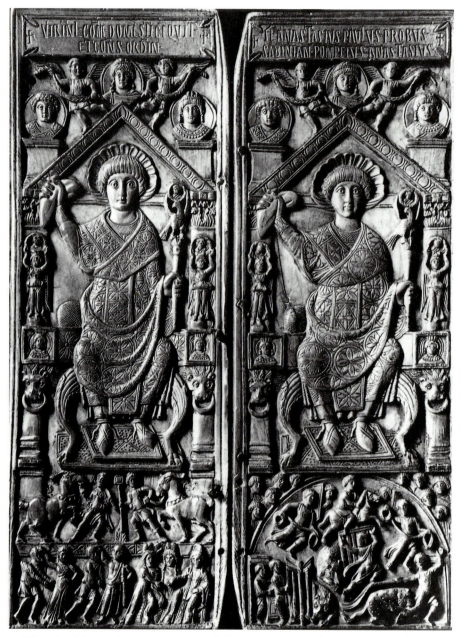

2. Diptych of Anastasius, 517. 36 × 13.1 cm (*left*), 36 × 13.3 cm (*right*). Paris, Bibliothèque Nationale, Cabinet des Médailles

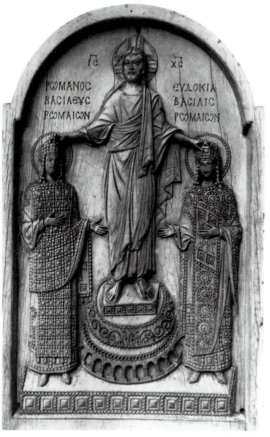

3. Christ Crowning Romanus and Eudocia, plaque.
24.6 × 15.5 cm. Paris, Bibliothèque Nationale, Cabinet des Médailles

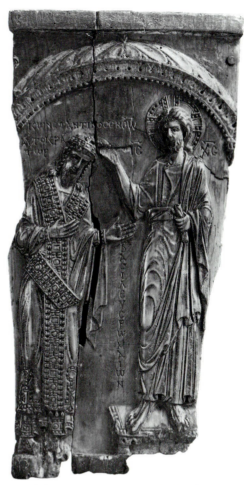

4. Christ Crowning Constantine Porphyrogenitus, plaque. 18.6 × 9.5 cm. Moscow, Pushkin Museum

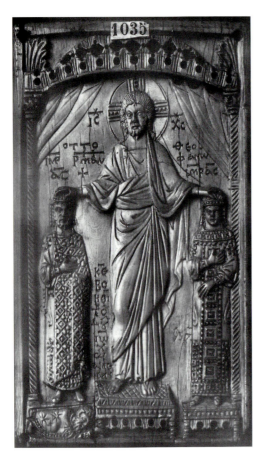

5. Christ Crowning Otto and Theophano, plaque.
18.6 × 10.8 cm. Paris, Musée de Cluny

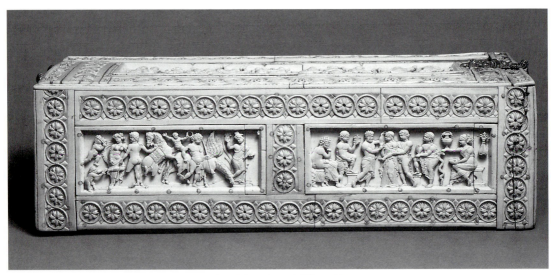

6. Veroli Casket. 11.5 × 40.5 × 15.5 cm. London, Victoria and Albert Museum

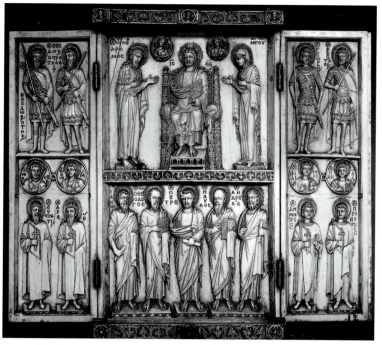

7. Harbaville Triptych (*open*). 24 × 28 cm. Paris, Musée du Louvre

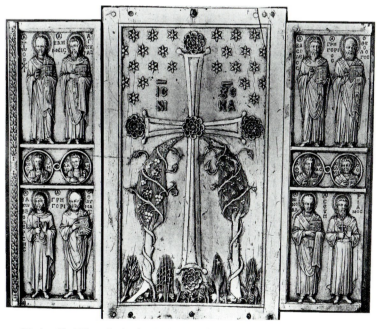

8. Harbaville Triptych (*back*). Paris, Musée du Louvre

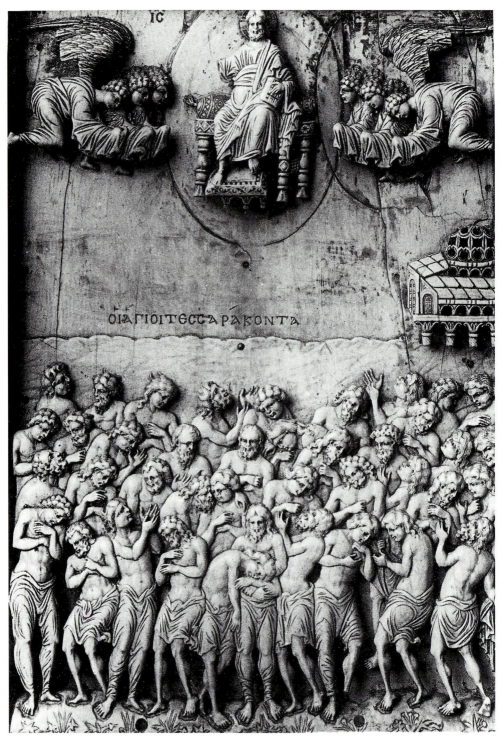

9. Forty Martyrs of Sebaste, panel. 17.6 × 12.8 cm. Berlin, Museum für Spätantike und Byzantinische Kunst

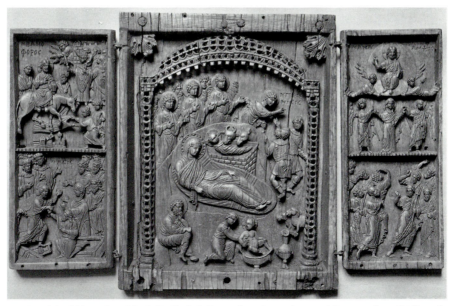

10. Nativity Triptych, with (*left*) Christ's Entry into Jerusalem and Descent into Hell; and (*right*) Ascension. 12.1 × 20 cm, open. Paris, Musée du Louvre

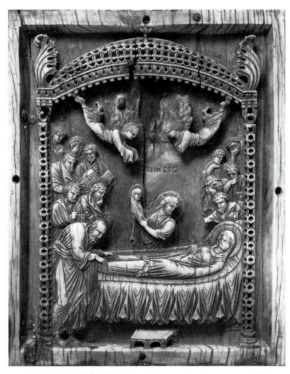

11. Koimesis of the Virgin, plaque. 18.7 × 14.9 cm. New York, The Metropolitan Museum of Art

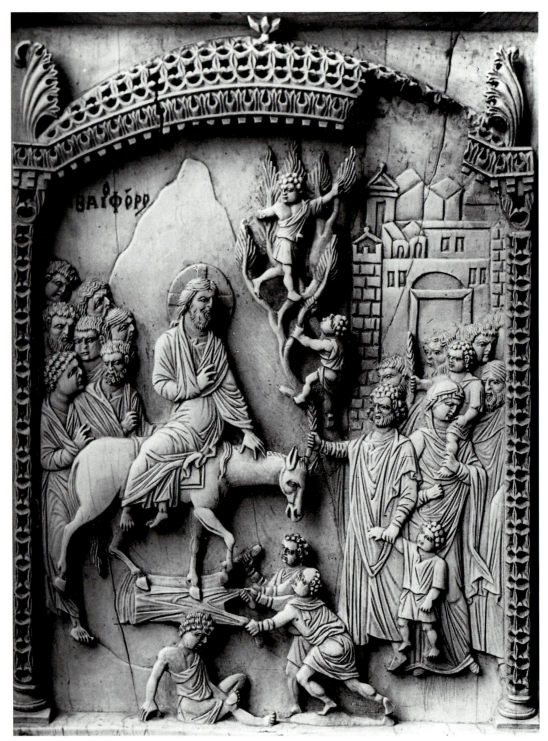

12. Christ's Entry into Jerusalem, plaque. 18.4 × 14.7 cm. Berlin, Museum für Spätantike und Byzantinische Kunst

tians had developed techniques of cutting and carving ivory and combining ivory with other substances, as in silver daggers provided with ivory handles.[6] In the third millennium, it was used to decorate furniture and to carve beads and boxes.[7] Certain objects were typical of Egyptian craftsmanship: ivory combs, boxes, spoons, ornamented beds and chairs, mirror handles; in some objects ivory was used as inlay for ebony and other woods, and was also used in relief or openwork plaques.[8] Ivory was in practical terms such a durable substance that is was employed, if available, in preference to wood, but wood carving was its closest analogue; it was superior to wood, however, for not only was it harder and more durable but it took a clean, crisp line.[9]

Techniques of staining and coloring all or part of the surface of ivory existed in Middle and New Kingdom Egypt. In cuneiform correspondence found at El-Amarna, a king of Babylon sends gifts to Akhenaton (r. 1379–1362 B.C.E.), requesting in return ivory objects "both carved and coloured in Egypt"; a long list of objects sent by the pharaoh, including bowls, oil vessels, ornaments, headrests, are all of stained ivory.[10] The discovery of the tomb of King Tutankhamen (c. 1350 B.C.E.) in 1922 produced dozens of objects that match the descriptions in texts. Along with the box with its painted relief panels were a headrest with blue paste inlay, an ivory papyrus burnisher with gold foil head, wooden walking sticks topped by figures whose heads and hands are of ivory, and a number of chests, chairs, and stools with ivory inlay.[11] A nearly contemporary piece, the head of a girl, preserved in the Victoria and Albert Museum, is stained brown, polished, and has inlaid eyes.[12] A late-eighteenth-dynasty fly whisk handle of a prancing horse in the Metropolitan Museum is stained reddish-brown and

has a black mane and garnet eyes.[13] The Walters Art Gallery has fifty Egyptian ivories, including a New Kingdom ointment box with traces of red and black pigment, and an ivory plaque carved in relief and inlaid with blue faience underpainted with red.[14] The references to color in the tablets are thus supported by excavated examples of painted ivory; it is clear that a tradition of carved and painted ivory existed in ancient Egypt (see pl. I).

Syrian and Anatolian Ivories

While Mesopotamia never had an extensive tradition of ivory carving until the Iron Age, Syria-Palestine and Anatolia had flourishing schools of ivory production in the Bronze Age, with several sites being major centers.[15] Statuettes of human figures, and plaques dating to around 3,500 B.C.E. were excavated in the 1950s at the site of Beersheba; small ornamental plaques pierced with holes filled with bitumen and forming designs were found.[16] Ugarit (Ras Shamra) was a major center of ivory production in the second millennium, with royal accoutrements such as beds, chairs, tables, and footstools with relief, openwork, and ivory inlay excavated in the palace.[17] These pieces, dating from 1300 to 1200 B.C.E., reflect Egyptian influence. Ninth-century ivories excavated at Hadatu (Arslantash) represent a blend of Egyptian and local styles, which in turn had a wide influence on ivories found throughout Anatolia and the Middle East. A series of carved and inlaid panels from Arslantash are tenoned for insertion into the frame of a piece of furniture, probably a bed or chair; an Egyptian-style carving showing the birth of the sun god has traces of gold on the surface, indicating it was wholly or partially gilt.[18] Quantities of Iron Age ivories from Syria were excavated at

Nimrud in Iraq (see section below), apparently booty and tribute taken by Shalmaneser III of Assyria (r. 858–824).[19] Those of Egyptian style have been referred to as "Phoenician School" because the origins of the style have been traced by scholars to Bronze Age sites such as Arslantash.[20] Typical are ebony furniture inlaid with ivory, ivory furniture overlaid with gold and silver, and ivory furniture inlaid with other materials.[21]

Acemhöyük, a Hittite site near Aksaray in Turkey, is the source of spectacular ivory finds dating to the nineteenth and eighteenth centuries B.C.E.[22] Although they show the influence of Syria and Egypt, these finds demonstrate an independent development that lasted until the fall of the Hittites around 1200 B.C.E. Outstanding examples of this Anatolian tradition are the "Pratt ivories" acquired by the Metropolitan Museum in New York in the 1930s. Several relief plaques of lions and a lion-headed goddess have inlaid eyes, with irises and pupils of different materials, and are varying shades of red with substantial traces of gilding.[23] The fire that destroyed the building in which the ivories were found resulted in the partial destruction and discoloration of many pieces.[24] However, the red color could not have been caused by heat or soil conditions. According to Bourgeois, it is an intentional, artificial coloration of the ivory for decorative purposes and relates to an ancient Anatolian technique.[25] Akkadian texts from Bogazköy describing trade objects for Hittite consumption distinguish between white and red objects made of ivory; the texts describe ivory as used for inlay, "filled with tooth," or covered with gold, as in the feet of a bed of ivory whose four lion feet are covered with gold. Other objects are described as being of red ivory.[26] The principal distinction made in the Hittite texts is between white and red ivory, and the Pratt ivories

support the existence of such a practice.[27] An Anatolian tradition of red-stained ivory encrusted with other materials can also be recognized.[28]

Cretan and Mycenaean Ivories

An early and semi-independent center of production of carved ivories originated in the palace culture of Minoan Crete. That Minoan practices apparently moved from Crete to mainland Greece is reflected in archaeological finds at Mycenae. While ivory carving is first attested in the Early Minoan II period of c. 2600 B.C.E. and continued into Middle Minoan times (c. 1900–1600 B.C.E.), the largest body of evidence was found buried at Knossos in the destruction caused by a sixteenth-century B.C.E. earthquake. Sir Arthur Evans excavated a deposit consisting of a group of ivory figurines of acrobatic figures.[29] The torsos and limbs of the figures, which are approximately twelve inches tall, were carved separately and attached at the joints; hair in the form of gold-plated bronze wires was attached to the heads in socket holes; girdles of metal encircled the tiny waists where loincloths were also attached. Bracelets and anklets were carved on arms and legs. The figures may have been suspended from wires to imitate participants in a bull dance ritual. The acrobats appear to the naked eye to have a brownish-red cast, and the excavator himself posed the question of whether the ivory itself was tinted.[30] He also cited the use of red to highlight other sculpture at Knossos, remarking that the taste for varied hues is such a universal characteristic of Minoan art that we may well believe that the male figures at least were originally stained a ruddy hue.

The same suggestion extends to the ivory figurines of "snake goddesses," which so closely resemble the faience snake goddesses from the

Temple Repository at Knossos.[31] Unfortunately, the so-called Boston Goddess and Boy God do not have verified findspots, nor does the similar figure in the Walters Art Gallery.[32] The Boston figurine, around fifteen inches tall, with applied gold belt, flounce hems, and snakes, is thought originally to have been polychrome like the faience goddess. (This is one of the many cases in which a few minutes with the piece under a microscope might be revealing.) Newly excavated at Palaikastro on Crete is an extraordinary male statuette of finely carved ivory with serpentine head and gold leaf accoutrements; unique for its size, it is 50 cm tall.[33] Details of veins and nails are well preserved. Again, we have an example of mixed media in the production of an ivory statuette. The composite figures from Crete can be seen as the forerunners of the colossal chryselephantine statues of the classical Greek world.

The first Mycenaean ivory objects that appear in the mainland shaft graves of the sixteenth century seem to be derived from Anatolian types, while fourteenth-century figurines such as the Two Seated Women and a Boy, and the Woman Seated on a Rock, both from Mycenae, are closely related in style and dress to the snake goddesses from Knossos.[34] The Linear B tablets from Pylos show that by the thirteenth century there was an abundance of carved ivory serving as furniture revetment; these documents demonstrate how important ivory was in the crafting of Mycenaean furniture.[35] Two solid ivory columns, 38 cm tall, with flutings, turnings, and stylized flowers, are preserved in the Archaeological Museum of Thebes in Greece. These presumed legs of a throne have traces of bright blue visible in patches.[36] In addition to furniture and furniture revetment, mirror handles, pyxides, hairpins, and musical instruments were carved in this luxury medium. Techniques of encrustation, covering with gold foil, and application of pigment, especially red and blue, are all described as part of the decoration of Mycenaean ivories.[37]

Assyrian Ivories

The largest body of evidence for the use of carved ivory for personal objects and furniture decoration in all of antiquity comes from the Assyrian palaces at Nimrud of the ninth to seventh centuries B.C.E. Much of this material was taken by the warlike Assyrian kings, making their palaces storehouses of precious booty. The palace structures themselves were ornamented with applied ivories, in ceiling beams, paneling, molding, and architraves of the gates and doorways. Ivory was used like wood, as a veneer. Not only were colors applied as pigment to all these architectural elements, but hollowed out areas were filled with colored paste, glass, jewels, and semiprecious stones, which appeared in conjunction with a liberal use of gold.[38] Barnett has identified various schools, including the Syrian and Phoenician, among the numerous finds, most of which still await publication.[39] The largest group is the so-called Syrian School, dating to the ninth and eighth centuries. Most pieces are highly ornamental and colorful, and relate closely to Egyptian styles and techniques, their makers having possessed what has been termed a "passion for polychromy."[40]

A series of fragmentary figures in the round came from the Northwest Palace of Assurnasirpal, dating to the ninth century; they represent beardless Egyptian-style males wearing kilts and must originally have been about thirteen inches high. Eyes are filled with black encrustation, and neck ornaments and kilts are inlaid in colored paste.[41] A series of thin panels with Egyptian-style figures from the same palace has inlays and

gold covering the surface; some pieces in this group have an undercoat of purple on the ivory, with gold leaf applied over it.[42] Among the Nimrud ivories is a head of a woman six and a half inches high; it was found in 1952 in mud at the bottom of a well seventy feet below ground level in the courtyard of Assurnasirpal's palace. Nicknamed the "Mona Lisa of Nimrud," this finely carved portrait, probably of a queen, has hair, pupils of eyes, and eyebrows stained black, and flesh stained a deep rosy hue.[43] Numerous plaques in cloisonné technique of the so-called Phoenician Style still have their inlaid colored paste and glass.[44] Ivories of this type are found all around the Mediterranean world, from Ur to Crete, and Perachora to Praeneste.[45] One of the most spectacular of the Nimrud ivories in the British Museum is a trapezoidal panel 6.5 cm high, carved with a highly stylized scene of a Negro being mauled by a lioness; the background pattern suggests a lotus and papyrus thicket. Lotus flowers are inlaid in lapis and blue frit, papyrus flowers in carnelian, while stems and outlines of the flowers are overlaid with gold. The tunic and hair of the Negro are gilded, his bracelets show traces of inlay, and the lioness has a piece of round lapis inlay set in her forehead. A lattice-work border at the bottom of the plaque is encrusted with bright blue lapis inlays.[46]

A series of princely tombs discovered at Salamis on the island of Cyprus yielded ivory thrones and other regal pieces of furniture that show striking similarities to the Nimrud ivories and are dated to around 700 B.C.E.[47] Gold was laid over the ivory of a throne-back along with blue glass inlay and other colored encrustations. Some furniture had legs terminating in carved hooves or claws of ivory; some pieces were inlaid with blue glass, and others, like those found at Nimrud, had ivory claws stained red.[48]

Greek Ivories

By the late eighth century the ivory industry in the Middle East had collapsed, and the ivory workers seem to have gradually established themselves in Greek centers around the shores of the eastern Mediterranean and the Aegean. At the same time, a taste for ivory objects developed at the Phrygian capital of Gordion, the gateway to the east on the high Anatolian plateau. From here it is likely that the craftsmen traveled west through the lands of the Lydian successors of the Phrygians; craftsmanship in ivory had arrived in Ionian Greece by the seventh century.

By whatever route the art of ivory carving arrived on mainland Greece, the surviving artifacts show influence coming ultimately from the Phoenician, Egyptian, and Syrian schools of the Near East, including their taste for polychromy. An Ionian origin is assigned to a small statue of a man subduing a lion, found in 1939 under the Sacred Way at Delphi in a cache of more than two thousand ivories. The lion tamer has a liveliness and presence far beyond its diminutive scale of only 12.5 cm in height. The eyes were inlaid, but the excavator's descriptions do not mention the color or shade of the ivory; to the naked eye, however, it appears a deep reddish-purple. The lion tamer has been compared stylistically to an important group of ivory statuettes excavated at Ephesus belonging to a so-called oriental style.[49] In the foundation deposit of the temple of Artemis, or Artemision, at Ephesus a cache of ivory statuettes was discovered by Hogarth in his excavations of 1904–5.[50] Fifty ivory statuettes or ceremonial objects dating to the seventh and sixth centuries B.C.E. provide a substantial body of evidence from which to draw some conclusions about early Greek ivories. Hogarth's report notes the application of gold on many. He also

suggests that the uneven discoloration of the surface of the ivories indicates that applied colors originally protected some parts of the surface; the green tint of some statuettes is also too uniform to be accidental, and others are stained brown and black.[51] The Ephesus ivories thus represent a large body of evidence of excavated ancient ivory in which gilding and staining appear consistently enough to be considered characteristic treatment of the medium.

Another tradition of the use of ivory in composite figures can be traced through finds on the Greek mainland. The tiny ivory head of a girl whose eyes have inlaid pupils and bronze lashes was excavated at Perachora and dates to the seventh century B.C.E.[52] More recent finds at Eleutherna consist of four more similar ivory heads.[53] The Perachora and Eleutherna heads are, in all probability, from figures whose drapery was carved in another material, making them early Greek examples of the category called acro-elephantine or chryselephantine statuary.[54]

Perhaps the best indications of what these chryselephantine statues would have looked like can be derived from the remnants of three life-size figures found at Delphi in 1939.[55] Their three large heads range from 18 to 21 cm in height. They have been dated by their discoverer, Pierre Amandry, to the early sixth century and are thought to be ex-voto offerings of an Ionian city. In their newly restored state in the Delphi Museum, the two better preserved heads, identified tentatively as Apollo and Artemis, make a strong impact on the viewer. The ivory of Apollo's head has been burned black, yet details of the almond-shaped eyes remain: the bone whites of the eyes have encrusted corneas and pupils; the bronze eyelashes have also been restored. Eyebrows, once filled with encrustation, now appear as arched furrows. Covering the top of the head is a wiglike mat of hair made of silver covered with gold leaf. Long locks made of sheets of gold embossed with parallel undulating lines hang down on either side of the head behind the ears. Hands and toes of ivory were also discovered. Though it is clear that the flesh parts of the statue were of ivory, the original color or shade is now impossible to ascertain. The garments were in another medium and were joined by tenons at the neck and hands. Numerous plaques of gold with animals in repoussé technique were attached to the garments and were meant to imitate embroidery or woven designs; the designs came up only to the knees, suggesting the statues were seated.[56] Gold diadems decorated with rosettes were worn by the figures, and rosettes set on ivory disks were also used as ornament. Gold bracelets, some in a reddish gold, were worn on the wrists, and a necklace of gold lions' heads was probably attached directly onto the garment. Thousands of tiny pieces of gold, silver, and bronze were found, mostly very poorly preserved, but some suggesting the wavy lines of a chiton; Amandry concludes that the robes were made of wood covered by an alloy of silver and gold or of bronze that was then gilt.[57] Volutes and stylized flowers of gold may have served as the ornament of a throne.[58]

Among the many ivory fragments found at Delphi were carved ivory reliefs depicting some two hundred figures of men and animals in narrative scenes; their average height is 7 cm.[59] Probably composed of mythological scenes in which numerous figures interacted, this work has traces of gilding on the hair of many of the figures, and animals were also gilt. To judge from the great number of iron nails found in the deposit, these plaques were fastened to a larger object, perhaps a wooden chest or, as Amandry suggests, a throne.[60]

An important archaeological discovery at Olympia can be linked with the Delphi statues. The so-called workshop of Phidias, the creator of the chryselephantine Zeus for the Temple of Zeus at Olympia, sheds light on the materials used in the classical period to make these colossal statues.[61] Not only were innumerable chips of ivory discovered at the site but also remains of molds probably used for casting the golden garments; pieces of glass and remains of red and blue pigment were also discovered.[62] The remains at Delphi together with the excavations at Olympia match Pausanias's descriptions of the chryselephantine Zeus at Olympia, in particular his throne; the texts will be discussed in chapter 4.

It has been remarked that the tools found in the workshop of Phidias at Olympia would have been appropriate to the making of jewelry. A recent exhibit at the Metropolitan Museum of Art in New York helps us visualize how the crafting of ornamental, especially gilded, portions of the statues might have looked. This exhibit of Greek gold jewelry dating to the fifth and fourth centuries B.C.E. conveyed vividly how gold was worked in classical antiquity.[63] Some of the larger objects in gold repoussé resemble in style, subject matter, and ornament the sheets of gold and small ornaments found with the Delphi statues.[64] Most surprising is the degree to which color played a role. Many objects had inlaid colorful stones and well-preserved traces of enameling in red, blue, and green.[65] The technique and effect would have been similar to the Byzantine Joshua Ivories at the Metropolitan Museum, described in chapter 1, in which red, blue, and green paint were applied next to and over gold. If polychromy in bright colors characterized these fine pieces of ancient Greek gold jewelry and ceremonial objects, it is likely that the gold applied to chryselephantine figures was also enameled. The glass

fragments found at Olympia are likely to be the residue of enameling on the gold ornamental portions of the chryselephantine Zeus and his throne.

Among the discoveries at Vergina in northern Greece in 1977 were numerous precious and courtly objects, among them a couch decorated with gilt ivory and a shield decorated with gold and ivory.[66] While the precise date within the fourth century B.C.E. and the identity of the occupants of the great tomb excavated by Manolis Andronicos are open to debate, the discovery is unquestionably one of the most important archaeological finds in recent history. The ornate wooden couch survives only in the remnants of decorative panels found scattered on the floor of the tomb; this couch as reconstructed was sheathed in ivory.[67] Glass plaques covered delicate cutout gold figures, and similarly, mythological figures carved in ivory in low relief were sheathed with thin sheets of gold foil. Other figures were carved in high relief, with the flesh parts of ivory and garments in another medium, probably wood, covered with gold. A series of heads in this latter group include portraits, some believe, of Philip II of Macedon and Alexander the Great; several of them have a clearly visible purplish cast. The shield, made of wood over which leather was stretched, is decorated on the front with an ivory relief of a pair of figures applied to a gilt background. The purplish stains on parts of this group may stem from their having been dyed, or they could be the residue of paint. Gold, silver, and ivory ornament form spirals and meanders around the border of the shield. The technical and artistic refinement of these examples of carved ivory combined with gold is impressive. From the life-size statuary at Delphi to the luxury furniture at Vergina we find testimony to the continuing fabrication in classi-

cal times of precious objects combining gold and ivory.

Etruscan and Roman Bone and Ivory

As in other arts, the Etruscans combined their own traditions with influences from Greece and the Near East.[68] Unlike Greek production, however, Etruscan ivories consisted of small personal objects rather than furniture or monumental cult statues. For example, a bone mirror handle in the Museum of Art and Archaeology, University of Missouri at Columbia, is dated in the late fourth century B.C.E.[69] This small luxury object with figures carved in low relief has well-preserved gilding and red and blue pigment. The background of the figures shows traces of deep blue, and red and gold appear on wings and on figures and borders of garments.[70] While color traces appear on seven other similar handles, this is the best preserved; its color scheme is comparable to painted relief scenes on contemporary Etruscan stone sarcophagi.

Ivory persists in playing a secondary role in the Roman world, and bone is often used as a substitute. Both appear as inlay for furniture or small plaques attached to furniture or boxes. Miniature portraits in ivory seem to have become the fashion in the second and first centuries B.C.E.; around this time furniture sometimes had legs or applied ornament of ivory.[71] One of the most substantial collections of small pieces—plaques and panels from boxes, statuettes and ornamental trappings—is in the Walters Art Gallery. This group of nearly one hundred pieces dating from the third through the sixth century includes some with substantial traces of color. Several particularly well-preserved pieces in bone from Coptic Egypt have panels retaining red, green, and black encaustic inlay.[72]

A special category of Late Roman and Early Byzantine ivory objects consists of diptychs, of which examples are found in museums all over the world. Although this category appeared in our test group, several recorded examples offer exceptionally well-preserved evidence of polychromy and contribute to our summary of evidence. In his study, Delbrueck estimates polychromy on the diptychs was total, as on sarcophagi, although now only traces remain.[73] In his catalogue of seventy-one diptychs, there are twenty-nine on which he recorded traces of color.[74] In some cases in which both leaves are preserved, they complemented each other, such that one half depicted certain details in relief while the other depicted equivalent features through painting; this intermingling of techniques can be seen, for example, in a diptych showing the slaughter of lions, in the Hermitage Museum in St. Petersburg.[75] Inset stones also occasionally provided a polychrome effect, as in the Barberini panel in the Louvre.[76] Delbrueck asserts that the relief of the Barberini panel was once painted because the right leg of the barbarian chief who stands behind the emperor's horse is not carved, indicating it had once been painted in.[77] Delbrueck accepts the notion that consular diptychs were entirely painted, with the principal colors used being purple, gold, black, red, blue, and green, and 41 percent of the diptychs in his catalogue have recorded traces of color.[78] Delbrueck's descriptions of polychromy on ivory diptychs correspond to the findings on diptychs in the study group discussed in chapter 1.

A few words should be said in conclusion about the loss of color that we know once was applied to ivories. The faint traces of polychromy we are now accustomed to detecting on ivories remind us that paint and gilding do not adhere easily to ivory and must depend on various con-

ditions of burial, storage, display, or conservation. Climate control in museums now helps preserve this sensitive medium, but the circumstances to which ancient ivories were subjected before excavation, or before climate control, were hardly conducive to the preservation of color on their surfaces. Most of the ivories in our test group are at least one thousand years old, which would seem ample time for them to lose most of their color. Ivory, like wood, contracts and expands with changes in humidity and environment, so it is not surprising that paint that flake off over time, leaving few traces. Both wood and ivory tend to split or crack because they are living substances with a vascular system of growth; very low humidity is therefore their worst enemy.[79] It is logical that the pool that provided humidity for the gold and ivory statue of Athena in the Parthenon also served to keep the wooden armature from warping in the dry summer weather.[80] Wood we know was routinely carved and then painted. Ivory, like wood, was also painted and stained, as much for protection of the surface as for embellishment, to heighten the effect. Both had absorptive tendencies but also tended to lose surface pigment over time. Pieces of ivory that have been dyed—that is, soaked or steeped in a solution—tend to retain their color, while applied paint or gold tends to flake off with expansion or contraction of the surface. Color has also been intentionally removed in the restoration of ivories by owners whose tastes preferred them to be monochrome.[81] Current methods of cleaning ivory may continue to remove traces of their coloration, but these are fortunately being reconsidered.[82] The practice of taking casts, popular in the nineteenth century, undoubtedly pulled color from the surfaces of ivories; cleaning and bleaching of ivories has further eliminated color traces.

The occasional survival of color traces on ivories characterizes the picture we have been able to piece together in this chapter from reports on ivories of the ancient Near East, Greece, and Rome. From descriptions or photographs of more recently excavated pieces to those which have been housed in museums and collections for centuries, it is clear that some objects were painted and gilt. The consular and other categories of diptychs are the best preserved examples and have the most thoroughly recorded traces of color of any of the categories of objects; they seem to have been entirely painted on their external surfaces, and some, like the Asclepius and Hygieia Diptych, were dyed red before further embellishment with painting and gilding (pl. VII). The natural color of ivory is exploited in some cases where it was used for inlay or appliqué, while carved pieces of ivory that were applied to furniture or boxes, or used as handles, or carved as statuettes appear often to have been painted partially or dyed in their totality. The fragmentary early examples of chryselephantine figures found at Delphi help us imagine these great artworks, and they too may have incorporated bright colors. Worked ivory, like carved wood or stone sculpture, was probably often painted in antiquity and has lost its color through a variety of circumstances. Different systems of application of polychromy were clearly used for different categories of objects, but clear differentiation among these categories is not possible without further study.

The same palette as on the ivories of our test group—consisting of red, green, blue, and gold—appears on many of the ancient recorded examples. Two or more of these same colors are also often juxtaposed, suggesting that the craftsman working in Byzantium was following procedures and conventions inherited from genera-

tions of ivory craftsmen, extending far back into antiquity. Byzantine craftsmen followed an ancient tradition that included carving of furniture, boxes, and other luxury objects for ceremonial or religious purposes. Likewise, the range of ways of applying colors, from painting with pigment in an opaque solution, to staining or dyeing—that is, steeping in color solution—to inlay with encrustation or jewels, to application of gold leaf, all are found to varying degrees in our surveys of both ancient and Byzantine examples. The degree to which ivories were polished with abrasives or oil at a late stage of crafting and as part of their maintenance, both to prepare for application of color and to enhance the overall surface appearance, is a further important consideration. Recently this aspect of ivory production has received the attention of conservators.[83]

While it is important not to overstate the case, this survey of examples of polychrome treatments of ivory in antiquity provides a glimpse of some of the predecessors in time and practice of the Byzantine ivories. The evidence from archaeological and museum records shows that the ancient craftsman, like the Byzantine one, when equipped with colored pigments, dyes, and bright metals, at least sometimes opted for a colorful treatment of ivory. The appearance of ivory in both ancient and medieval times is gauged from a new and different standpoint in the next chapter. There, using yet another approach involving analysis and assessment of literary evidence, convergences are traced between the physical evidence already examined and the texts.

Chapter 4

The Testimony of Ancient and Medieval Texts

The ancient Greek and Roman authors are rich in allusions to ivory, trade in ivory, and objects carved out of ivory. Fortunately for us, Byzantine and Western medieval texts discuss ivory in ways that help us visualize its original appearance. Poets, travelers, even artists themselves, furnish us with accounts, sometimes in verse, sometimes through metaphors or similes, in prose accounts, or through rhetorical descriptions. Together they reveal much about the varied uses and appearances of ivory, offering insights on what must have been a range of artistic practices in antiquity and the Middle Ages. The present chapter on texts is the counterpart of the preceding ones on physical evidence of polychromy and its makeup. In anticipation of finding convergences between textual accounts and observed instances of polychromy on ivories, we turn now to the descriptions of writers who knew and experienced ivory's appearance as part of their own lives.

The textual descriptions, while often enigmatic, imprecise, or simply not as informative as we would like, are worth scrutinizing closely, for they provide a challenging and unexplored dimension to our study. Literary allusions to ivory in Homer provide glimpses of ivory in the context of late Bronze Age Greece as well as in the subsequent generations in which the Homeric poems were shaped. While ivory is given high

symbolic value, it also appears juxtaposed with other media in ways that suggest various options for its appearance. Texts with a more topical interest pertain to chryselephantine statues of classical antiquity. These extraordinary creations of gold and ivory have vanished, despite their impressiveness, and we have only the texts to help us understand not only their construction, but their resulting appearance. Roman and Byzantine sources reflect a wide range of practices in their descriptions of the uses and appearances of ivory in diverse classes of objects. Here we encounter unexpected kinds of information, like the fact that women were painters on ivory, or that painted diptychs continued in use in medieval Byzantium. Finally, several medieval sources suggest that diverse ancient techniques and traditions were ongoing throughout the Middle Ages and also in the West. The texts elucidate evidence from the preceding chapters and help refine our perception of the complex and varied appearances of ivory.

The Appearance of Ivory in Homer

The earliest literary sources describing ivory artifacts were examined by Jane Burr Carter, whose research focused on Homeric references to the uses and appearance of ivory.[1] While Carter's concern was primarily to associate references in texts with the forms and iconography of excavated pieces, we will examine the Homeric passages to glean information explicit to ivory's overall appearance, specifically the neglected aspect of its color. The nine references to ivory in the *Iliad* and the *Odyssey* deal with ivory in terms of contrast and juxtapositions of different hues, values, and surface qualities. Verbal images of ivory in Homer include a wide range of metaphorical possibilities.

A famous passage in Book Four of the *Iliad* describes an arrow wound in the thigh of Menelaus :

the tip of the weapon grazing the man's flesh,
and dark blood came spurting from the wound.
 Picture a woman dyeing ivory blood red—
a Carian or Maeonian staining a horse's cheekpiece,
and it's stored away in a vault and troops of riders
long to sport the ornament, true, but there it lies
as a king's splendor, kept and prized twice over—
his team's adornment, his driver's pride and glory.
So now, Menelaus, the fresh blood went staining
 down
your sturdy thighs, your shins and well-turned
 ankles (*Il.* 4.139–47).[2]

Homer powerfully describes the sharp contrast between the color of flesh (*chroa*) with that of blood (*haima*). The ivory dyed red (*elephanta . . . phoiniki*) is indicated with the term *phoiniki*, which includes, among other meanings, a bright crimson red, or a purplish-red.[3] The passage evokes the dyeing process in which bright red stain permeates the white of ivory. In the process it tells us about the visual, material, and aesthetic connotations of stained ivory. Visually, the color of blood, the color of stain or dye, and the color of stained ivory are all comparable under the term *phoiniki*.[4] This ivory was blood-red. Materially, ivory's value is enhanced through dyeing it red, as conveyed here by its association with a king's treasure. In aesthetic terms, the red-dyed cheekpiece is of such great beauty that it makes the horse's rider proud. What is valuable is considered beautiful, as well as vice versa. Finally, the image of the Maeonian or Carian women must stem from actual early practices for producing dyed ivory, perhaps by women who were brought as slaves from these regions to the Mycenaean palaces of Ionian Greece. The

women brought with them the knowledge about dyeing and remained associated with the exotic products of their labor. The passage carries information about the perceptions and connotations of colored ivory; we will return to it after considering other images of ivory in Homer.

In Book Five of the *Iliad* a charioteer is killed in battle and drops his reins:

> out of his grip the reins white with ivory flew
> and slipped to the ground and tangled in the dust
> (*Il.* 5. 582–83).[5]

The reins "white with ivory" (*leuk' elephanti*) are juxtaposed with the color of dust, a weak contrast of white against gray-brown. This allusion represents a specific technique, in which ivory serves as an appliqué, with small, carved pieces pierced and sewn to the leather reins.[6] This passage evokes ivory that is white, not dyed like the cheekpiece. Horse ornaments of both aspects, colored and uncolored, have been excavated at Nimrud.[7]

In the *Odyssey,* ivory is juxtaposed with bright, familiar substances and colors, as in Book Four, when Menelaus's palace is described by Telemachus:

> can you believe your eyes?—
> the murmuring hall, how luminous it is
> with bronze, gold, amber (*elektron*), silver and
> ivory!
> This is the way the court of Zeus must be,
> inside, upon Olympos. What a wonder! (*Od.*
> 4.72–75).[8]

The listener is presented with a virtual palette of colors as the materials are listed, all of high intrinsic value, and all with a metallic sheen or surface luster.[9] Symbolically associated with the court of Zeus, ivory appears among other rare, costly, and visually striking media, all of which shine, for the luminous materials decorating the hall are described with the term *steropen*. Bronze, gold, amber, silver, and ivory are therefore all evocative of the glancing off of light or the flash of lightning. It is not the color of ivory per se that is specified, but rather its reflection of light.[10] This passage indicates that ivory, like the other materials, was probably rendered light-reflecting through a surface treatment like polishing. Shining and costly materials are greatly admired, for Homer tells us the appropriate response to them: "What a wonder!"[11]

Further attributes of ivory, and their connotations, are evoked in Book Eight. A kingly gift takes the form of a sword in an ivory sheath:

> this broadsword of clear bronze goes to our guest.
> Its hilt is silver, and the ringed sheath
> of new-sawn ivory—a costly weapon (*Od.*
> 8.403–5).[12]

The extraordinary brightness of the white of newly sawn ivory (*neopristou elephantos*) is matched by the brightness of silver in a joint display.[13] The simple form, *pristos,* appears twice more in the *Odyssey*. In Book Eighteen, Athena makes Penelope supernaturally beautiful in preparation for a meeting with the suitors:

> With ambrosia
> she bathed her cheeks and throat and smoothed her
> brow . . .
> Grandeur she gave her, too, in height and form,
> and made her whiter than carved ivory (*Od.*
> 18.192–96).[14]

The ultimate beauty in female flesh is to surpass in whiteness the color of carved or sawn ivory.

The topos implies that freshly carved ivory was whiter than ivory that had aged.

In Book Nineteen, Penelope refers to sawn ivory in the well-known description of the gates through which dreams pass. This enigmatic passage contrasts ivory with its near look-alike, horn:

Two gates for ghostly dreams there are: one
 gateway
of honest horn, and one of ivory.
Issuing by the ivory gate are dreams
of glimmering illusion, fantasies,
but those that come through solid polished horn
may be borne out, if mortals only know them (*Od.*
 19.562–67).[15]

The respective values and appearances of the materials vary, for while the intrinsic worth of ivory is much greater than horn, by which we can probably assume bone, in this passage, their outward appearances are similar when polished. However, paradoxically, their symbolic meanings here are reversed, for ivory (*pristou elephantos,* in line 564) is given negative connotations.[16] Ivory is unreliable, not to be trusted: a "glimmering illusion" (*elefairontai*), while whatever is associated with horn is honest and dependable: what you see is what you get.[17] By implication, ivory is unattainable to most people, and desiring it will only lead to disappointment. Homer's ivory is noted for its gleaming or shining surface, for its blood-red color when dyed, or for its whiteness when newly sawn.

Ivory assumes different appearances when Homer combines precious metals and ivory on objects reserved for royalty: ivory is described as part of the embellishment of a key, a chair, and a bed. A key to the storeroom of Odysseus's palace is "of bronze with a handle of ivory."[18] Penelope's

chair is inlaid "with silver whorls and ivory," while their bed, made by Odysseus from an olive tree, is ornamented "with silver, gold, and ivory," and the bed is stretched between "a pliant web of oxhide thongs dyed crimson."[19] In these passages ivory is combined with other precious and bright media, in particular, furniture, reminding us of the throne in the house of Solomon mentioned in the Hebrew Scriptures:

The king also made a great ivory throne, and overlaid it with the finest gold. The throne had six steps. The top of the throne was rounded in the back, and on each side of the seat were arm rests and two lions standing beside the arm rests, while twelve lions were standing, one on each end of a step on the six steps. Nothing like it was ever made in any kingdom (1 Kings 10.18–20).[20]

Here we have not the juxtaposition but the superimposition of precious media, "ivory overlaid with gold" (*periechrusosen*), with a multiplication of value in the covering of one precious substance with another. The closest analogy to Solomon's throne is the throne of Phidias's Olympian Zeus (see below).

References to furniture in Homer and in Hebrew Scriptures correspond to finds from Egyptian and Mycenaean sites, such as the solid ivory legs of a throne from Thebes on which are substantial traces of blue stain, or the ivory-sheathed couch from Vergina with its applied gold leaf covered by glass, considered in chapter 3 above.[21] In Homer the various treatments of ivory are well documented, as are its color, texture, and juxtaposition with other media. Its heroic or kingly aspect is emphasized through its association with royal objects and accoutrements and with other intrinsically precious media.[22] Poetic and formulaic allusions in Homer prepare us for

the largest body of textual evidence on ivory: Pausanias's descriptions of the ultimate creations in ivory. Although there is an interval of almost one thousand years between Homer and Pausanias, the assembled literary passages, which focus on specific themes or topics, provide corroborative evidence and bring new insights to the study of the appearance of ivory objects.[23]

Pausanias and the Chryselephantine Statues

Pausanias, the tireless and observant second-century C.E. traveler and investigator of the Hellenic world, saw for himself the greatest works ever to be made of ivory. His *Description of Greece* in ten books is of utmost importance to archaeologists, historians, and art historians, for it comprises the largest set of references to the now almost entirely lost art of antiquity.[24] A major category of objects that fascinated Pausanias was the composite gold and ivory, or chryselephantine, statues. Our survey of the appearance of ivory artifacts in antiquity would be incomplete without taking into account Pausanias's testimony on these influential creations. From their overall structure to their ornamentation, including coloring, and even their care and maintenance, these works merit and require our attention, for ivory was the prime medium for religious and artistic expression in classical antiquity.[25]

Chryselephantine work was reserved for statues of divinities placed in temples, and these were made to delight the divine as much as mortal beholders of the works.[26] While no one doubts the existence of chryselephantine statues, it is difficult to reconstruct the fabric and appearance of the different parts. Pausanias remarks on the beasts who were the source of ivory, describing Pyrrhus using elephants in battle against the Romans:

When on this occasion they [the elephants] came in sight the Romans were seized with panic, and did not believe they were animals. For although the use of ivory in arts and crafts all men obviously have known from of old, the actual beasts, before the Macedonians crossed into Asia, nobody had seen at all. . . . This is proved by Homer, who describes the couches and houses of the more prosperous kings as ornamented with ivory, but never mentions the beast (Paus. 1.12.3–4).[27]

Pausanias acknowledges that ivory had an early and prominent place among "arts and crafts of men" (*erga kai andron cheiras*), and he knows of Homer's descriptions of the use of ivory for ornamentation of couches and houses (*klinas men kai oikias . . . elephanti epoiese kekosmemenas*). The primacy of the medium of ivory in the manufacture of statues, however, is Pausanias's prime concern:

And the Greeks in my opinion showed an unsurpassed zeal and generosity in honouring the gods, in that they imported ivory from India and Aethiopia to make images (5.12.3).[28]

Pausanias differentiates the use of ivory for ornamentation, as found in Homer, from the classical Greek use of ivory "to make images" (*elephas es poiesin agalmaton*), that is, as the basic material for the statues.

The cult statues he encountered, still in existence in the second century C.E. all over Greece, impressed him most. He describes the colossal statue of Zeus at Olympia in some detail:

I know that the height and breadth of the Olympic Zeus have been measured and recorded; but I shall not praise those who made the measurements, for even their records and measurements fall far short

of the impression made by a sight of the image (5.11.9).[29]

The "sight of the image": even the word for image, *agalma*, does not include simply an object; it describes an emotional reaction; it is a thing that is a source of pleasure or evokes delight, something that is the object of wonder and worship.[30] Pausanias customarily describes chryselephantine statues in honor of various gods simply as "an image made of gold and ivory" (*elephantos to agalma kai chrusou*).[31] But in the case of the colossal statue by Phidias at Olympia he says much more. The passage is worth looking at closely:

The god sits on a throne, and he is made of gold and ivory. On his head lies a garland which is a copy of olive shoots. In his right hand he carries a Victory, which, like the statue, is of ivory and gold; she wears a ribbon and—on her head—a garland. In the left hand of the god is a sceptre, ornamented with every kind of metal, and the bird sitting on the sceptre is the eagle. The sandals also of the god are of gold, as is likewise his robe. On the robe are embroidered figures of animals and the flowers of the lily. The throne is adorned with gold and with jewels, to say nothing of ebony and ivory. Upon it are painted figures and wrought images . . . (5.11.1–2).[32]

When the statues are described, they are "made" of gold and ivory, using a form of the verb *poieo*, to make, produce, or create (very often the past participle passive, *pepoiemenos*), or its compound, *empoieo*, meaning to make on or in. The verb *ergazomai*, meaning to work a material or to be made or built, is also used, often appearing in the participle as *eirgasmenos* (6.19.10). Another frequently repeated form is *epeirgasmenos* (2.27.2; 6.19.13). The first, *poieo*, seems to refer to the fabric or substance, and the latter, *ergazomai*, to the working, i.e., carving in relief or crafting. But sometimes they are used interchangeably (8.27.2; 8.46.4). The translator has rendered *graphe* as painted, which is used elsewhere to describe both delineation, as in a drawing, and what was undoubtedly a painting in colors. The painting by Panaenus in the Painted Stoa in Athens, for example, is referred to by Pausanias as *gegrammenon*.[33] Clarification of these terms helps us assess Pausanias's descriptions of the figures and their decoration.

At the beginning of the description of Zeus, Pausanias refers not to a statue, but to the god himself, as is common in Greek practice: "He sits on the throne, he is made of gold and ivory, on his head is a garland, and in his hand he carries a victory," and so on. The garland on his head is described as imitating (*memimemenos*) olive shoots, from the verb *mimeomai*, to mimic, imitate, or represent, arousing curiosity as to how the imitation was accomplished, in gold or in ivory, or in one of these painted or otherwise colored realistically. The scepter is specifically described as ornamented with many metals (*metallois tois pasin enthismenon*). And when it comes to his robe embroidered (*empepoiemena*) with animals and flowers, it is not clear what material is used, gold with incisions and other inlaid metals or enameling, or ivory overlaid with gold and painted or inlaid. It is safe to conclude, however, that it was made to resemble, with some degree of naturalism, an enormous person seated on an actual throne.

The throne is even more fully described than the figure of Zeus. It is adorned (*poikilos*), or more precisely, wrought, in various colors, with gold, jewels, ebony, and ivory, and there are both painted figures (*zoa te ep' autou graphei memimemena*) and carved images (*agalmata estin eirgasmena*)

used in this adornment.[34] Here we are told explicitly that the imitations of figures are painted and that the images are worked or carved, probably in relief. The stretchers of the throne, the feet, the screens surrounding it, and the footstool are described, with similar allusions to details and images being either painted (*graphai*) or worked in gold:

Between the feet of the throne are four bars, each one stretching from foot to foot. The rod straight opposite the entrance has on it seven images. . . . On the other rods is the band that with Heracles fights against the Amazons. The number of figures in the two parties is twenty-nine (5.11.3–4).[35]

It is clear from the number of figures that these images (*agalmata*) were small-scale reliefs, which must have been applied to the spanners or stretchers between the legs of the throne. The screens around the throne, on the other hand, were barriers of wood:

At Olympia there are screens constructed like walls which keep people out. Of these screens the part opposite (*apantikru*) the doors is only covered with dark-blue paint; the other parts show pictures by Panaenus. . . .This Panaenus was a brother of Pheidias; he also painted the picture of the battle of Marathon in the Painted Portico at Athens (5.11.4–6).[36]

Pictures (*graphai*) appear only where they can be seen when standing to the side of or behind the statue, while in the front, the screens are only covered with blue (*kuanos*), presumably so as not to distract from the effect of the drapery falling around the god's feet.[37] The credentials of the painter are assured, for he painted (*gegrammenon*) the famous picture of the Battle of Marathon in

the Stoa Poikile in Athens. Both Phidias and Panaenus are referred to as painters by Pliny, writing about two generations earlier than Pausanias. He and his fellow artists were versatile. They painted sculpture and carved objects as well as pictures:

it is said that even Phidias himself was a painter to begin with, and that there was a shield at Athens that had been painted by him; and although moreover it is universally admitted that his brother Panaenus came in the 83rd Olympiad, who painted the inner surface of a shield of Athena at Elis made by Colotes, Phidias's pupil and assistant in making the statue of Olympian Zeus. . . . Indeed the brother of Phidias Panaenus even painted the Battle at Marathon between the Athenians and Persians; so widely had the employment of colour now become and such perfection of art had been attained (*N.H.* 35.34.54–57).[38]

The screens at Olympia must have been painted in colors. To describe painting on panels and the painting of sculpture, Pliny uses the verb *pingo,* which is specified in this passage as painting in colors (*colorum*). Phidias, according to Pliny, was a master of painting on both wood and sculpture, which must have included works in both marble and ivory. The discovery at the so-called workshop of Phidias at Olympia of not only numerous chips of ivory and molds for the gold and glass for draperies, but also of pigments would tend to confirm this.[39] Paintings on wood in color, however, were more unusual, while painting ivory statues was a long-established practice.[40]

From Pausanias's description of the footstool and pedestal of the throne we can also deduce that a polychrome treatment was used.

The footstool of Zeus, called by the Athenians *thranion,* has golden lions and, in relief, the fight of

Theseus against the Amazons. . . . On the pedestal supporting the throne and Zeus with all his adornments are works in gold: the Sun mounted on a chariot, Zeus and Hera. . . . There are also reliefs of Apollo with Artemis, of Athena and of Heracles, and near the end of the pedestal Amphritrite and Poseidon . . . (5.11.7–8).[41]

The lions were of gold, perhaps cast or carved from wood and gilded, and the scenes, starting with Theseus and the Amazons, worked in relief (*epeirgasmenen*), in bands attached to the footstool and pedestal and similar to those on the stretchers. Those on the pedestal are gilded or cast in gold, which is what is probably meant by "works in gold" (*chrusa poiemata*). These works in gold and additional reliefs (*epeirgastai*) appearing on the pedestal were probably painted or gilded or done in gold enameling. The variety of materials and techniques employed simultaneously on the Zeus, his throne, and associated structures is impressive.[42]

The tradition of decorating chairs or thrones with ivory relief plaques as well as inlays of ivory, ebony, and stones has been attested in Homer and in the Hebrew Scriptures; the ivory reliefs discovered buried under the Sacred Way in Delphi may have been part of the revetments from thrones belonging to the large chryselephantine figures with which they were discovered.[43] In the light of both archaeological evidence and literary descriptions, the throne of the Olympian Zeus would seem to have had a wooden core covered with ivory revetment in the form of carved panels and bands of painted and gilded reliefs. The many painted reliefs of figures and scenes described on the throne would have alternated with ornament, which included inset jewels, enameling, ebony, and ivory inlay; gilded wood, ivory, or cast gold

and figures and animals served as finials or knobs.

Care of ivory involved preservation of its colors as well as of the ivory and wood. The abundance of ivory utilized in the Olympian Zeus required special climate-control measures, about which Pausanias speaks:

All the floor in front of the image is paved, not with white, but with black tiles. In a circle round the black stone runs a raised rim of Parian marble, to keep in the olive oil that is poured out. For olive oil is beneficial to the image at Olympia, and it is olive oil that keeps the ivory from being harmed by the marshiness of the Altis (5.11.10).[44]

The lavish use at Olympia of olive oil, an expensive commodity even in antiquity, indicates the disregard for cost when it came to maintaining a statue of the god.[45] In comparison, the Athena in the Parthenon was "benefited, not by olive oil, but by water" (5.11.10). Dampness was not a problem on the Acropolis, but rather, low humidity; hence the pool of water served to humidify the ivory of the statue and the wooden armature supporting it, which kept them from shrinking and cracking. The Zeus, however, was preserved by treatment with oil. Some of its parts had pigments and enameled gold applied over the ivory.[46]

Care of the statues through polishing is linked to the practice of coloring their flesh parts. At Olympia there were hereditary polishers:

The descendants of Pheidias, called Cleansers (*phaidruntai*), have received from the Eleans the privilege of cleaning the image of Zeus from the dirt that settles on it, and they sacrifice to the Worker Goddess before they begin to polish (*lamprunein*) the image (5.14.5).[47]

The terms used here for the process suggest above all that it consisted of shining or brightening the statue. The oil from the receptacle could have been used to polish the ivory surface, or it could simply have been used to remove dust and dirt. A further function of polishing is suggested by Vitruvius:[48]

But if anyone proceeds in a less crude fashion, and wishes a vermilion surface to keep its colour after the finishing of the wall is dry, let him apply with a strong brush Punic wax melted in the fire and mixed with a little oil. Then putting charcoal in an iron vessel, and heating the wall with it, let the wax first be brought to melt, and let it be smoothed over, then let it be worked over with a waxed cord and clean linen cloths, in the same way as naked marble statues; this process is called *ganosis* in Greek. Thus a protective coat of Punic wax does not allow the brilliance of the moon or the rays of the sun to remove the colour from these finished surfaces by playing on them (*De arch.* 7.9.3–4).[49]

The term *ganosis*, from the root *ganos* (brightness), suggests the type of process described by Pausanias. According to Vitruvius, *ganosis* was a treatment with wax and oil to preserve the red tinting on the nude parts of marble statues.[50] Pausanias's *phaidruntai* (Cleansers) could thus have been preserving in a similar fashion the color of tinted flesh as well as tinted hair and lips as they proceeded with their oil treatment.[51] The more lifelike their appearance, which probably included flesh tinted darker or lighter to resemble male or female flesh, according to common conventions, and other accented features, the more chryselephantine statues would have been objects of wonder (*thauma*).[52]

A final glimpse of the chryselephantine Zeus of Olympia is provided by Cedrenus, the twelfth-century Byzantine chronicler. He provides insights on the structure of this statue. In his *Synopsis Historion* he describes the colossal statue, which had been brought to Constantinople.[53] It was part of the collection of ancient sculpture in the palace of Lausus near the hippodrome.[54] Cedrenus refers to the statue as "the ivory Zeus of Phidias" (*ho Pheidiou elephantinos Zeus*),[55] then mentions the loss of Lausus's sculpture collection in the fire of 475, which ravaged that part of the city.[56] The thirteen-meter-high statue had apparently lost its gold by the time it arrived in Constantinople, if Cedrenus can be trusted in this detail. Lacking its original revetment and glorious appearance, however, it still appeared as an ivory statue, not as a patching together of wood and ivory. Offering an indication as to the makeup of the statue of Athena Parthenos, Thucydides describes the forty talents of gold on Phidias's statue, all of which was removable; the same was probably true of the Zeus at Olympia.[57] The evidence thus suggests that the Zeus at Olympia was made of panels of ivory mounted on a wooden framework. Over these panels were originally laid molded sheets of gold and other forms of ornament; this is not the first instance we have seen of one precious substance, gold, laid over another, ivory, to produce the ultimate effect. This supreme outlay of expense was appropriate to the most supreme gods.

Pausanias's description of the chryselephantine Athena in the Parthenon is not as helpful as that of the Zeus at Olympia for reconstructing the appearance of chryselephantine statues.[58] He does mention, however, that this statue was stripped of its gold ornament by the tyrant Lachares in 295 B.C.E.: "He [Lachares] took golden shields from the Acropolis, and stripped even the statue of Athena of its removable ornament."[59] Just what was removed by Lachares is

not clear. If it was Athena's gold jewelry, the golden nikai and other accoutrements, then the figure would simply have been less splendid; but if it was the gold plates attached to the statue to represent her tunic, then these must have fit over the ivory. Otherwise she would have been left dismantled, with the wooden armature showing. Without her golden tunic she would have been seen in the nude![60] The gold plates attached to the statue must have been removable without completely disfiguring the statue, that is, they were attached to fit over the ivory.

As for the color of Athena's flesh, the ivory would not have been tinted as dark a color as Zeus's, for artistic convention dictated light-colored female flesh and darker brown for males. Her cheeks were probably tinted red or pink, as suggested by a passage in Himerius, the fourth-century C.E. rhetorician:

Pheidias was not always modelling Zeus, nor making bronzes of Athena with her weapons, but he also addressed his art to other gods and applied ornament to the Maiden, spreading a flush over her cheek, that the beauty of the goddess might be covered by this instead of a helmet (*Or.* 21.4).[61]

The adornment (*kosmesis*) applied to Athena's cheek would have been either a diluted reddish pigment that was painted on, or possibly the flesh parts were dyed—that is, steeped in red or pink dye. Unfortunately we have no evidence to determine the technique used.

The diverse array of materials and techniques described by Pausanias for the Zeus at Olympia was probably applied to the Athena Parthenos as well. A near-contemporary of Pausanias, Plutarch, describes in his *Life of Pericles* the requirements for the ambitious artistic projects of the statesman:

The materials to be used were stone, bronze, ivory, gold, ebony, and cypress-wood; the arts which should elaborate and work up these materials were those of carpenter, moulder, bronze-smith, stone-cutter, dyer, worker in gold and ivory, painter, embroiderer, embosser, to say nothing of the forwarders and furnishers of the material . . . (*Per.* 12.7–13).[62]

Among those employed in this formidable undertaking were the painters who would have painted backgrounds and details on the many marble sculptures and reliefs for the architecture. They also painted appropriate parts of the chryselephantine statue of Athena. Among the workers are those in gold and ivory, *malakteres* (softeners or molders), suggesting that there were people who softened ivory so that it could be spread out and molded in preparation for fastening in large sheets or pieces to the wooden armatures of the colossal statues.[63]

Regardless of cost, so numerous were chryselephantine statues in the classical period[64] that there does not seem to have been a need to describe them in great detail, for everyone had seen them, as, for example, in the description of a statue of Athena at Aegeira in Achaia:

The sights of Aegeira worth recording include a sanctuary of Zeus with a sitting image of Pentelic marble. . . . In this sanctuary there also stands an image of Athena. The face, hands and feet are of ivory, the rest is of wood, with ornamentation of gilt work and of colours (Paus. 7.26.4).[65]

This passage is significant because it notes an exception. The sanctuary could not boast the true chryselephantine works of Olympia and Athens, for the image of Zeus was of marble, and the

Athena had flesh parts of ivory and the rest of wood gilt and painted (*xoanon chrusoi te epipoles dienthismenon esti kai pharmakois*). The costly version, we can thus deduce, would have been entirely sheathed in ivory with gilding and painting, rather than of gilt and painted wood. An alternative technique was also used for the image of Zeus in the Olympieum at Megara, which could not be properly completed because the Peloponnesian War absorbed all available funds:

The face of the image of Zeus is of ivory and gold, the other parts are of clay and gypsum. . . . Behind the temple lie half-worked pieces of wood, which Theocosmus intended to overlay with ivory and gold in order to complete the image of Zeus (Paus. 1.40.4).[66]

In this case, only the face was of ivory and gold, with the gold probably used for the hair; the wooden armature for the rest of the statue was never completed, requiring a makeshift arrangement of clay and gypsum.

Through Pausanias's descriptions and our own deductions based on his accounts, we can envision the appearance of the chryselephantine statues. The best chryselephantine technique required an armature of wood with panels of ivory fastened to it, over which were attached removable gold plates. These in turn were worked with inlaid and painted materials, including glass, enamels, precious and semiprecious stones; exposed ivory parts must have been painted with the appropriate pigments or stained. The thrones were a significant element in statues of seated divinities, with inlays in numerous materials, painted and gilded reliefs of ivory, and surrounding wooden barriers also painted. The result is almost unbelievably complex and far from a simple combination of two materials, gold and ivory. When carefully read, Pausanias and other authors give us an idea of how chryselephantine statues actually looked, and, most important, the overall polychrome effect.

Roman and Byzantine Sources on Works in Ivory

Roman and Byzantine authors often refer to ivory not as the principal topic of discussion, but through metaphors or in passing, between the lines, so to speak. These sources, nonetheless, provide valuable information for our purposes, and Pliny in particular tells us much about the uses and appearances of ivory. Passages refer to ivory in connection with a wide range of subjects, from magic statues to blushing cheeks to ceremonial chairs, revealing not only the diverse uses of ivory, but also the different ways it could appear. At times the whiteness of ivory was preserved, and at others it was colored in various ways. Its properties as a medium for fine carving exceeded those of even the most dense wood. In spite of its expense, ivory was therefore the ideal medium for carving luxury objects of high symbolic value.[67] In contrast to the colossal figures of gold and ivory just discussed, smaller objects were made from ivory in the Roman and Byzantine periods; it was also often used as revetment for objects made of wood. As we shall see in some specific cases, the texts can be used to explain the original function of surviving ivories.

The techniques, and possibly many of the actual art works of the ancient world, were known to Pliny the Elder, the scientific compiler and observer of the first century C.E., and author of the *Natural History*. As we saw above, he is well informed about the art of painting in classical

Greece. He also tells us in a more practical manner about specific materials and techniques employed by artists. According to Pliny, encaustic, or painting with pigments suspended in hot wax, was practiced according to three methods:

In early days there were two kinds of encaustic painting, with wax and on ivory with a graver or *cestrum* (that is a small pointed graver); but later the practice came in of decorating battleships. This added a third method, that of employing a brush, when wax has been melted by fire . . . (*N.H.* 35.41).[68]

Durability is the virtue of the third and newest method, which involved use of a brush (*penicillo*); this method was developed closer to Pliny's own day. However, encaustic technique had long been practiced on wood using a *cestrum,* and on ivory also using a *cestrum.* The application of color to engraved ivory was apparently an old tradition when Pliny wrote.[69]

Comparisons between flesh and ivory occur in several passages, some of which equate blushing with the dyeing of ivory. For example, a blush is decribed in Book Twelve of the *Aeneid*:

And just as when a craftsman
stains Indian ivory with blood-red purple,
or when white lilies, mixed with many roses
blush; even such, the colors of the virgin (*Aen.* 12.67–69).[70]

The mixing and suffusing of one color with another are evoked by this passage, just as a blush spreads or a stain seeps into ivory; "*sanguineo . . . violaverit ostro . . . ebur*" means to dye ivory blood-red. Another Virgilian simile refers to the beauty of young Aeneas's flesh:

And there Aeneas
stood, glittering in that bright light, his face
and shoulders like a god's. Indeed, his mother
had breathed upon her son becoming hair,
the glow of a young man, and in his eyes
glad handsomeness: such grace as art can add
to ivory, or such as Parian marble
or silver shows when set in yellow gold (*Aen.* 1.588–93).[71]

Art describes nature, as color applied to ivory is equated with the "glow" (*lumenque . . . purpureum*) of the young Aeneas. However, in the case of Pygmalion, in the famous story in Ovid's *Metamorphoses,* his lifelike statue has flesh with the whiteness of ivory:

With wondrous art he successfully carves a figure out of snowy ivory, giving it a beauty more perfect than that of any woman ever born. And with his own work he falls in love. The face is that of a real maiden, whom you would think living and desirous of being moved, if modesty did not prevent. So does his art conceal his art. Pygmalion looks in admiration and is inflamed with love for this semblance of a form. Often he lifts his hands to the work to try whether it be flesh or ivory; nor does he yet confess it to be ivory (*Met.* 10.247–55).[72]

While art is generally perceived to be an illusion or contrivance, Pygmalion frustrates this notion by making the ivory statue so lifelike that it no longer looks like art. There can be no doubt in the case of Pygmalion's ivory statue that its whiteness was considered the color of ideal female flesh.[73]

In Ovid's *Amores,* in contrast, the relation between the staining of ivory and female flesh is made explicit, as a woman's blush is compared, among other things, to the color of dyed ivory:

her conscious face mantled with ruddy shame
like the sky grown red with the tint of Tithonus'
 bride,
or maid gazed on by her newly betrothed;
like roses gleaming among the lilies where they
 mingle,
or the moon in labour with enchanted steeds,
or Assyrian ivory Maeonia's daughter tinctures
to keep long years from yellowing it.
Like one of these, or very like,
was the colour she displayed . . . (*Amores*
 2.5.33–41).[74]

This simile echoes the Homeric one discussed above, and we assume Ovid knew of a contemporary practice of dyeing ivory, for the allusion to "some Carian or Maeonian woman," although recognized and enjoyed by any educated reader, would otherwise simply be an anachronism.[75] The process of dyeing (*tinxit*) gives ivory the color of a blush, the color term for which is *purpureus,* or a deep reddish cast. In addition, the customary purpose of dyeing ivory is stated: it prevents the ivory from turning yellow, for it was expected to turn yellow over time unless some treatment prevented it.[76] In an elegy by Propertius (1st century B.C.E.) the special properties of the climate at Tibur near Rome, where Hercules was worshiped, are referred to as beneficial: "by the favour of Hercules the ivory ne'er grows yellow [in Tibur]."[77] While Ovid in the *Amores* describes the staining of ivory as a way of preventing its yellowing over time, Propertius indicates ivory will not turn yellow if kept in the appropriate climate.[78]

Blushing evokes the staining of ivory in yet another passage from Ovid:

the boy blushed rosy red
for he knew not what love is. But still the blush
 became him well.

Such colour have apples hanging in sunny
 orchards,
or painted ivory; such has the moon, eclipsed, red
 under white,
when brazen vessels clash vainly for her relief (*Met.*
 4.329–33).[79]

The color of apples serves metaphorically for the blush, indicating a red called *rubor*, also compared to painted ivory.

Yet another blush, a passage in Claudian's *Rape of Proserpine* (c. 396 C.E.), compares Proserpine's blush to the glow of ivory:

A glowing blush (*purpura*) that mantled to her clear cheeks suffused her fair countenance and lit the torches of stainless purity. Not so beautiful even the glow of ivory which a Lydian maid has stained (*tinxerit*) with Sidon's scarlet dye (*Rape of Proserpine* 1.272–75).[80]

The allusion to dye from Sidon in Phoenicia specifies not only its source but its name: *purpura* or *ostro*.[81] The image in the Homeric simile, the color of blood, is missing, and in its place is the dye known as Sidonian purple.[82] Claudian probably knew of an ongoing tradition of either producing the dye or of producing ivory objects dyed in Sidon.

Various objects, from boxes and pieces of furniture to ceremonial plaques, were made or decorated with ivory. The practice of painting these objects, exemplified in Roman and Etruscan artifacts discussed in chapter 3, is confirmed by the texts. Pliny explicitly mentions a painter on ivory in a rare reference to female artists, among them Iaia of Cyzicus:

When Marcus Varro was a young man, Iaia of Cyzicus, who never married, painted pictures with

the brush (*penicillo pinxit*) at Rome and also drew with the *cestrum* or graver on ivory, chiefly portraits of women, as well as a large picture on wood of an Old Woman at Naples, and also a portrait of herself, done with a looking-glass. No one else had a quicker hand in painting, while her artistic skill was such that in the prices she obtained she far outdid the most celebrated portrait painters of the same period, Sopolis and Dionysius, whose pictures fill the galleries (*N.H.* 35. 40.147–48).[83]

We do not know what kinds of ivory objects she engraved and painted with pictures and portraits; one would very much like to have more details of this woman's art. The technique she used is probably the one Pliny describes in chapter 41 in connection with encaustic, in which hot wax colored by pigment is used on engraved ivory. Pliny also says that boxes made by cutting wood into plaques are more luxurious when the wood is covered with an even more precious wood, or when it is covered with ivory.[84] The many Roman bone and ivory plaques preserved at the Walters Art Gallery in Baltimore are thought to have come primarily from boxes, and very likely served as the kind of painted revetment Pliny describes. Ivory continued in Roman antiquity, as in classical Greek antiquity, to be associated with the color of flesh, with luxury objects, and with honoring the gods.[85]

The curule chair is a beautifully crafted piece of furniture for which there exists scattered literary and artistic evidence. Our idea of this chair, which is traditionally used by Roman magistrates, is formed from representations of seated figures on coins and consular diptychs and in manuscripts. The chair, derived from a collapsible type of army campstool with ornamental posts and feet, could be decorated with reliefs and finials.[86] Unfortunately, none survive. Literary sources, however, help attest its use and appearance. Livy, writing in the first century B.C.E. to the first century C.E., mentions this type of chair on three occasions along with other precious objects given, for example, to Eumenes by the Romans. In his *History of Rome*, Livy describes these honors:

> gifts together with a curule chair and an ivory scepter . . . [87]
> gifts of an ivory scepter, a robe of state, and a curule chair . . . [88]
> Masinissa was given a gold wreath, golden patera, a curule chair, an ivory scepter, and embroidered toga. . . .[89]

The chair was associated from early times with dispensing the duties that came with high office, along with ivory scepters and rich garments.[90] It appears in Athenaeus's description of Antiochus, king of Syria, in the *Deipnosophistai*. The king pretends to canvas votes and then serve as tribune or judge "seated on the ivory chair" (*epi ton elephantinon diphron*).[91] Silius Italicus, recounting the early history of the Romans in his *Punica*, describes the origin of their attributes of office, the *fasces* and axes, in the city of Vetulonia:

> Along with these seats of office she adorned the high curule chairs with the beauty of ivory, and first bordered the robe of office with Tyrian purple (*Punica* 8.486–87).[92]

In the *Fasti*, Ovid not only refers to the ivory chair of office as "curule . . . of ivory" (*eburque curule*) but as the "far-seen" ivory chair (*conspicuum . . . ebur*).[93] The curule chair is depicted on numerous ivory diptychs, for example, the consular diptychs of Anastasius, dated to 517 (see fig. 2) and of Magnus, dated to 518, both made

in Constantinople.[94] These diptych leaves show the consul seated on an elaborate version of the curule chair, with the curved legs carved to resemble lions' legs and feet; lions' heads holding rings in their mouths support the complicated superstructures, while Victories standing on knobs serve as finials; elaborate seats and embroidered cushions appear in mixed perspective. The consuls hold scepters corresponding to Livy's descriptions of the ivory scepters that accompanied the curule chairs as gifts. As we have seen, the ivory diptychs were often dyed and painted. The diptych of Anastasius has pigment traces of red stain, and blue, green, red, and gold localized around the chair; the diptych of Magnus has green background and garments, and the ornaments of the chair are red. If the ivory diptychs are any indication of the colors of the ivory chairs, they would have been conspicuous indeed.

Another classification of ivory objects known only through the literary sources is doors. Doors of ivory appear, for example, in Diodorus of Sicily, in his account of the land of Panchaeitis:

The doorways of the temple are objects of wonder in their construction, being worked in silver and gold and ivory and citrus-wood (Diodorus Siculus, 5.46.6).[95]

There are further references to ivory on doors in Cicero and in Virgil. In Cicero's *Against Verres* the doors of a temple are extolled; they were part of the loot taken from the temple of Athena in Syracuse:

And now I come to speak of the doors of this temple . . . doors more exquisitely wrought in ivory and gold have never existed in any temple at all. You can hardly believe how many Greek writers

have left us descriptions of the beauty of these doors. . . . Upon those doors were various scenes carved in ivory with the utmost care and perfection. Verres had all these removed. He wrenched off, and took away, a lovely Gorgon's face encircled with serpents. With all this, he showed that it was not only the artistic quality of these objects but their cash value that attracted him; for there were a number of massive golden knobs on these doors, all of which he carried off without hesitation; and it was not the workmanship but the weight of these that appealed to him (*In Verrem* 2.4.56/124).[96]

The barbarism of looting these exquisitely decorated doors especially offended Cicero because Verres did not appreciate or seek to retain the beautifully crafted doors intact but simply stripped them of their precious materials. The passage is also, of course, a witness to the fate of much of the art of antiquity. Further evidence of such reveted doors comes from Virgil's *Georgics* in which he describes battles and other exotic and Nilotic scenes appearing on imaginary doors "of solid gold and ivory" (*ex auro solidoque elephanto*).[97] Ivory doors had carved ivory plaques affixed to them carrying pictorial scenes carved in relief. The plaques were probably treated like ancient reliefs in the coloring of backgrounds, and reliefs and frames included the use of metals, including silver and gold.[98]

The appearance of such doors is difficult to reconstruct without a more detailed description. Doors with inset panels containing figural scenes are depicted on a Late Antique ivory plaque in the Castello Sforzesco in Milan, dating to around 400.[99] The Holy Sepulcher is shown after Christ's Resurrection, with the women approaching. The doors of the sepulcher have ornate moldings, framing six panels with biblical scenes, three on each valve. Similar doors, carved of cypress wood,

with scenes on panels surrounded by classicizing ornament, survive on the church of Santa Sabina in Rome.[100] They date to c. 430 and might be seen as wooden versions of the doors depicted in the Milan panel. They also resemble in style and format carved ivory panels attached to a mid-sixth-century piece of furniture, the ivory throne of Archbishop Maximian. This unique example of Early Byzantine ivory-reveted furniture has its entire wooden core overlaid with panels depicting narrative scenes, portraits, and ornament.[101] The principles of organization and design found on the Santa Sabina doors and on the throne best help us reconstruct the techniques used for ivory doors.

A final category of ivory objects attested in the literary sources is the so-called "ivory books." The *libri elephantini* are mentioned in passing in the *Scriptores Historiae Augustae,* on the emperor Tacitus (275 C.E.):

And now, lest any one consider that I have rashly put faith in some Greek or Latin writer, there is in the Ulpian Library, in the sixth case, an ivory book, in which is written out this decree of the senate, signed by Tacitus himself with his own hand. For those decrees which pertained to the emperors were long inscribed in books of ivory (*Scriptores Historiae Augustae: Tacitus* 8.1–2).[102]

Whether these ivory books were, like the consular diptychs, hinged plaques with recesses to hold wax in order to be inscribed, or parchment books or codices in our modern sense, with covers made out of ivory, cannot be determined. But later Byzantine ceremonial plaques referred to as *plakes* (tablets) may may shed light on this problem.

In the *Historia Augusta* ivory panels were used to record names and deeds of emperors. A similar practice of recognizing and recording the appointment of important officials at the Byzantine court is attested in the *Kletorologion of Philotheos,* a work by an imperial official of c. 899–900; it was inserted into Constantine Porphyrogenitus's *Book of Ceremonies* of the mid-tenth century.[103] This text describing the ranks, titles, and ceremonies at the Byzantine court confirms the continued use of ivory tablets on ceremonial occasions and is useful for assessing the function and appearance of some preserved ivories of the Middle Byzantine period. In a list of functionaries, the *patrikios,* at the twelfth level, is honored through the presentation of ivory tablets: "decorated ivory tablets accompanied by (enclosing) engraved codicils [revised] according to the law, from the imperial hand" (*plakes elephantinai kekosmemenai sun kodikellois eggegrammenois eis tupon tou nomou, ek basilikes cheiros epididontai . . .*).[104] At the thirteenth level, the title of *anthupatos* is awarded with "purple inscribed codicils, from the imperial hand" (*kodikelloi halourgoeideis gegrammenoi . . .*).[105] The fifteenth level, that of *zoste patrikia,* or "mistress of the robes," receives "ivory tablets like those of the *patrikios,* given by the imperial hand" (*plakes elephantinai homoios tois patrikiois . . .*); this award too included *kodikelloi.*[106] Eunuchs also received honors of ivory tablets as insignia; the eighth order received plaques without codicils, and the ninth order plaques with codicils, indicating that codicils were an enhancement of the award.[107] According to Bury, the Patricians were divided into two ranks: the ordinary Patricians, who retained as their insignia the ivory tablets, and those to whom the dignity of Proconsul was added, who had purple tablets.[108] However, it is unclear from the texts whether the tablets, the writing, or the codicils were purple.[109] If the codicils were written documents, this could

mean that they were made of sheets of purple-dyed parchment; purple parchment is familiar from early Byzantine manuscripts and was a treatment usually restricted to imperial commissions.[110] If, as Alexander Kazhdan suggests, the codicils were written documents that were put inside the diptych's sealed wings, then we are dealing with ivory tablets used as a kind of envelope.[111] The appearance of the ivory tablets (*plakes*) themselves remains to be determined, for we are told only that the tablets were decorated (*kekosmemenai*). This could mean they were carved, but were they also painted? If the codicil refers to the inscription itself, then it could have been written in purple ink on the ivory tablets, or alternatively, in another color ink on a purple-dyed ivory tablet. In the list of nineteen dignities, codicils (*kodikelloi*) usually appear in conjunction with tablets, but in one case tablets are mentioned specifically as without codicils. Could the codicils be the writing, perhaps including an imperial signature, on the plaques? When official documents are referred to in other parts of the list, they are listed as *chartes eggegrammenois*, or, as Bury translates the term, diplomas.[112] These are clearly different from the codicils. The purple-inscribed codicils, *kodikelloi halourgoeideis gegrammenoi,* therefore appear to be plaques made of ivory dyed purple and inscribed. The color is described as sea-purple (*halourgis*), which was the most expensive kind of coloring, and was restricted to imperial prerogative. It is ranked above red, *kokkinos,* which was a less expensive and prestigious color, as indicated in the colors of the tunics awarded officials. The titles of *kouropalates* were rewarded with a red tunic (*chiton kokkinos*), as opposed to the higher rank, *nobelesimos,* who received a purple tunic (*chiton ex halourigidos*).[113] In summary, the references to ivory tablets and purple codicils in the *Kletorologion* of Philotheos

seem to reflect two kinds of ivory objects: first, ivory diptychs that are inscribed and decorated, and perhaps carved and painted, and, second, purple-dyed ivory diptychs that are inscribed.

There are no identified surviving examples of these ceremonial tablets or diptychs, although a depiction on the dedication page of the Vienna Dioscurides manuscript may depict a sixth-century version of these imperially awarded ivory tablets. In the miniature on fol. 6 verso, Anicia Juliana is seated on a curule chair and holds in her left hand an oblong object with a white lozenge surrounded by four gold triangular segments at the corners. If this is an example of a *codicillus,* as Weitzmann proposes, it could represent an ivory diptych with gilt decoration.[114] As we found in chapter 1, ivory diptychs were often stained or painted red, and many also had traces of gilding.[115] Although consular diptychs stopped being produced in 541, honorary plaques of a similar type probably continued to be used in ceremonies such as those described above.

An ivory panel at Dumbarton Oaks dated in the tenth century poses a tantalizing problem in connection with these kodikelloi, for its function is unknown; a matching leaf is preserved in the museum at Gotha in Germany, and it is thought that they formed a diptych.[116] Unlike the earlier consular diptychs, these are arched in design; there is a cross on the front of each at the center of which is, on the Dumbarton Oaks piece, a medallion with the bust of an emperor, and, on the Gotha example, a bust of Christ. The reverses of both plaques consist of recessed fields, similar to those on the consular diptychs but shallower and arched in shape. Weitzmann, finding this diptych enigmatic, raised the possibility that the sunken fields were meant to contain parchment sheets but also commented that there is no evidence that parchment sheets cut to the

size of ivory plaques were produced in Byzantium.[117] Two sets of similar plaques in Bamberg appear to have served the same purpose, whatever that was.[118]

The function of the diptych may be explained from the evidence we have gathered. The recesses could have held parchment sheets as Weitzmann suggests. Alternatively, inscriptions could have been written directly on the ivory in the recess, comprising the codicils mentioned in the *Kletorologion of Philotheos*. The outside of the panel at Dumbarton Oaks indeed proves to have been brightly painted, with a green-stained border over parts of which were substantial remnants of bright blue paint (pls. XVI, XVII). Bright green and red crystals were visible on the cross, and on the emperor's loros were traces of blue pigment; traces of gilding also appeared around the frame. The Dumbarton Oaks, Gotha, and Bamberg plaques are very likely surviving tenth-century examples of the "decorated ivory plaques" awarded officials on the ceremonial occasions of conferring the titles referred to in the *Kletorologion of Philotheos*.

Ivory in Theophilus and Others

Theophilus, whose writings about pigments were discussed in chapter 2, contributes to our understanding of the customary practices of producing and decorating ivory objects in the Middle Ages. In his *De Diversis Artibus,* one of the earliest surviving medieval treatises on artistic techniques, is a section on bone and ivory: *De sculptura ossis*.[119] In the following chapter on "Staining Bone Red" (*De rubricando osse*) he describes the practice:

There is a plant called madder, the root of which is long, slender and red. It is dug up, dried in the sun, pounded in a mortar with a pestle, lye is poured over it and it is heated in an unused pot. After it has been well boiled, the tusk of an elephant, or bone of a fish, or horn of a stag, becomes red when placed in it. From these bones or horns, one can make knops in turned work for the crosiers of bishops and abbots, and smaller knops appropriate for various uses.[120]

The procedure is simple enough and is probably of some antiquity, since madder was easily obtainable throughout the Mediterranean world in antiquity and would have been an inexpensive alternative to *purpureus*.[121]

Techniques recorded in a fifteenth-century manuscript of Jehan le Begue probably also incorporate ancient practices. Among the many chapters on different aspects of production are, for example, one on the recipes for making pigments and dyes.[122] In this manuscript are also found verse chapters copied from the author Eraclius, thought to have been written in the tenth century. In his *De coloribus et artibus romanorum* (*On Colors and Arts of the Romans*), one technique discussed is: "Of gold-leaf, how it is laid on ivory." In chapter 9 he writes:

You will decorate carvings in ivory with gold leaf. Now hear in what manner this thing is done. Seek to obtain the fish which is called "huso," and keep its air-bladder liquefied by being boiled in water, and with this mark over the place where you wish to lay the gold; and you will thus easily be able to fasten it to the ivory.[123]

Gilding, which appears frequently on Byzantine ivories, was probably applied in a similar manner. In chapter 19 Eraclius writes about the art mentioned by Plutarch, the bending of ivory:

If you wish to bend and adorn ivory, put it into the aforesaid mixture for three days and three nights. Having done this, hollow out a piece of wood in whatever manner you like, and then put the ivory into the cavity, and turn and bend it just as you like.[124]

Finally, in a later chapter, surviving only in Old French, a technique is described which may have its origins in the treatment of chryselephantine statues:

To make a colour which is called posc for the undraped parts of images.—Mix a little cynobre with simple flesh colour and a little minium and you will have the said posc color, with which you will redden teeth (gums), nostrils, mouths, hands, the under part of necks, the wrinkles of foreheads, the temples, and the articulations and other members in all the undraped parts of painted and round figures. [125]

The application of red to flesh shows the survival of a separate formula for this pinkish color.

Lastly, in a manuscript in Brussels of 1635 by Pierre Le Brun, an intriguing reference is made on the subject of painting on ivory:

Ivory must be washed with the water which is found under horse-dung, for the colours cannot be applied without this secret and invention.[126]

Various polychrome treatments of ivory appear in a wide range of sources, from Homeric times through the Middle Ages, indicating a consistently used set of practices for coloring ivory. In a few cases, techniques mentioned in the texts are identifiable in preserved works. The options available to the craftsman seem to have changed little over time, both in terms of the colors he could choose and the techniques for applying them. The ancient and medieval palette depended primarily on red, blue, green, and gold. Traditions were probably very slow to change, with artistic practices handed down from generation to generation in the apprentice system known to have existed. The craftsman, or craftsperson, since women may well have pursued the trade, could dye the ivory, soaking it until it absorbed the dye. Polishing and smoothing probably took place next; then the craftsman would paint details or features of figures, backgrounds, and gild other elements. The work received a final protective coating of oil or wax. The two techniques most often attested are gilding and dyeing red. The gradual yellowing of ivory with age was an accepted fact, as it took on a deep yellow color similar to that of old piano keys. The natural yellowing process of ivory forced the craftsman, or the patron, to make a decision: to dye, paint, polish, or gild—he could choose some, all, or none of these options, but it is unlikely that ivory was carved and then left entirely untreated.

Now that we have examined the textual evidence for coloring ivory, the systems of values governing this polychrome treatment—optical, intrinsic, and philosophical—must be examined in order to discover not only why it was important for Byzantine ivories to have been painted and gilded, but also how these practices conformed to a wider set of aesthetic considerations. It remains to show how the patterns of coloration observed on our test group compare to those of other contemporaneous works and media, for to understand why ivory was painted, we must recover the aesthetic system to which this medium belonged. This requires confronting the issue of just how fundamental color is to Byzantine art.

Chapter 5

Color on Ivory and the Byzantine Aesthetic

Why did the Byzantines paint their ivories? In order to approach this question we need to understand how Byzantine attitudes toward color were shaped and to examine practices that are most revealing about the Byzantine system governing the use of color. Since it is well known that Byzantine civilization considered itself in many respects heir to classical antiquity,[1] we address the extent to which the Byzantines continued ancient Greek and Roman approaches to color. The roots of the Byzantine system of color, as well as the symbolism and status associated with colors, lie deep in antiquity; indeed, polychromy on ancient sculpture provides some surprising analogies with Byzantine usage. But Byzantium superimposed on these old patterns a more elaborate approach. It is this Byzantine rationale for using color that we must pursue in an effort to understand the aesthetic and symbolic values associated with color in that culture. Selected literary sources provide insights on this score; striking too are analogies between color on ivories and in other artworks and media. Together these help contextualize the Byzantine practice of applying bright, saturated colors to ivory.

Ancient Concepts of Color

Works by classical writers indicate how color was perceived in antiquity.[2] In Homeric and classical

Greek poetry, colors were often vested with specific meaning. They were inseparable from colored things, as in the combined words lily-white (*leirioeis*) or wine-dark (*oinops*). Alternatively, colors belonged to groups defined more generally by brightness instead of hue, or their proximity to white or to black, as Eleanor Irwin explains in her book on ancient Greek color terms.[3] Theophrastus posited four colors: white, black, red, and green (*leukon, melan, eruthron,* and *chloron*), while Plato's primary colors were white, black, red, and "bright" (*leukon, melan, eruthron,* and *lampron*) respectively. White was a binary term always combined with hue or object terms to indicate lightness of hue (*ochros*: light yellow; *glaukos*: light blue), while "bright" (*lampron*) was a property unto itself, meaning lustrous or shimmering, a word we would use today to describe surface texture.[4] Aristotle (*De sens.* 439a–442a), in contrast, defined and named seven colors, including white and black: yellow (*xanthon*), crimson (*phoinikoun*), purple (*halourgon*), green (*prasinon*), and blue (*kuanoun*); other shades could be mixed from these. His approach resembles more closely our system of primary and secondary colors.

In Plato, color is parallel to form or shape, for whatever is perceived by sight has form and color: "let this be our definition of shape—the only thing which is always accompanied by color" (*Meno* 75b). The impact of color is described by its relation in contrast to another color or idea; opposites were described as parallel to dark or light: dark clothing (*melas*) was associated with death or mourning and white clothing with festivals or a good day (*leuke hemera*). Symbolic values were attached to opposites: for example, white lambs were worthy of sacrifice to the Dioscuri, and black ones suitable victims for the Erinyes.[5] In a fragment of Parmenides' table of opposites, earth was dark and air, bright; and of

course the connotations of day and night are associated with the concepts of light and dark that accompany them.[6] In general, hue is most evident in colors that have high value and intensity, while dark colors tend to merge and be seen primarily as dark, and only secondarily as having hue.[7] The Greeks were attuned to forms with bright or shining surfaces as much as to particular hues. Qualities other than hue were of prime importance, judging from color epithets used in Greek poetry (shining, light, or dark). In contrast to these philosophical concepts of color, more concrete examples of Greek attitudes to color can be seen in the application of color to Greek architecture and sculpture.

Polychromy on Ancient Sculpture

In studies of polychromy on Greek architecture and sculpture the colors encountered are very similar to those mentioned in poetry. While surviving traces of color cannot be described as "shining" or "dark," they nonetheless were originally bright, saturated colors. One of the most revolutionary revisions of our perception of a medium came with Gisela Richter's analyses of polychromy on Greek sculpture.[8] She based her initial conclusions on observations of Archaic grave stelae in the Metropolitan Museum of Art, on which she consistently found traces of red, black, blue, and green, and she concluded that "the regular palette of the archaic Greek artist was the same as the Egyptian and Minoan."[9] The palette was used abstractly, as in the use of red for women's hair or for horses, more to differentiate areas or forms than to evoke natural appearance.

The work of Richter is pushed a stage farther in Penelope Dimitriou's dissertation on the polychromy of Greek sculpture.[10] Dimitriou provides an assessment of ancient color theories,

pigments, and painting techniques, and her comprehensive catalogue of traces of polychromy on Archaic and classical sculpture in stone is an important contribution to the study of ancient art. Both Richter and Dimitriou derived their conclusions from visible traces of color on sculpture. There are also cases in which even faint traces of color no longer remain on sculptures we know were once painted, as in the sculptures of the Parthenon. According to Dimitriou's research, these supreme examples of three dimensional and relief sculpture have over time lost their colors, gilding, and metal attachments.[11] Although many colors were observed and recorded on the Parthenon sculptures at various times by travelers and scholars, there are none to be seen today. Some pigment traces may have been removed in the course of cleaning.

Many other sculptures, however, were buried in the earth after standing for a relatively short time exposed to sun, wind, and rain, such as the Archaic korai, or maidens, from the Acropolis. These often retain substantial traces of their original painting, especially the more heavily painted drapery and hair.[12] The flesh parts, however, which had a smoother surface, have lost their delicate, transparent colors.[13] A brief summary will serve as an indicator of the colors found on ancient Greek art and architecture.

Colors of sculptures, both architectural and freestanding, correspond to the color terms used in Greek prose and poetry and philosophic writings. On Doric friezes of the Archaic and classical periods the triglyphs were usually blue and the metopes white, with subjects painted in contrasting colors.[14] Ionic friezes of the Archaic period, such as the Siphnian Treasury at Delphi, had an azurite blue background and figures in red, yellow, blue, green and the reserved color of the stone; the flesh of male figures has been re-

stored as light red and female figures as the reserved color of the stone.[15] In classical friezes, such as on the Hephaisteion and Parthenon, the background was blue and figures were in red, blue, and green with armor, reins, and acoutrements added in metal.[16] Pedimental groups in classical temples were seen against blue backgrounds and were polychrome like the reliefs, with male flesh tinted red, and white for females.[17] The red of the himation of the Athena of the Peisistratid Temple on the Acropolis is still clearly discernible. Garments were brightly colored, and on the Parthenon the accessories were gilded:

The figures of Athena of both pediments may be restored with red peplos, blue and red aegis and gilded bronze helmet, snakes and gorgoneia. The draperies of the other figures of the pediments may be restored in color schemes of red, blue, violet and yellow.[18]

The extensive evidence of polychromy on ancient stone sculpture and of the practice of gilding on marble and limestone sculpture probably also reflects the color scheme applied to the numerous lost examples in chryselephantine technique, discussed above in chapter 4.[19] Indeed Dimitriou asserts that the polychrome appearance of stone sculpture was derived from the great ivory and gold statues. The question remains regarding how much of the relief surface or of freestanding sculpture was colored and how much was left the natural color of the medium.[20] It is known that backgrounds and clothing of figures were painted in stone sculpture, and flesh parts were also regularly painted. Therefore, if the prime model for stone sculpture was chryselephantine work, it follows that substantial portions, including the flesh of the chryselephantine statues, would have been stained or painted.[21]

The classical ideal was apparently just as concerned with color as with form. Painters of ancient sculpture were as highly paid as sculptors, indicating that both were considered vital to the production of art.[22] The work of Dimitriou and Richter helps substantiate this formerly rejected idea; the changed perception resulting from Dimitriou's study applies to sculpture in all media, as well as to architecture.[23] The polychrome appearance of Greek statuary and reliefs was paralleled by small-scale sculpture, including carved ivories and reliefs; these probably all shared a colorful appearance.[24] Throughout antiquity, sculptures of all sizes and in all media, including stone, ivory, and terracotta, were normally polychrome.[25]

Conventions and concepts of color developed in the classical period—what Dimitriou terms "lavish polychromy"—continued in the later Hellenistic and Roman cultures. Hellenistic reliefs were completely colored, and Roman figures and reliefs representing Roman themes were painted as well.[26] The color scheme on most sculpture included a wider range of colors than in classical times: blue, yellow, red, rose, purple, and gilding. For example, the reliefs on the cuirass of the marble Augustus of Prima Porta have draperies in purple, crimson, rose, and blue, while the chiton and himation of Augustus were crimson and purple-red; the irises of his eyes were also painted.[27] The backgrounds of Roman reliefs were red, blue, and rose, as on wall paintings, and red, purple, violet, rose, yellow, blue, and gilt are preserved on draperies and details. In painting of hair, flesh, and features, and on foliage the shades approximated nature. The reliefs on the column of Trajan were reported by the mid-eighteenth-century travelers Stuart and Revett to have been painted and gilded

on a blue background, although all traces of polychromy have since disappeared.[28]

If polychromy was the rule rather than the exception on ancient Greek and Roman figural and monumental sculpture, then what about Byzantium? Byzantine architectural sculpture of all periods—capitals, imposts, cornices, and moldings—was regularly painted and gilded.[29] Figure sculpture in the round, however, ceased to be a standard art form by the sixth century C.E., although small-scale sculpture continued, primarily in luxury objects made of ivory and silver. We may assume carved wooden objects were also produced, but here we are at a loss because so few survive. Architectural sculpture, as in antiquity, provides ample evidence of polychromy. Among the excavated ruins of the early Byzantine church of Hagios Polyeuktos in Constantinople (524–27), for example, architectural elements such as the peacock niches and ornate moldings were discovered to have pigment traces of bright blue, red, green, and gold; in the background of inscriptions and relief ornament of vines was bright blue pigment.[30] The capitals and imposts in the church of San Vitale in Ravenna are still brightly painted today.[31] In Middle Byzantine architecture, traces of polychromy in red and blue can easily be detected on, for example, the capitals of the Theotokos Church at Hosios Loukas (mid-tenth century), the templon screen of the Katholikon of Hosios Loukas (late tenth century), and the cornices of the north church of Constantine Lips in Constantinople (early tenth century), among others.

In addition, the Byzantines had an appreciation for naturally polychrome materials, in particular, marbles. A taste for combining them was inherited from the Romans and applied to architectural interiors, as they had been, for example, in the

Pantheon in Rome. Colorful marble revetments, often appearing in matched pairs formed of split slabs, appear in church decoration of all periods of Byzantine civilization, from Hagia Sophia in Constantinople (532–37) to the church of the Chora Monastery, Kariye Djami (c. 1310–20). When church decoration was in fresco, painted imitations of colored marbles appeared on the lower walls.[32] The symbolic importance of these many juxtaposed natural colors of stone in buildings is evoked by numerous Byzantine authors, among them Procopius, Paul the Silentiary, Constantine Porphyrogenitus, and Nicholas Mesarites, to name a few. Procopius, for example, describes the marbles of Hagia Sophia:

Who could recount the beauty of the columns and the marbles with which the church is adorned? One might imagine that one has chanced upon a meadow in full bloom. For one would surely marvel at the purple hue of some, the green of others, at those on which the crimson blooms, at those that flash with white, at those too which Nature, like a painter, has varied with the most contrasting colors. Whenever one goes to this church to pray, one understands immediately that this work has been fashioned not by human power or skill, but by the influence of God.[33]

According to Procopius, the transcendent effect of the combined colors symbolically helped bring the viewer closer to God.

Not only did the Roman practice of polychrome marble revetment find lavish application in Byzantium, but numerous ancient Greek and Roman statues were transported to the capital from all over the Mediterranean world to embellish it. The Byzantine perception of all this antique statuary has been described by one

scholar: "Aesthetically, then, there appeared, to the Byzantines, to be no difference whatever between ancient and their own art; the only difference was one of subject matter."[34] Byzantium, in other words, saw herself as still part of the ancient world, or an extension of antiquity, while also defining herself as a Christian empire.

Ancient traditions were reflected in all aspects of Byzantine culture, including those associated with production and technologies. It is therefore no more surprising to find painted architectural sculpture than it is to find painted ivory diptychs or icons and boxes with painted and gilded ivory revetment, maintaining the same colorful appearance as works of Greco-Roman antiquity. Byzantium's own conception of herself as part of a continuous culture from the past, combined with artistic practices passed along from generation to generation, encouraged a continuum of ancient artistic traditions, even extending back to the ancient Egyptians. In Byzantium, color played an important role in material surroundings generally, particularly in architectural interiors, and in all sculptural media.

The continuity with ancient art forms is reflected in the perpetuation of a whole set of ancient values in Byzantine culture. Philosophical and symbolic associations with color in ancient culture were affirmed through literary usage.[35] Color schemes remained remarkably stable, with warm colors (red and yellow) usually balancing cool colors (blue and green), and with accents in black and separation of colors from one another accomplished by reserving areas of white ground.[36] Not only was the palette of classical sculpture continued in Byzantium, but many of the same pigments were also used. In the observations of Byzantine ivories described in chapter 1, for example, the range of colors consistently included

bright, saturated primary colors—red, blue, and green—in addition to gold. The pigments identified on ivories, described in chapter 2, were vermilion (cinnabar) for red, malachite for green, lapis, azurite, or Egyptian blue for blue. The continuity of usage of bright primary colors in Byzantium, in preference over mixed or diluted shades, suggests a conscious continuation of ancient artistic practices and adherence to a shared aesthetic. However, there are heightened meanings, symbolism, and connotations, both religious and social, that are associated with color in the Byzantine system. These can best be perceived in allusions to color in Byzantine texts.

Color in Byzantine Literature

The frequent references to color in Byzantine *ekphraseis* and other literary descriptions indicate the significance of color as a medium of expression in Byzantium. While a comprehensive treatment of color in Byzantine culture is beyond the scope of this chapter, a few literary examples will suffice to reveal Byzantine usage and attitudes toward color.[37] They show, among other things, that color was essential to a Byzantine value system reflecting status. For example, the word purple was not a purely descriptive adjective, but synonymous with a dyestuff having powerful overtones. *Halourgeis,* named after the costly dye obtained from the murex shellfish, was reserved for usage by the emperor. The wearing of garments dyed in this dye was a way of indicating power and authority.[38] The imperial association with sea-purple goes back at least to the Hellenistic period, when we find purple hats (*kausiei halourgeis*) among the kingly gifts bestowed by the ruler Eumenes (Plut., *Eum.* 8.6.7).[39] The connotations in Byzantium of purple color can be illustrated in a Byzantine treatise of the late ninth century, the *Kletorologion of Philotheus.* This work describes official protocol at the Byzantine court and lists the honorary tokens or insignia awarded officials, starting with the highest rank. Just below the rank of caesar is the nobelisimus, who is awarded a purple chiton with gold, also a chlamys and belt (*chiton ex halourgidos chrysothetos kai chlamys kai zone*).[40] The kouroplates, the next rank below nobelisimus, is awarded a red chiton decorated with gold, and chlamys and belt (*chiton kokkinos chrysopoikilos kai chlamys kei zone*). From this example it is clear that *halourgidos*, or wrought-in-the-sea-purple, was superior to red (*kokkinos*).[41] No doubt it was sea-purple dyed cloth that was confiscated from Liudprand of Cremona, the tenth-century diplomat, as he was crossing the Byzantine frontier on the way home:

"These stuffs are prohibited," they replied, "and when the emperor spoke as you say he did, he could not imagine that you would ever dream of such things as these. As we surpass all other nations in wealth and wisdom, so it is right that we should surpass them in dress. . . . every purple vestment you have acquired must be returned to us."[42]

Liudprand's grumpiness at his treatment may have been justified, but everyone, including visitors, was supposed to know and obey the rules pertaining to imperial purple.

The term for the purple dyestuff is supplemented by the name of the murex shellfish itself, the *porphyra*. Homer used the term to describe blood, or simply dark things, like the sea. From this term the deep reddish-purple stone quarried in Egypt at Mons Porphyriticus was named. The best-known association with porphyry is in the *porphyra*, a porphyry-lined room in the royal palace in Constantinople where royal children

were born; the name of one emperor, Constantine VII Porphyrogenitus (Constantine-born-in-the-purple), assured that he was properly associated with imperial birth. In Byzantium, any purple object was regarded as having superior value and imperial connotations. There is no pigment that produces what we refer to as purple color, but it could be obtained by mixing red and blue pigments. We have already seen how thorny the problem is of untangling terms and equivalent colors according to our own usage. What we see as red may have been referred to by the Byzantines as purple (*halourgis* or *porphyrios*)[43] while their terms for red (*phoinikeos* and *kokkinos*) might have described substances that look more purple to us. While we have identified instances of red pigment, vermilion, confirmed on ivories, we have not tested for the purple dye of the murex. It is entirely possible that ivories were first steeped in this dye, perhaps in a manner similar to the dyeing of purple parchment, before being painted with precious pigments. I hope further studies and scientific tests may clarify this suggestion in due course.

Colors had further specific associations within the culture, as in the blue mantle and red shoes of the Virgin, the colors of the rainbow, or the colors of the factions of the hippodrome—blues, greens, whites, and reds, to name a few. There were also taboos in the improper use of colors, as is suggested by Nicholas Mesarites in his description of the Church of the Holy Apostles in Constantinople. Christ's garments set an example of modesty in their coloration:

The robe of the God-Man is colored more with blue than with gold, warning all by the hand of the painter not to wear brilliant clothing or to seek purple and linen and scarlet and hyacinth, or to go dressed in luxurious robes. . . .[44]

The colors of luxurious robes are to be worn knowingly, as signs of conspicuous consumption. In all these examples we continue to see a palette of bright colors, similar to those encountered repeatedly, from architectural sculpture to ivories.

Not only were colors part of a hierarchy connoting relative status, but they were regarded as imbuing any object, image, or building with a spiritually transcendent quality. A profusion of colors, or colors juxtaposed with one another or with gold, became essential to the Byzantine aesthetic.[45] For example, John of Damascus (c. 750) defines the transformative role of color and asserts the primacy of sight over hearing because of the perception of colors:

The first sense is that of sight. The sense organs or media of sight are the nerves leading from the brain and the eyes. Fundamentally, it is the visual impression of color that is received, but along with the color the sight distinguishes the colored body, also; its size and shape, the place where it is and the intervening distance . . . (*De fide orthodoxia* II, chap. 18).[46]

Or, as Liz James has expressed it more directly in a study of color: "Colour in Byzantium is a crucial element in giving an image meaning."[47]

In the Middle Byzantine period during the artistically brilliant period of the tenth century commonly referred to as the "Macedonian Renaissance," we read of renewed reliance on colors and their symbolic values. For just as church doctrine of the post-iconoclastic period stressed the importance of images, it correspondingly relied on colors to make up the forms of holy images. One has only to look at the mosaics of Hosios Loukas with their monumental figures and scenes seemingly suspended before backgrounds

of glittering gold tesserae. Mosaic compositions achieved their effect through an optical blending of colors of individual tesserae when seen at a distance.[48] The art of mosaic is a celebration of color with the power to communicate divine truth.[49]

The patriarch Photius in his sermons of the 860s describes the spiritually uplifting effect of polychrome mosaics. In his tenth homily, on the church of the Virgin of the Pharos, the chapel of the imperial palace of the emperors in Constantinople, the forms and colors constitute a transcendent mode of expression:

On the very ceiling is painted in coloured mosaic cubes a manlike figure bearing the traits of Christ. Thou mightest say He is overseeing the earth, and devising its orderly arrangement and government, so accurately has the painter been inspired to represent, though only in forms and in colours, the Creator's care for us.[50]

Through vision, color, according to Photius, facilitates the viewer's spiritual union with Christ. Evoking the splendid polychrome impression made by the church and its decoration, he then suggests that the mosaic pavement of the church is even superior to the work of the ancient masters:

The rest of the church, as much of it as gold has not overspread or silver covered, is adorned with many-hued marble, a surpassingly fair work. The pavement, which has been fashioned into the forms of animals and other shapes by means of variegated tesserae, exhibits the marvellous skill of the craftsman, so that the famous Pheidias and Parrhasius and Praxiteles and Zeuxis are proved in truth to have been mere children in their art and makers of figments. Democritus would have said, I think, on

seeing the minute work of the pavement and taking it as a piece of evidence, that his atoms were close to being discovered here actually impinging on the sight.[51]

He even refers to the atom theory of Democritus, the first Greek philosopher to attempt a theory of color.[52] Although formulaic, these statements indicate Photius's awareness of the ancient tradition of colored imagery claiming the power to transcend reality. The idea is similarly expressed in the seventeenth homily on the image of the Virgin in the apse of Hagia Sophia. As Photius describes the image he recapitulates the Byzantine theory of images:

To such an extent have the lips been made flesh by the colours, that they appear merely to be pressed together and stilled as in the mysteries. . . . Just as speech is transmitted by hearing, so a form through sight is imprinted upon the tablets of the soul. . . .[53]

The artistry of creating such images is not so much in the craftsmanship of laying mosaic tesserae as in manipulating the colors. The effect combines church dogma with aesthetics:

For, having mingled the bloom of colours with religious truth, and by means of both having in holy manner fashioned unto herself a holy beauty[54]

The definition of the Byzantine aesthetic would be incomplete without color, by which the transcendent ideals of Orthodoxy are expressed in a visually harmonious scheme.

Color is celebrated throughout the epic poem written down sometime in the eleventh or twelfth century, *Digenes Akrites*.[55] This story of love, battles, heroic exploits, and exotic luxury takes place largely on the Arab frontiers of the Byzantine

empire. It constantly appeals to the visual imagination of the reader and is filled with vivid descriptions of material surroundings, attributes, and possessions. Although following conventions, these descriptions evoke objects and persons as not only colorful but as gleaming, bright, or shining, just as we have noted in the ancient Homeric poems. Colors described are bright and saturated, as they contribute to creating an impression of richness. In her assessment of color in *Digenes Akrites,* Liz James identifies clear links between the use of color terms in antiquity and eleventh-century Byzantium.[56]

In Nicholas Mesarites' poem on the church of the Holy Apostles, written around 1200, he describes the beauty of the church as being made up of qualities perceptible through sight as color and through mind as geometry:

For it fills the sight in the beauty of its colors and with the golden glimmer of its mosaics; it strikes the intelligence through its surprising size and skillful construction (XIII.2).[57]

According to Mesarites, the harmonies produced by a combination of diverse colors echoed those of nature; with the addition of gleaming gold mosaics (*psephidon chrusizonti*) a synthesis between earthly and heavenly splendor was made perceptible to the human mind. Mesarites' ekphrasis turns "listeners into spectators" and also reveals the culture's contemporary attitudes and associations with color. The interior of the church is called the "Dome of Heaven" because it is the dwelling place of Christ, and Christ is described in terms of light: "since the Sun of Justice shines in it, the light which is above light, the Lord of Light, Christ. . . ."[58] Byzantine literary sources are rich in allusions to color that suggest color is not defined extensively in terms of its hue, but

with regard to both brilliance and saturation. The resulting perception of color goes beyond the classical color scale and awareness of light and dark/black and white elements. In Byzantium, color is an "element in the definition of being."[59]

Color in the Arts and the Symbolic Importance of Color

Color is fundamental not only to Byzantine material culture, but to the Byzantine mind and imagination. For example, the techniques used by mosaicists create illusions of modeling in a medium comprised of individual cubes of color. In this art, the importance of complementary colors as well as of colors having planned equal intensity or contrasting intensity, color chains, and sequences all become apparent.[60] In her study James deals not only with creation of imagery but with vision. In mosaics, for example, we detect juxtapositions of metallic and matte surfaces. The less modeled and more abstract handling of color is combined with an awareness of color and its properties when colors are mixed; the basic scheme of colors—red, blue, green, and yellow—remains the visual basis for the Byzantine system.

The emphasis on color found in the cited literary descriptions of famous buildings and their decoration is paralleled in the many preserved Byzantine art objects in museums and libraries around the world. Enamels combine fields of color and gold in an effect similar to that of mosaics, but enamels are more intimate, with their skillful use of tiny gold wires or cloisons to separate fields of colored glass. This art, ultimately derived from the jeweler's craft in antiquity, developed by the tenth century in Byzantium into an art of sumptuous display, mainly in the service of the Church. Works such as the Pala

d'Oro, the chalices of emperors, icons, and book covers now preserved in the treasury of San Marco in Venice are representative of this technique and aesthetic.[61] If we compare individual panels of the Pala d'Oro with ivory panels that belonged to diptychs or triptychs, not only is their size comparable, but also the use of gilding and bright shades of blue, red, and green. Figures and festival and gospel scenes are isolated against plain gold backgrounds, and they often stand under openwork canopies, as we have seen in a group of case studies in chapter 1 (see figs. 10–12).[62] The use of inset jewels, pearls, or stones (which occasionally occurs in ivories) is a common feature of enamelwork.[63] The shared aesthetic between enamels and ivories is apparent when the issue of color is recognized as relevant to the comparison. There is no conflict, as some scholars claim, between works made out of colored materials and painted ivories.[64] This attitude reflects a mechanistic view of how artists worked and does not take into account the principles governing the appearance of the finished product. In the case of ivories whose surfaces were entirely gilded with colors applied over the gold, there seems a deliberate attempt to rival the effect of gold enameling. For example, the Harbaville Triptych in the Louvre had traces of gilding on all surfaces, including the faces and hands of Christ and the Virgin Mary (see chapter 1, p. 19). An analogous treatment in enamel is the tenth-century icon of St. Michael in the Treasury of San Marco whose gold repoussé hands and face amid intricately worked rinceau background, cloisonné wings in shades of blue and green, and inset jewels (and formerly, pearls) give an impression of otherworldly splendor.[65]

An analogous case of multiplied or saturated values is apparent in the legendary description of the altar of Haghia Sophia in the *Narratio de S. Sophia*, chapter 17:

Wishing to make the altar table much costlier than gold, he called in many specialists and told them so. They said to him: Let us place in a smelting-furnace gold, silver, various precious stones, pearls and mother of pearl, copper, electrum, lead, iron, tin, glass and every other metallic substance. Having ground all of these in mortars and bound them up, they poured them into the smelting-furnace. After the fire had kneaded together these [substances], the craftsmen removed them from the fire and poured them into a mould, and so the altar-table was cast, a priceless mixture. . . .Who can behold the appearance of the altar-table without being amazed? Who indeed can comprehend it as it changes color and brilliance, sometimes appearing to be gold, at other places silver, another gleaming with sapphire—in a word, reflecting seventy-two hues according to the nature of the stones, pearls and all the metals?[66]

In the altar, as in the Harbaville Triptych and the St. Michael icon, different kinds of value are brought together in a single object: intrinsic, aesthetic, and symbolic.

Like mosaics and enamels, illuminated manuscripts strove for bright jewel-like colors, obtained at great expense. In Byzantine manuscripts, backgrounds of figural scenes or iconic images, when they are not painted in illusionistic styles, are regularly a single color, like blue or gold.[67] The abstraction of backgrounds, especially in manuscript illuminations, with fields of gold leaf, are clearly linked to mosaics, enamels, and painted icons with their predominantly gold grounds. Many ivories have either gold or blue backgrounds. In the case of the Joshua panels at the Metropolitan Museum, which were

part of our initial study, frames were red, backgrounds were blue; figures were done in red, blue, and green, and halos in gold. A comparable manuscript page is in a Menologium for the First Half of January, Mount Sinai, Cod. 512, dated c. 1055–56.[68] Here the saints appear in three oblong horizontal registers; their robes are in a variety of colors, backgrounds are bright blue, and frames red; halos and accents on borders of robes are gold.

Ivories also share an aesthetic with other media, such as Byzantine textiles. These combined the bright colors of silk threads with metallic gold threads, sometimes in pictorial scenes in medallions juxtaposing bright colors like red and green.[69] Still other media such as icons and steatites are also comparable in their use of bright colors and gold. Steatites were treated like ivories in their decoration, which regularly consisted of gilding and of painting with colors, although this important aspect of the art form has been both neglected and misunderstood by scholars.[70] The coloration of all these media is in harmony with that of painted ivory, all incorporate substances of high intrinsic value, and all were highly prized in Byzantine culture. Ivories were no exception and can now be seen as fully connected with the other arts that were synonymous with luxury, sophistication, and imperial taste.

To the Byzantines, the value of these various media—mosaics, enamels, illuminated manuscripts, painted icons, textiles—lay not only in their rare and precious materials but in the artistry with which they combined colors to produce the most striking visual effect. The belief that color was materialized light lay behind the constant juxtapositions of saturated colors and defined the basic principles of the Byzantine aesthetic.

Light gleaming or shining or glistening, the property of color most admired by the ancients, produces a mystical effect in which physical and theological illumination merge. The color of an object was just as significant as its medium because of the high intrinsic and spiritual value of color. Overlaying already precious materials, like gold or ivory, with symbolically rich and precious colors, like enamel, jewels, and expensive pigments, produced an object even more valuable than the sum of its parts.

Although we lack contemporary technical descriptions of Byzantine ivories, we can gauge that ivory was more prized for its rarity and its properties as a medium for fine carving than for its beautiful grain and whiteness when newly carved. As a raw material, ivory's whiteness was proverbial, but as an art form, it consistently conformed to the dominant aesthetic of the culture. As in the other media discussed above, it was the brightly painted and metallic colors that dazzled the eye, along with the knowledge of its rarity and costliness, that gave ivories their place among the arts. Color was not an end in itself, a mere form of decoration, but an essential expressive device that gave enhanced value and meaning to any crafted object.

The Symbolic Meaning of Color on Ivory

The qualities writers have admired, of light gleaming and reflecting from surfaces, surely applied to painted ivories, whose surfaces could shine only if they were treated with wax over colored portions and polished, as in the ancient technique of *ganosis*. The frequent application of gold would have left the colored portions lusterless in comparison, so we must assume a final stage in the process of painting ivories of oiling

or waxing and polishing. In dyed ivories, the same must have applied, except that the grain of the ivory would have been visible through the polished coating. By examining ancient techniques of coloring, staining, polishing, and gilding, we arrive at a visualization of how colored ivories actually looked, and why they could look only that way. Without applied color, they would have been anomalies within their culture.

In Byzantium as in antiquity, ivory is associated with other precious materials as well as with kingly or imperial power, and its symbolic context links it with the highest ideals of beauty. Adding layers of other precious materials in the form of costly pigments only enhanced the value of an already powerful symbol. Hence the rationale behind the layering of colors over the gold leaf on ivories, noted in chapter 1. Different kinds of value packed together in a single object resulted in a saturation of value. Just as Paul the Silentiary equated ivory with precious metals, Middle Byzantine ceremonial gave insignia alternatively of precious metals, colored silk, or colored ivory. The logic behind Byzantine colored ivories lies in its ancient antecedents. The strength and continuity of tradition was among the various messages and symbols carried in layers like the pigments on painted ivory. The symbolic aesthetic of color in Byzantium required that an object be as colorful as possible to be

beautiful. Furthermore, according to the dominant aesthetic within Byzantium, color was part of a system of multiple values that included not only what was visible on the surface, but what existed in layers underneath the surface: what you knew was there. With this in mind, one sees artistic output, including painted ivory, in a different way.

In a study of Renaissance painting Marcia Hall stresses the basis for the choice of unmixed colors according to Cennini's system. She notes the aesthetic preference of the Cennini-style painters for a brilliance of color like that of stained glass or manuscript illumination; the medieval tradition out of which all these had come condemned "corrupted" color (mixed or broken) precisely because it was less brilliant.[71] It would have been unthinkable to a painter in the medieval tradition who wanted to be associated with the best in quality and taste to leave reserved areas or use dull colors for his commission. The taste for brilliance inherited by Cennini had been shared by the Byzantines, and by the ancients before them. The color system used in the trecento represented the world in glowing colors and shining gold, for these were seen as the vehicle toward representing the transcendent. Then, with the Renaissance and the discovery of linear perspective, everything changed.[72]

Conclusion *Shifting the Paradigm*

 In this book I have demonstrated how one might utilize an awareness of the presence of color on Byzantine ivories to shape our understanding of not only the medium of carved ivory, but also the art produced by this civilization, and even the culture itself. For the implications of colored ivory have reverberations that encourage us to see the ancient and medieval world in some new ways. The survival of numerous examples of this exquisite and fascinating art form in museums throughout the world insures that Byzantine ivories will continue to be the subject of debates and research. Now that polychromy has become part of our definition and visualization of ivory as it originally appeared, it remains to analyze further examples, seeing them fully as they are. Whenever possible, color schemes need to be reconstructed. In this way the medium can gradually be integrated into a picture of Byzantine artistic production of wider scope than formerly. At least, the art form will not continue to be isolated as it has been in the past but will be envisioned as sharing the dominant aesthetic of Byzantine art. One could even say that ivories represent the quintessential case of saturated value and brilliance characteristic of the output of Byzantium, a combination of intrinsic and optical values that result in heightened symbolic and spiritual meaning.

The method used in this study follows the interdisciplinary approach needed to interpret any aspect of classical or Byzantine culture. The inquiry started as a search for explanations of why the Byzantines would have colored such a beautiful and costly substance as ivory, and it developed into a broader study. The question has been examined here from a variety of perspectives and points of view. A quantitative analysis of the evidence of ivory's appearance through the eye of the microscope—with its gleam of gold and patches of bright red, green, and blue—was followed by a probe into the makeup of pigments, identified through laboratory testing. Even without these analyses, the accumulated visual and textual evidence points to the conclusion that ivories were originally colored. Archaeologically excavated pieces indicate patterns and techniques of coloring ivory, from Egyptian tombs to the ruined palaces at Nimrud. Passages in ancient authors shed intriguing light on the use and connotations of ivory in the ancient world. The conservative Byzantines, however, not only preserved ancient traditions of craftsmanship, but added their own ceremonially rich connotations to established practices, such as the presentation of purple-dyed ivory insignia to titled functionaries at the imperial court. High status was recognized and given its due in part through the heightened symbolic use of colored ivory.

The connection between the importance of color within Byzantine culture and the treatment of ivory permits us to draw together several threads of our research into a revised assessment of ivory. It is impossible to say at this juncture that all ivories were painted and gilded, or how much of the surface might have been left the natural color of ivory, or to what degree the surface was polished before or after coloring. Nevertheless, without overstating the case, the new and newly interpreted information presented here, combined with a study of contextual evidence, suggest that in Byzantium ivory was regularly painted and was seen as a richly colored medium.[1] Within the value system of Byzantium and the ancient world, value was cumulative. Layers of precious substances produced a still more precious result than the sum of the parts. Hence the rationale for packing every kind of value possible into any given object. Color, if interpreted as materialized light, played a symbolic as well as an intrinsic role in this layering process and provided access to the divine. To paint with precious pigments or gold on any substance was to multiply its value, thereby rendering an object not just costly but holy or transcendent. While it is entirely possible that ivories were occasionally repainted after they left Byzantium, as we have seen in the case of the St. Petersburg Forty Martyrs Triptych, the coloration of the group studied here is too consistent and the appearance of the remaining traces too similar to suppose that this was the result of many individual decisions to give the art form colors it did not have previously. The case, like the rationale, for original coloring is now clear-cut, and the question of when ivories received their initial coloring is no longer a matter for debate.

The Byzantine love of bright, saturated colors can be amply demonstrated. The Byzantine aesthetic governed all the colorful objects we associate with Byzantium, from large-scale monumental sculpture to the frescoes and mosaics on the walls of churches and palaces, to polychrome marbles, silk textiles, illuminated manuscripts, painted icons, and enamels—and ivory was no exception. We have explicitly related patterns of coloration on ivories to those of other media. Byzantium sought out colored materials and created webs or layers of colors wherever possible,

in accordance with this aesthetic. If a medium was not naturally polychrome, it would be rendered so under this system; it would be combined with precious objects and metals, to obtain the most colorful and brilliant effect. Even pure gold was inlaid or overlaid with fields of color. The function of these overlays of value was to indicate status in response to the needs of a society where status differentiation counted. To sponsor the making of an object, or a church program, that utilized brightly colored and shining materials was an enhancement of status, whether imperial, aristocratic, or local. The language of materials and colors was well understood in Byzantium.

The Byzantines—or *Romaioi,* as they preferred to be called—saw themselves as direct heirs of the Greco-Roman past, itself the product of Egyptian and other great Near Eastern cultures. Many of the working methods were probably retained, more or less as in antiquity, in a conscious desire to emulate that tradition. But the Byzantines in actuality extended this aspect of the past to encompass more subtle, complicated, and theologically and philosophically interconnected concepts of art. The coloring of ivory through various means is only one aspect of the persistence of ancient traditions—and the development of a distinctly medieval one in Byzantium. The work of scholars on color perception and symbolism makes it clear that this system applied to all created aspects of the physical world in Byzantium, and that the precious material of ivory, just like any other medium, would only be enhanced by color.[2]

Polychrome art forms were characteristic of Byzantine taste as they had been of ancient Egyptian, Near Eastern, Greek, and Roman taste. The case for polychrome Greek sculpture has been built only comparatively recently. As one scholar recently stated: "color was not a topic to be pushed into the category of style, iconography or the place of art in society; we now recognize color as an essential element in the understanding of all of these."[3] The color system discussed in this book did not favor pastel or dull colors but more often bright ones; we all know the effect of a color of lower intensity juxtaposed with a bright one. Through colors it was possible to create a system of balance and harmony. The Byzantines were thoroughly aware of this and had such a system very much under control. Every color was seen in relation to other colors. There was no such thing as the isolated form; all were subject to a system, and bright, saturated colors were at its core.

Although now pale reflections of their former appearance, Byzantine ivories represent a great challenge to our modern perception and imagination. We can expect to encounter other such revisions in seeing periodically, as analytical methods are put to use in new ways.[4] Can we visualize ivories as they were intended to be seen? If we do so we reintegrate them into their artistic and cultural context; we regain their full meaning along with a glimpse of their lost predecessors, in the long line of creations going back to the chryselephantine works and beyond, to the luxuries enjoyed by pharaohs.

The evidence of color on ivory, combined with a better understanding of its meaning, necessitates a paradigm change, for the notion of predominantly monochrome ivories has proved to be at odds with the culture that produced them.[5] The utility of this revisionist claim lies partly in a shift of awareness to a lost reality, but we gain in the process a better understanding of the aesthetic framework to which ivory belonged within Byzantine culture. We even sense the power of small ivory objects to reflect the nature, if not the soul, of a great civilization.

*Appendix A: Ivories
Project Database*

Ivories Project Database
28 July 1993

	Index Number	Type	Period	Date	Red	Gold	Blue	Green	Bl./Br.	Other
Metropolitan Museum of Art, New York:										
1. Joshua Panels	17.190.135-137	Pl	B		lc	lc	lc	lc,st	br st	bl ec
2. Diptych of Justinian	17.190.53	Cd	LA		cr,lc				rs-is	
3. Putti & Animals Casket	17.190.235	Ck	B			lc				
4. Myth & Warrior (bone) Casket	17.190.237	Ck	B	10-11						
5. Putti & Warriors Casket	17.190.239	Ck	B			lc				
6. Beheading of Hazor	17.190.140	Pl	B		lc			cr		or
7. Koimesis Panel	17.190.132	Pl	B	?	sp	lc	lc	ec,st,cr		
8. Deesis & 12 Apostles Casket	17.190.238	Ck	B	11-12	lc	lc	lc			
9. Wing of Triptych, Frag.	980.294	Tr	B			fl,lc				
10. Adam & Eve working	17.190.139	Pl	B		is					
11. Adam & Eve harvesting	17.190.138	Pl	B		is,fk			fk		
12. Deesis Plaque	17.190.133	Pl	B			fl	bu-bl	lc		
13. Hodegetria Statuette	17.190.103	Pl	B		cr		lc		rs	
14. Crucifixion Plaque	17.190.44	Pl	B		lc	lc	lc	lc		
15. Pyxis	17.190.34	Py	LA		lc	lc		lc		
16. Pyxis	17.190.57	Py	LA							
17. Apostle Paul	41.100.156	Fr	LA		fk	fl	fk			
18. St. Demetrius Plaque	1970.324.3	Pl	B		lc			lc		
Walters Art Gallery, Baltimore:										
19. Casket	71.115	Ck	B		cr	lc	fk	cr		
20. Genesis Casket	3869/71.295	Ck	B	11-12	is	lc	bu-gn fl			
21. Sorrowing Adam	3866	Pl	B	12	is,lc	fl	fl	fk		
22. Warriors & Putti Casket	71.298	Ck	B	11-12			bu-gn			
Liverpool Museum, Liverpool:										
23. Hygieia Leaf	M.10044	Di	LA	5	fl,st	lc		cr		or-rd
24. Asclepius Leaf	M.10044	Di	LA	5	cr,st	fk	fl			or-rd
25. Crucifixion Triptych	M.8065	Tr	B	10	st	lc	lc-eyes			pk st
26. Crucifixion & Nativity	MayerN.35/GW215	Pl	B	11		lc				
27. Crucifixion Plaque	MayerN.32/GW172	Pl	B	10		lc	lc			

	Index Number	Type	Period	Date	Red	Gold	Blue	Green	Bl./Br.	Other
28. St. John the Baptist	M.8014	Pl	B	10	is					
29. Venatio	M.10042	Cd	LA	5		lc	lc	fk		
30. Bone Box		Bx	LA							
31. Diptych of Clementinus	M.10036	Cd	LA	6						
Fitzwilliam Museum, Cambridge:										
32. Throne Panel #1	M.10-194	Fr	LA	6	lc,cr	lc	l-bu		mt	rd-or
33. Throne Panel #2	M211-1904	Fr	LA	6	lc,cr	lc	fk			yw fl
34. Griffins & Lions Casket (bone)	M.18-1904	Ck	B	12	fk	lc				
35. Crucifixion	GW26/McClean 38	Pl	B	10-11	lc	fl				
36. Christ Blessing Panel	M.13-1904	Pl	B	10	lc	fl				
British Museum, London:										
37. Nativity Panel	Dalton 19/GW5	Pl	B		lc,rs	fl		lc		pk st
38. Vision of Ezekiel	Dalton 18	Pl	B		rs			lc		tk ec
39. Panel from Casket	Dalton 16	Ck	B							
40. Panel, Apotheosis of Romulus	M&LA 57,10-13,1	Cd	LA		lc	lc		lc,st		
Victoria and Albert Museum, London:										
41. Veroli Casket	216-1865	Ck	B		lc	lc	lc	lc	bl ec	
42. Symmachorum Panel	212-1865	Di	LA	4-5		lc		lc	bl ec	wh rs
43. Joshua Plaque	265,67	Pl	B		lc	lc	fk	lc,st	bl ec	
Dumbarton Oaks Byzantine Collection, Washington, D.C.:										
44. Triptych wing, Constantine VII	47.11	Pl	B		cr	foil,fk	lc	cr		d rs
45. Plaque, Archangel Gabriel	72.21	Pl	B		cr			fk		h rs
46. Leaf, Imperial Di	37.18	Di	B		rd-pk	fl	lc	st lc,cr		fa-bu,am rs
47. Diptych of Philoxenus	35.4	Di	LA			fl	ec	cr		pk st
48. Pyxis, Moses & Daniel scenes	36.22	Py	LA	5-6	lc,gr	Ld	lc			l-bu
49. Plaque, Nativity	51.30	Pl	LA-B	7-8	st			cr		br-rd,st,ec
50. Triptych Panel, Descent from Cross	52.12	Pl	B	10	sp?	lc,fk	cr	fl		l-gr
51. Plaque, Incredulity of Thomas	37.7	Pl	B		cr,gr	fk	rs	cr		pk-rd
52. Triptych Panel, Dormition	37.5	Pl	B		cr			ec		pk,or

am = amber; B = Byzantine; bl = black; br = brown; bu = blue; Bx = box; Cd = consular diptych; Ck = casket; cr = crystal(s); d = dark; Di = diptych; ec = encrustation; fa = faience; fk = flake(s); fl = flake(s); Fr = furniture; Fg = figurine; gd = gold; gn = green; gr = ground; h = heavy; is = inscription; l = light; LA = Late Antiquity; lc = localized; Ld = lid; mt = metallic; or = orange; pk = pink; Pl = plaque; Py = pyxis; rs = residue; Sc = scepter; sp = spot(s); st = stain; tk = thick; Tr = triptych; wh = white; wx = waxy; yw = yellow

	Index Number	Type	Period	Date	Red	Gold	Blue	Green	Bl./Br.	Other
53. Lid of Box, Tyche	47.8	Bx	LA	4–5			cr	fk		mt rs
54. Plaque, Warrior	52.11	Pl	B	10			bu-gn lc			
55. Statuette, Ares	38.63	Fg	LA	4–5	pk-rd cr		rs			
56. Box Lid, Hygieia	48.15	Ld	LA	6		fl?	l-bu			
Museum für Spätantike und Byzantinische Kunst, Berlin/Dahlem:										
57. Scepter of Leo VI	2006	Sc	B	9–10	lc,st	fl	bu-gn cr	cr		
58. Panel, Forty Martyrs	574	Pl	B	10	lc,is	lc	lc-gr	lc		pk-rd st
59. Raising of Lazarus	578	Pl	B	10	fl,cr	fk,gr	fl,cr	st		yw rs
60. Entry into Jerusalem	1590	Pl	B	10	cr,lc	lc gr	bu-gn cr	d, cr		yw cr
61. Berlin Pyxis	563	Py	LA	5	lc					pk-rd st
62. Pyxis, Marian Scenes	585	Py	LA	5–6	lc					wh rs
Musée de Cluny, Paris:										
63. Panel, Diptych of Areobindus	13135	Cd	LA	6	lc,cr	fl		cr	rd-br cr	rs is; ec eyes
64. Nicomachorum Panel	Cl.17048	Di	LA	4–5	cr,st	fl		cr,lc	rd-br-cr	rd-pk cr
65. Mythological Casket (bone)	Cl.13075	Ck	B	11–12	lc	lc		cr,lc		
66. Pyxis	Cl.444	Py	LA	6	lc			cr,lc	rd-br	rs
67. Panel, Otto & Theophano	Cl.392	Pl	B	10	lc,is	lc		cr		
Cabinet des Médailles, Paris:										
68. Panel, Romanus & Eudocia	300	Pl	B	10	lc,cr		bu-gn cr	cr		d-rs-is
69. Diptych of Anastasius	55, no. 296 bis	Cd	LA	6	cr,st		lc	lc,cr		wh rs
70. Panel, Diptych of Sividius		Cd	LA	5	cr,st		cr	cr		wx rs
71. Crucifixion Triptych	4651	Tr	B	10	lc,cr,is	leaf	cr	lc,cr		pk
72. Diptych of Philoxenus w/ medallions		Cd	LA	6	lc	fl	cr	cr	st	
73. Diptych of Philoxenus	3264	Cd	LA	6	cr,lc		cr	cr		pk frame
74. Panel, Diptych of Magnus	3267	Cd	LA	6	cr			st overall		pk
75. Panel, Diptych of Justinian	3263	Cd	LA	6	cr	lc	cr	st,cr		bu-gn
76. Panel, Diptych of Felix	41	Cd	LA	5	st	fl	fk	cr		wh rs
77. Thiasos & Apollo	E.2686	Pl	LA	6	cr		lc			or,yw,pk
Musée du Louvre, Paris:										
78. Wing of Triptych, St. Theodore	OA3620	Pl	B	10	is,lc	lc		lc	st	

	Index Number	Type	Period	Date	Red	Gold	Blue	Green	Bl./Br.	Other
79. Harbaville Triptych	OA3247	Tr	B	10	lc	lc-gr	cr	cr		
80. Putti & Warriors Casket	OA7503	Ck	B	10	lc	lc				
81. Plaques from a Casket	OA1329-1130	Pl	B	10	lc,cr		lc,cr	cr,lc	st	
82. Nativity Triptych	OA5004	Tr	B	10	lc	fl	cr	cr	bl eyes	wh rs
Hermitage Museum, St. Petersburg:										
83. Plaque, Angel	260	Pl	B	11	cr	lc				
84. Triptych, Forty Martyrs	299	Tr	B	10	pk	lc	lc	cr		wh rs
85. Panel, Deposition	266	Pl	B	10				lc		wh rs
86. Panel, Dormition	24	Pl	B	10				bu-gn rs; l-gn		
87. Panel, Virgin & Child Hodegetria, standing	3K III 102	Pl	B	10					br sp	
88. Plaque, Four Saints	14	Pl	B	10	cr					
89. Triptych		Tr	B	11	cr	lc	cr	cr		
90. Triptych wing, St. John Baptist	303	Tr	B	11	cr	lc				
91. Panel, Virgin		Pl	B			lc				rs
92. Virgin & Child, statuette from Plaque		Pl	B	10	rose cr					
93. Panel, Crucifixion	26	Pl	B	10	cr	lc		cr		
94. Panels, Annunciation & Visitation	300;301	Pl	B	6-7		lc			br st-gr	
95. Diptych, Twelve Feasts	13	Di	B	10-11	lc	lc	lc,cr	cr,rs		
96. Plaques, saints & angels	186	Tr	B	10		lc		gr-gd		
97. Panel, Diptych of Areobindus	12	Cd	LA	6	or-rd,st					
98. Plaque, Tragedy scenes	15	Pl	LA	6	pk,cry	lc				
99. Jonah Story	6	Py	LA	6	pk				cc	
100. Joseph Story	8	Py	LA	6	st				cc	rs

am = amber; B = Byzantine; bl = black; br = brown; bu = blue; Bx = box; Cd = consular diptych; Ck = casket; cr = crystal(s); d = dark; Di = diptych; cc = encrustation; fa = faience; fk = flake(s); fl = fleck(s); Fr = furniture; Fg = figurine; gd = gold; gn = green; gr = ground; h = heavy; is = inscription; l = light; LA = Late Antiquity; lc = localized; Ld = lid; mt = metallic; or = orange; pk = pink; Pl = plaque; Py = pyxis; rs = residue; Sc = scepter; sp = spot(s); st = stain; tk = thick; Tr = triptych; wh = white; wx = waxy; yw = yellow

Appendix B: Diagrams of Joshua Ivories

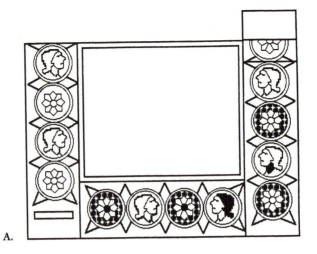

A.

☐ Missing

■ Traces of gold

▦ Traces of red & blue & gold

B.

☐ Missing

▨ Traces of red

▧ Traces of red & gold

A–C. Suppliants from Gibeon before Joshua (17.190.137)

Pigment samples

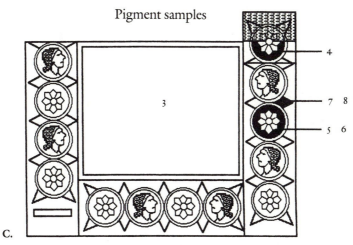

C.

3 Green from robe of bending figure (Box 10, Stub 2 #III)

4 Green from rosette (Box 10, Stub 2 #4)

5 Blue from rosette (Box 10, Stub 3 #I)

6 Red from rosette (Box 10, Stub 3 #II)

7 Green from vegetal decoration (Box 10, Stub 3 #III)

8 Green from vegetal decoration (Box 10, Stub 3 #IV)

D.

☐ Missing

■ Traces of green pigment and/or green staining

D–F. Ambush of Soldiers of Ai by the Israelites (17.190.135)

E.

	Missing
	Traces of gold
	Traces of red & blue & gold

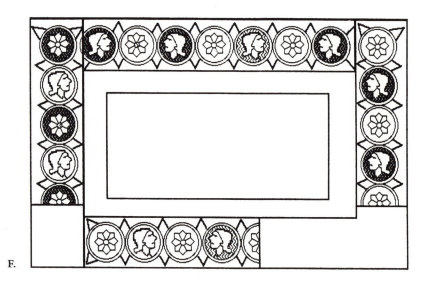

F.

	Missing
	Traces of red
	Traces of red & gold

Notes

List of Abbreviations

AB *Art Bulletin*

AJA *American Journal of Archaeology*

BCH *Bulletin de Correspondance Hellénique*

CR *Classical Review*

DOP *Dumbarton Oaks Papers*

JHS *Journal of Hellenic Studies*

LSJ H. G. Liddell, R. Scott, and H. S. Jones, *A Greek-English Lexicon*. 9th edition. Oxford: Oxford University Press, 1973.

ODB *Oxford Dictionary of Byzantium*. 3 vols. Ed. A. Kazhdan et al. New York: Oxford University Press, 1991.

Pauly-Wissowa *Paulys Real-Enclopädie der classischen Altertumswissenschaft,* herausgegeben von Georg Wissowa. Stuttgart: J. B. Metzlerscher Verlag, 1984.

SCon *Studies in Conservation*

Abbreviations for names of classical authors and their works follow the standard forms listed at the beginning of *The Oxford Classical Dictionary,* ed. N.G.L. Hamond and H. H. Scullard, 2d ed. (Oxford: Clarendon Press, 1970).

Introduction

1. See, for example, W. Maskell, *Ivories: Ancient and Medieval* (London: Chapman and Hall, 1875), who attributes the painting of ivory to current tastes which "run in opposition to the old," and who defends the practice as relating to contemporary usage: "it by no means follows that such a mixture [of art forms] is necessarily false in taste; rather it must be left to the judgment and decision of the time and of the country for which the sculptures are made" (105).

2. Alfred O. Maskell, *Ivories* (1905; repr., Rutland, Vt., 1966), was one of the first to deal comprehensively with the history of objects of carved ivory. Although he dedicates considerable attention to ancient and medieval ivories, including Late Antique and Byzantine examples, especially those in British collections, he makes only brief mention of the subject of "colouring and staining" near the end of the book, relating the visible color on Gothic ivory statuettes to a decorative principle detected in all cultures. Although he recognized the frequency with which ivory was painted, he feared the results might be garish: "The great test is the reserve, discrimination, and restraint, which are of importance to preserve it from the suspicion of vulgarity . . ." (492–93). The same unease is evident in O. M. Dalton's *Catalogue of the Ivory Carvings of the Christian Era in the British Museum* (London: British Museum, 1909), in which he discusses the practice of painting and staining ivory carvings in the Middle Ages: "The ivory carvings of the Middle Ages, when they left the hands of the artists, presented a totally different appearance from that with which we are now familiar. . . . The texture of the ivory was largely concealed by painting and gilding; instead of a single subdued tone there was an almost disquieting brilliance of colour" (xlix). He assumes

that Early Christian and Byzantine ivories, as a sub-category of medieval ivories, were included in this practice.

3. Richard Delbrueck, *Die Consulardiptychen und verwandte Denkmäler* (Leipzig and Berlin: W. de Gruyter, 1929) is the standard work on ivory consular diptychs. The great catalogues of Byzantine ivories on which all scholars of Byzantine art rely were published by Adolf Goldschmidt and Kurt Weitzmann in the 1930s: *Die byzantinischen Elfenbeinskulpturen des X.–XIII. Jahrhunderts,* vol. 1, *Kästen;* vol. 2, *Reliefs* (Berlin: B. Cassirer, 1930–34); in these works, instances of color are sometimes noted, but there is little discussion of their implications.

4. W. F. Volbach, *Elfenbeinarbeiten der Spätantike und des frühen Mittelalters* (Mainz: Verlag des Römisch-Germanischen Zentralmuseums, 1952), does not mention polychromy in the 260 catalogue entries, even when its presence is evident in his photo illustrations; see, for example, cat. no. 52 on page 38, and pl. 13. More recently, the beautiful volume on the ivories in the Walters Art Gallery in Baltimore, R. H. Randall Jr., *Masterpieces of Ivory from the Walters Art Gallery* (New York: Hudson Hills Press, 1985), with 37 color plates, takes note of polychrome wax inlay evident on some Coptic examples and offers an essay describing polychromy on several Gothic ivories but never deals with the subject on ancient or Byzantine pieces.

5. A. Cutler, *The Craft of Ivory: Sources, Techniques, and Uses in the Mediterranean World: A.D. 200–1400* (Washington, D.C.: Dumbarton Oaks, 1985); gilding is mentioned in the case of a rosette casket with the following comment: "Thus in their original state the boxes at Dumbarton Oaks (and other collections) would have been much gaudier than is suggested by the chaste uniformity of hue that they present to the museum visitor today," but the author states: "Late antique and Byzantine ivories were not originally painted" (50).

6. Ibid., 50.

7. A. Cutler, in *The Hand of the Master: Craftsmanship, Ivory, and Society in Byzantium (9th–11th Centuries)* (Princeton: Princeton University Press, 1994), revises his views somewhat but still expresses skepticism about color:

> Were the traces still visible coeval with the plaques to which they attach? (144).

It follows that not only autopsy but propinquity is a necessary condition for the proper reading of carved ivory. If this is a truism, its implications for both the medium and scholars who write its history have not always been grasped. Just as every gram of an ivory is an integral part of its overall mass, so—if I may use the concept of weight in a figurative sense—all details of a plaque's cutting and carving are relevant to its assessment. And it is precisely these subtleties that are lost, more often than not, when an ivory is studied from afar or even in photographs of its entirety (35–36).

The Glory of Byzantium: Art and Culture of the Middle Byzantine Era, A.D. 843–1261, exh. cat., Metropolitan Museum of Art (New York: Metropolitan Museum of Art and Harry N. Abrams, 1997) is an illustration of the current division in the field on the issue of polychromy on ivories, as a glance at the numerous entries on ivories would show; sometimes obvious polychromy is completely ignored. The exhibition catalogue appeared while this book was in production, and so I am unable to cite all references to ivories that are discussed in both.

8. Cutler, *Hand of the Master,* 146.

9. Commenting on two similar ivories with iconic renderings of the Forty Martyrs, one in St. Petersburg and one in Berlin, Cutler questions whether the abundant blue pigment on the St. Petersburg piece could be original. He notes that "color on the similar plaque in Berlin has been tactfully removed"

(ibid., 146). The problem of surviving color still exists for Cutler: "In other cases the age of the paint is unlikely to be determined until such traces of pigment have been physically or chemically analyzed, and even then there will remain the problem of interpreting the polychromy in terms of period taste." The problem of taste and adjustments to suit current tastes is indeed important. O. M. Dalton, *Ivory Carvings,* suggests that to avoid the unpleasant irregular effect of wear, color was deliberately removed (li). W. Maskell, *Ivories,* notes that plaster casts of most ivories were made in the 19th century (109). This practice must have further removed any traces of color. An ivory casket on display in the exhibit "The Glory of Byzantium" (March–July 1997) was cleaned to remove its polychromy just prior to the exhibition (see *Glory of Byzantium,* cat. no. 78, p. 131).

10. A representative sampling of ivories of different types and of various periods from major museums resulted, by chance, in the round figure of one hundred.

11. See *Iliad* 4.142–47 and the discussion in chapter 4.

12. G.M.A. Richter, "Polychromy in Greek Sculpture," *AJA* 48 (1944): 321–33.

13. See Elizabeth C. Parker and Charles T. Little, *The Cloisters Cross: Its Art and Meaning* (New York: Metropolitan Museum of Art, 1994), 26–27. The morse ivory of this intricately carved cross was colored, with red and blue in the backgrounds of figures and scenes and green and red used to enhance decorative dots. The pigments were determined by scientific analysis, and since they were known to be available to the Romanesque artist, are thought to be part of the original decoration (28).

14. See Dany Sandron, "La sculpture en ivoire au début du XIIIe siècle, d'un monde à l'autre," *Revue de l'art* 102 (1993): 48–59; see especially the study of polychromy by Agnès Cascio and Juliette Levy on 54–59, in which coloration appears as a partial treatment. A new book by Peter Barnet, *Images in Ivory: Precious Objects of the Gothic Age,* exh. cat. (Princeton:

Princeton University Press, 1997), includes an essay by Danielle Gaborit-Chopin on "Polychrome Decoration of Gothic Ivories."

Chapter 1

1. Cat. nos. 17.190.135–37; see Goldschmidt and Weitzmann, *Kästen,* 23–24, nos. 1–3, and pl. I. For a discussion of the Joshua plaques see C. L. Connor, "New Perspectives on Byzantine Ivories," *Gesta* 30 (1991): 100–111.

2. See Goldschmidt and Weitzmann, *Kästen,* 23–24.

3. The photo was taken using a macro lens, with a 20-second exposure at f.3.5 while sweeping a UV lamp back and forth several inches above the surface of the ivory.

4. Photo by Mark Wypyski, Department of Objects Conservation, Metropolitan Museum of Art.

5. Cutler, *Craft of Ivory,* 24. The capture of Egypt by Muslims in the 7th century and subsequent closing off of trade routes to Zanzibar and India led to an increasing scarcity of African and Asiatic ivory. Practically no examples of ivory carving remain to attest to the survival of the art in this period and during Iconoclasm. Although there was a resurgence of ivory carving in the Middle Byzantine period, pieces are thinner and generally of smaller dimensions than those of the early period (54). On the availability of ivory see also A. MacGregor, *Bone, Antler, Ivory, and Horn: The Technology of Skeletal Materials since the Roman Period* (Beckenham, Kent: Barnes and Noble, 1985), 38–40.

6. See, for example, P. Williamson and L. Webster, "The Coloured Decoration of Anglo-Saxon Ivory Carvings," in *Early Medieval Wall Painting and Painted Sculpture in England,* ed. S. Cather, D. Park, and P. Williamson, B.A.R. British Series 216 (London: B.A.R., 1990), 177–94.

7. See A. O. Maskell, *Ivories,* 109.

8. Acc. no. M10044. Margaret Gibson, *The Liverpool Ivories: Late Antique and Medieval Ivory and Bone*

Carving in Liverpool Museum and the Walker Art Gallery (London: HMSO, 1994), 10–15. Also see Del-brueck, *Die Consulardiptychen*, 217–18. The representations of Asclepius and Hygieia are thought to be modeled on Hellenistic cult statues standing in temples in Rome.

9. See D. Kinney, "A Late Antique Ivory Plaque and Modern Response," and A. Cutler, "*Suspicio* Symmachorum: A Postscript," *AJA* 98 (1994): 457–80.

10. See J.-P. Caillet, *L'antiquité classique, le haut moyen age et Byzance au Musée de Cluny* (Paris: Ministère de la Culture, Editions de la Réunion des Musées Nationaux, 1985), no. 48, 104–7 and col. pl. on page 18. The two leaves were separated sometime between 1790 and 1860 (p. 104).

11. Kinney and Cutler (see note 9 above), 475: according to Cutler, the difference in the color of the two leaves, one being deep brown and the other lighter in color, can be explained by the fact that "ivory being highly hygroscopic, absorbs salts and other minerals from any liquids with which it comes in contact. The deep brown of the Nicomachi leaf is scarcely surprising in view of its long subterranean residence."

12. *Byzance: L'art byzantin dans les collections publiques françaises,* Musée du Louvre (Paris: Editions de la Réunion des Musées Nationaux, 1992), 54–56, no. 15 (inv. 55, no. 296 bis).

13. See *Byzance*, no. 168 and pages 258–59, where the casket is described as "pourpré." My observation was made from outside the case; I was not able to examine this piece under the microscope.

14. See *Byzance*, no. 148 and pages 232–33.

15. For a study of the Romanus Ivory see I. Kalavrezou-Maxeiner, "Eudokia Makrembolitissa and the Romanos Ivory," *DOP* 31 (1977): 307–20.

16. The color plate in A. Bank, *Byzantine Art in the Collections of Soviet Museums* (Leningrad: Aurora Art Publishers, 1985), pl. 122, actually shows the red pigment clearly enough, but this is another instance where one sees it only if one is looking for it, for there is no mention in the catalogue entry of color.

17. See A. Effenberger and H.-G. Severin, *Das Museum für Spätantike und Byzantinische Kunst Berlin* (Mainz: Verlag Philipp von Zabern, 1992), no. 122, col. pls. pp. 210–11.

18. The actual chamber of the royal palace in which the child of imperial parents was born was called the *porphyra* after the porphyry stone of which it was built. See Anna Comnena, *The Alexiad,* trans. E.R.A. Sewter (New York: Penguin, 1979), 17, note 2, and 219, note 5.

19. See *Byzance*, no. 160, 247–49.

20. For a study of rosette caskets based on the examples preserved at the Metropolitan Museum, see Connor, "New Perspectives."

21. For examples, see ibid., p. 100 and figs. 4, 5.

22. See John Beckwith, *The Veroli Casket* (London: HMSO, 1962).

23. See *Byzance*, no. 155A and B, 242–43.

24. See *Byzance*, no. 149, 233–36.

25. The catalogue description notes: "Elfenbein mit kleinen Resten von Bemalung" (Effenberger and Severin, *Berlin*, no. 124, 214–15).

26. *Byzance*, no. 154, 241.

27. Inv. 17.190.132. Goldschmidt and Weitzmann, *Reliefs*, no. 234, pl. LXXIV; this ivory is the twin of a piece in Munich, Staatsbibliothek Cod. Lat 4453, Cim 58.

28. See K. Weitzmann, *Catalogue of the Byzantine and Early Medieval Antiquities in the Dumbarton Oaks Collection,* vol. 3, *Ivories and Steatites* (Washington, D.C.: Dumbarton Oaks, 1972), 2.

Chapter 2

1. See *Munsell Book of Color: Matte Finish Collection* (Baltimore: Munsell Color, 1976): "Standard Method of Specifying Color by the Munsell System," N.A., American Society for Testing and Materials: Designation: D 1535–68, fig. 2, in Addendum. The Munsell scale shows the five primary and five secondary hues arranged in circular fashion, starting with Red in the twelve o'clock position, proceeding clockwise with Yellow-Red, Yellow, Green-Yellow,

Green, Blue-Green, Blue, Purple-Blue, Purple, and Red-Purple, abbreviated as the first letter of each color or color combination. In a standard chart, each of these hues (H) is indicated by a 5, as in 5R, while intermediary hues are 10s, as for example a shade between red and yellow-red would be coded 10R. A correlated set of notations for each Hue is Value (V), or the lightness or darkness of a color in relation to neutral gray; the scale extends from pure black to pure white, with 0/ referring to pure black and 10/ to pure white; 5/ signifies colors that are halfway in value between black and white. Third, the Chroma (C) notation indicates the saturation or departure of the hue from a neutral gray, with neutral gray having 0 (zero) saturation. This scale extends from /0, for a chroma equivalent to neutral gray, to /14, which is strong and bright. Any color can thus be defined according to a three-part symbol: H/V/C.

2. While not absolutely infallible, this system was the best that could be devised under the circumstances. Conditions varied greatly from museum to museum, but the constant was the focused lighting of the area under the microscope, and thus of the traces of colors I was observing. For the difficulties others have encountered and the range of solutions, see Nigel Strudwick, "An Objective Colour-Measuring System for the Recording of Egyptian Tomb Paintings," *Journal of Egyptian Archaeology* 77 (1991): 43–56, esp. 44–45. The traces of colors I was observing were too small for the use of a colorimeter.

3. The catalogue numbers of these ivories are: Joshua Plaques and borders: Metropolitan Museum of Art acc. no. 17.190.135–37; Oppenheim Casket: Metropolitan Museum of Art acc. no. 17.190.238; Forty Martyrs Triptych: Hermitage cat. no. 299. The red, blue, and gold polychromy evident in plate XV, a photograph taken in 1988 of the Oppenheim Casket, has been removed. The cleaned ivory was in the exhibition at the Metropolitan Museum of Art, "The Glory of Byzantium." In the catalogue of this exhibit, the entry on this ivory by the curator, Charles T. Little, explains the decision: "Until this exhibition, the casket was covered with red and blue polychromy.

However, the area under the lock plate shows no evidence of polychromy, which indicates the casket was never intended to have color." Note 1 further states: "The casket has been restored to its original unpainted state by Pete Dandridge, Conservator, Objects Conservation, The Metropolitan Museum of Art." See *Glory of Byzantium,* cat. no. 78, p. 131. The stated reasons for removing the polychromy require further consideration and will be addressed in a separate publication.

4. See Rutherford J. Gettens, Robert L. Feller, and W. T. Chase, "Vermilion and Cinnabar," *SCon* 17 (1972): 50–53, and Daniel V. Thompson Jr., "Artificial Vermilion in the Middle Ages," *Technical Studies in the Field of the Fine Arts* 2 (1933): 62–71.

5. Daniel V. Thompson, *The Materials of Medieval Painting* (London: George Allen and Unwin Ltd., 1936), 104.

6. From the report by Diana Harvey under the supervision of Pete Dandridge, in a letter dated 22 August 1990.

7. From the report by Mark Wypyski dated 17 July 1990. For the difficulties in distinguishing among the green pigments see H. Kühn, "Verdigris and Copper Resinate," in *SCon* 15 (1970): 12–36, esp. 13.

8. The sampling of the blues in the background of the scene of the Forty Martyrs by a conservator at the Hermitage in St. Petersburg was made possible by Mme. Vera Zalesskaya, Curator of the Oriental Collections.

9. From the report by Mark Wypyski dated 20 June 1994.

10. Four Armenian manuscripts of the 10th through 12th centuries at San Lazzaro, Venice, were pigment-tested with the results showing some of the same pigments and metal as detected on the ivories under discussion: ultramarine blue, vermilion, and gold; see T. F. Mathews and M. V. Orna, "Four Manuscripts at San Lazzaro, Venice," *Revue des Etudes Arméniennes* 23 (1992): 525–50.

11. Works which were especially useful on the classifications, definitions, and properties of pigments are Selim Augusti, *I colori pompeiani* (Rome:

De Luca, 1967) and Thompson, *Materials.* Recent studies of pigments which provide useful parallels for our efforts to define pigments on ivories and their properties are: Francesca Ronca, "Protein Determination in Polychromed Stone Sculptures, Stuccoes, and Gesso Grounds," *SCon* 39 (1994): 107–20; and David A. Scott and William D. Hyder, "A Study of Some Californian Indian Rock Art Pigments," *SCon* 38 (1993): 155–73.

12. See Thompson, *Materials,* 85–86.

13. Theophrastus, *De lapidibus*: see *Theophrastus On Stones,* Introduction, Greek text, English translation, and commentary, by E. R. Caley and J.F.C. Richards (Columbus: Ohio State University, 1956). See also Gettens, Feller, and Chase, "Vermilion," 45–69, esp. 46; there were also deposits in the Altai Mountains and in Russian Turkestan (46).

14. Another name, "Indian cinnabar," was mistakenly given to "the gore of a snake crushed by the weight of dying elephants, when the blood of each animal gets mixed together"; this was considered an ideal red to represent blood in a picture (*N.H.* 33.38).

15. For comparative values of other pigments referred to in Pliny, see Augusti, *Colori pompeiani,* 147–49. Cinnabar was damaged by the action of sunlight and was therefore first applied to a surface and then coated with hot wax and polished to retain its bright scarlet color (*N.H.* 33.41).

16. Thompson, *Materials,* 102–3.

17. See *The Greek Herbal of Dioscorides, Illustrated by a Byzantine A.D. 512, Englished by John Goodyer A.D. 1655, Edited and First Printed A.D. 1933,* by R. T. Gunther (Oxford: Hafner, 1934), 637–38; for the Greek, *Pedanii Dioscuridis Anazarbei, De Materia Medica, Libri Quinque,* ed. Max Wellmann, vol. 3 (Berlin: Henrici Stephani, 1958), 5.94.

18. Vitruvius further notes that the workshops which were in the Ephesian mines were moved to Rome because the ore had been discovered in Spain; the workshops for refining the ore were located between the temples of Flora and Quirinus (*De. arch.* 7.9.4.).

19. Gettens, Feller, and Chase, "Vermilion," 47; see also Thompson, "Artificial Vermilion," 62–70, esp. 63.

20. Since the earliest text describing its manufacture was derived from a Greek source, the invention may have been known in Hellenistic times; it is also surmised that it was derived from Syrian, Arabic, or Byzantine alchemy (Thompson, *Materials,* 104).

21. Gettens, Feller, and Chase, "Vermilion," 62.

22. See Theophilus, *De Diversis Artibus: The Various Arts,* trans. C. R. Dodwell (London: Thomas Nelson and Sons, 1961), especially the chapter "De cenobrio," which describes the process of making dry-process vermilion. See also Cennino d'Andrea Cennini, *The Craftsman's Handbook: The Italian "Il libro dell' arte,"* trans. D. V. Thompson Jr. (New York: Dover, 1933); esp. for the materials for the preparation of pigments, see 21–22. For the original Italian text see *Cennino d'Andrea Cennini da colle di Val d'Elsa: Il libro dell'arte,* ed. D. V. Thompson Jr. (New Haven: F. Le Monnier, 1932), 21–23.

23. Theophilus: *De Diversis Artibus.* Although scholars disagree on his dates, there is good reason to assign his work to the years between 1110 and 1140 (see xxxiii). Theophilus calls vermilion "cenobrium," and describes how to obtain various shades of rose by mixing it with other elements (1.4.7, 14 or 16); this would be appropriate for a more illusionistic style painting. For staining wood red, he suggests grinding vermilion or red lead with linseed oil and applying the solution with a brush (1.20).

24. The preparation of cinnabar is similarly described in *The "Painter's Manual" of Dionysius of Fourna,* trans. P. Hetherington (1981; repr. Redondo Beach, Cal.: Oakwood Publications, 1989), 11, as a blend of mercury, sulfur, and "mourtasangki," presumably quicksilver.

25. Cennini, *Craftsman's Handbook,* 24.

26. According to Thompson:

given abundant vermilion, the standard to intensity in the painter's palette automatically rises.

Equally brilliant blues and greens and yellows were required to go with it. The classic earth colors would no longer serve alone. Beautiful, precious, and esteemed in itself, vermilion required a proper setting of other pigments (Thompson, *Materials,* 106–7).

27. Lapis, from the Latin word for stone, and lazulus, a Latinized form of the Persian term for blue, was also used as a semiprecious stone from early Egyptian times and for cut and polished stones in jewelry and furniture. See also R. Gettens and G. Stout, *Painting Materials* (New York: D. Van Nostrand Co., 1942), 163–67, on natural and artificial ultramarine blue.

28. These quarries were described by Marco Polo in connection with his journey of 1271; see J. Plesters, "Ultramarine Blue, Natural and Artificial," *SCon* 11 (1966): 62–91, esp. 63.

29. Thompson, *Materials,* 145–46. Dioscurides records its use as a medicine. If taken internally, "the sapphire stone [lapis lazuli] is thought to be good for ye scorpion-smitten being drank" (*De mat. med.* 5.157).

30. *De arch.* 7.9.6. Lapis lazuli was also called "caeruleum Scythicum," as distinct from other blues: see Augusti, *Colori Pompeiani,* 66–68.

31. Plesters, "Ultramarine," See also R. J. Gettens, "Lapis Lazuli and Ultramarine in Ancient Times," *Alumni* 19 (1950): 342–57.

32. A. Epstein, *Tokalı Kilise* (Washington, D.C.: Dumbarton Oaks, 1986), 23, 29.

33. Ultramarine is more common in Byzantine manuscript illumination of this time than in monumental painting (ibid. 23).

34. Ibid. 147–48. See also Cennini, *Craftsman's Handbook,* where he writes "On the character of ultramarine blue and how to make it," 36–39.

35. Thompson, *Materials,* 149–50.

36. Cennini, *Craftman's Handbook,* 36.

37. *De arch.* 7.9.6.

38. *De. arch.* 7.14.2

39. *De mat. med.* 5.194.

40. See Kühn, "Verdigris and Copper Resinate" (note 7 above), 12–36, esp. 12–13.

41. *De arch.* 7.12.1.

42. *De div. art.* 1.35,36. The *Painter's Manual* refers to a similar process and calls it verdigris or "tzing-kiari" (p. 11).

43. Cennini, *Craftsman's Handbook,* 31–32 (chapter LI).

44. Ibid., 31–32.

45. Ibid., 33.

46. Thompson, *Materials,* 162–63.

47. Cennini, *The Craftsman's Handbook,* 30.

48. Thompson, *Materials,* 194–95.

49. Cennini, *The Craftsman's Handbook,* 96–98.

50. M. P. Merrifield, *Original Treatises on the Arts of Painting* (New York: Dover Publications, 1967), 192. The corresponding reference in Theophilus is given as E. Ed., p. 404.

51. *De div. art.* 1.23.

52. Cennini, *Craftsman's Handbook,* 97.

53. Theophilus echoes the same sentiment concerning the materials for painting in his introduction to *De diversis artibus* but adds a practical note: that if cheaper ways are learned for acquiring materials, the materials should not be prized less.

54. *De div. art.* 4.

55. The *Painter's Manual* is probably an 18th-century version of an earlier Byzantine instruction book on technical and iconographical aspects of Byzantine painting; it incorporates methods and materials used in post-Byzantine times along with very old traditions, and would on the whole complicate our assessment of specific pigments used in Middle Byzantine painting. However, the handbook undoubtedly belongs to the same genre of treatises that we have been consulting in this section and is extremely valuable as the only surviving Byzantine painting manual. See esp. 4–16 on instructions for painting.

56. Cinnabar and malachite were among the pigments found in the Athenian Agora, indicating that

two of the same pigments were used in antiquity as in the Byzantine ivories that were pigment-tested; see E. R. Caley, "Ancient Greek Pigments from the Agora," *Hesperia* 14 (1945): 152–55, esp. 153; on ancient pigments see also Marie Farnsworth, "Ancient Pigments, Particularly Second Century B.C. Pigments from Corinth," *Journal of Chemical Education* 28 (1951): 72–76.

57. On Tyrian purple see K. McLaren, *The Colour Science of Dyes and Pigments* (Bristol: A. Hilger, 1983), 9–11. An inquiry into the chemical makeup of purple dye and its possible detection on ivories is a study that should be undertaken; see also Patrick E. Mc-Govern, "A Dye For Gods and Kings," *Archaeology* 43 (1990): 33, 76.

Chapter 3

1. See Richard D. Barnett, *Ancient Ivories in the Middle East,* QEDEM Monographs (Jerusalem: Institute of Archaeology of the Hebrew University of Jerusalem, 1982), 53–55: "We can see that in 1912, when Poulsen produced his fundamental work on early Greek art and the Orient, scholars had absolutely no idea of the true size, varieties and importance of the ancient trade in ivory and the ivory-worker's art, except perhaps for some conception of its role in Egypt" (53).

2. According to Barnett, *Ancient Ivories:*

It is impossible to speak without excitement of the enormous importance of Mallowan's and Oates's discoveries at Nimrud and of their impact on the history of Near Eastern art and of ivory carving. As Mallowan himself writes, "The ivories recovered from Nimrud amount to tens of thousands of fragments, in addition to many hundreds of larger pieces" (54).

For Petrie's discoveries at Abydos and elsewhere in Egypt see 18ff.

3. Ibid., 55.

4. Recent finds in Europe and Russia show that 40,000 years ago Cro-Magnons developed technological innovations for working ivory solely for purposes of personal adornment. See Randall White, "The Dawn of Adornment," *Natural History* 102 (1993): 60–67. I am indebted to Michael Godfrey for bringing this article to my attention. Beads and bracelets were found in burials on human skeletons at the Russian site of Sungir; the ivory beads were strung alternating with animal teeth, but the bracelets had been scored and painted. An ivory pendant of an animal from the same site was colored with red ocher, and rows of drill holes were filled with black manganese (64). While tools and weapons were made of other substances, personal ornaments were often of ivory and were painted. Much later, around 17,000 B.C.E., cave peoples engraved mastodon and other types of ivory, bone, and teeth with lifelike sketches of animals, similar in silhouette to the paintings at Lascaux and Les Eyzies in southern France. Although their function is unclear, carved ivory seems to have shared in the early origins of human artistic creativity (see A. O. Maskell, *Ivories,* 41–52).

5. African tusks were larger than Asiatic ones, and also harder and denser; they could be 10 feet long and weigh up to 220 pounds, although the average was 80 pounds. Heavier tusks were from the forested areas closest to the equator, while long, thin ones came from areas of savanna. East coast ones were pale, light yellow, and slightly transparent; they did not darken with age as did those from the west coast. See N. J. Beihoff, *Ivory Sculpture through the Ages* (Milwaukee: Milwaukee Public Museum, 1961), 19–20. See also Irene J. Winter, "Ivory Carving," in *Ebla to Damascus: Art and Archaeology of Ancient Syria,* ed. Harvey Weiss (Washington, D.C.: Smithsonian Institution Traveling Exhibition Service, 1985), 339–46, esp. 340; and Cutler, *Craft of Ivory,* 22–29, on the yield in Asian vs. African ivory tusks.

6. Ibid., 16.

7. Ibid., 18.

8. Ibid., 15.

9. Ibid., 10–11.

10. Ibid., 19 and notes 51, 52–56.

11. See P. Fox, *Tutankhamun's Treasure* (London: Oxford University Press, 1951), casket (cat. nos. 540, 551) in pls. 64, 65; *Treasures of Tutankhamun,* exh. cat., Metropolitan Museum of Art (New York: Metropolitan Museum of Art, 1976), for color plates.

12. Barnett, *Ancient Ivories,* 21 and pl. 6c, d.

13. Cat. no. 26.7.1293; for a color photograph see *The Metropolitan Museum of Art Guide,* ed. K. Howard (New York: Metropolitan Museum of Art, 1985), 101.

14. See Randall, *Masterpieces,* 46–47, col. pl. 10, and 48–49, col. pl. 15.

15. See *Ivory: The Sumptuous Art,* exh. cat., Walters Art Gallery (Baltimore: Walters Art Gallery, 1983), 9. See also Winter, in *Ebla to Damascus,* 339–46.

16. See J. Perrot, "Statuettes en ivoire et autres objets en ivoire et en os provenant des gisements préhistoriques de la région de Béersheba," *Syria* 36 (1959): 8–19, see esp. figs. 3–6.

17. See Winter, in *Ebla to Damascus,* 341 and fig. 65.

18. See ibid., 341–5 and cat. nos. 171–77. See also an ivory plaque from Arslantash, on display in the Metropolitan Museum in New York (cat. no. 1957.57.80.4) on which sphinxes, hair of figures, and ornamental elements are gilded.

19. Ibid., 346.

20. Barnett, *Ancient Ivories,* 46. The precise origins of this style are still open to debate.

21. Winter, in *Ebla to Damascus,* 346.

22. See B. Bourgeois, "An Approach to Anatolian Techniques of Ivory Carving during the Second Millennium B.C." in *Ivory in Greece and the Eastern Mediterranean from the Bronze Age to the Hellenistic Period,* ed. J. L. Fitton, *British Museum Occasional Papers* 85 (London: British Museum, 1992), 61–66.

23. See P. O. Harper, "Dating a Group of Ivories From Anatolia," *Connoisseur* 172 (1969): 156–62. See also Randall, *Masterpieces,* col. pl. 16 and pp. 36–39.

24. For a study of the chemical properties of ivory, including changes in its composton on burning, see Hugh Taylor, "Mycenae 1939–1954: Part VII. Chemical Investigations on Ivory," *Annual of the British School at Athens* 50 (1955): 248–50; see esp. 249 for the red color on the Pratt ivories.

25. Bourgeois, "Anatolian Techniques," 64.

26. See H. C. Güterbock, "Ivory in Hittite Texts," *Anadolu* 15 (1971): 1–7.

27. Ibid., 7.

28. Bourgeois, "Anatolian Techniques," 64–65.

29. See Sir Arthur Evans, *The Palace of Minos at Knossos,* vol. 3 (London: Macmillan and Co., 1930), 428–35 and supplementary plate XXXVIII.

30. Ibid., 429–31. A similar figure, about 25 cm tall, of a female with arms raised could have belonged to such a group: see *Art Treasures from the Royal Ontario Museum,* ed. T.J.A. Heinrich (Toronto: McClelland and Stewart, 1963).

31. Evans, *Knossos,* 442 and fig. 306 and the discussion on 436–56.

32. See Randall, *Masterpieces,* col. pl. 19 (cat. no. 56).

33. See O. Dickens, *The Aegean Bronze Age* (Cambridge: Cambridge University Press, 1994), 173.

34. See Barnett, *Ancient Ivories,* pls. 28c and 32a; see also J.-C. Poursat, *Catalogue des ivoires mycéniens du Musée National d'Athènes* (Paris: Ecole française d'Athènes, Boccard, 1977), nos. 47 and 48, pl. IV.

35. Barnett, *Ancient Ivories,* 36 and note 13. See also M. Ventris, "Mycenaean Furniture on the Pylos Tablets," *Eranos* 53 (1955): 109–24, esp. 111–12. Ivory is referred to as used for inlay (117), carved into decorative lions' heads (112), carved elements of ebony chairs and footstools: "1 ebony chair with ivory back carved with a pair of finials and with a man's figure and heifers; 1 footstool, ebony inlaid with ivory pomegranates" (119), and employed in several "'headless', ivory-topped tables" (119).

36. See K. Demakopoulou and D. Konsola, *Archaeological Museum of Thebes* (Athens: General Direction of Antiquities and Restoration, 1981), 54 and pl. 25; the legs were excavated in the "Arsenal," a Mycenaean palace at Thebes dated to the 15th–14th century B.C.E.

37. See J.-C. Poursat, *Les ivoires mycéniens: essai sur la formation d'un art mycénien* (Paris: Ecole française d'Athènes, Boccard, 1977), 47–48, for example: "Remarquons simplement qu'il s'agit là de couleurs largement utilisées dans l'art des fresques, et que ce procédé peut établir un lien entre cet art et celui des ivoires" (p. 48). See also 212–16 on the relationship between ivories and frescoes, including coloration on carved relief in ivories (216).

38. See, for example, polychromy on the Nimrud ivories from Fort Shalmaneser on display in the Metropolitan Museum: openwork plaque (cat. no. 1960.60.145.6) has blue inlay; a chair back (1959.59.107.1) has red inlay; a plaque (1961.61.197.10) has red and blue glass inlay in cloisonné technique; a large (6″ high) female head (1954.54.117.2) has extensive inlay in eyebrows, pupils of eyes, necklace; a panel of a woman wearing a headdress (1962.62.269.2) is heavily encrusted with blue. For an account of the discovery of the largest group of ivories, see M.E.I. Mallowan, "Ivories of Unsurpassed Magnificence—The Finest and Largest from the Ancient Near East—Discovered in This Season's Excavations at Nimrud," *The Illustrated London News,* Aug. 16, 1952, 254–56.

39. Barnett, *Ancient Ivories,* 44–55.

40. Ibid., 47.

41. See R. D. Barnett, *A Catalogue of the Nimrud Ivories in the British Museum* (London: British Museum, 1957), 175–76 and pl. VI.

42. Ibid., 177, cat. no. C.50. Barnett cites this technical anomaly but has no explanation; he states, however, that "the practice was continued in late antiquity on consular diptychs. . . . The technique of staining with purple was also familiar to Homer who describes it as an Anatolian practice" (p. 156). See also 156–57 for cloisonné technique, with inlays mostly in glass, and also painting of ornaments, eyes and brows, and patterns in clothing.

43. Barnett, *Ancient Ivories,* pl. 46 a, b; cf. André Parrot, *Arts of Assyria* (New York: Golden Press, 1961), 150 and col. pl. 185. See in addition: Barnett, *Ancient Ivories,* 62; also Mallowan, "Ivories of Unsur-

passed Magnificence" (see above note 38), esp. 255, fig. 13: a large (10.5 cm tall) ivory head of a woman, of "fine-grained brown ivory" with inlaid eyes, eyebrows, and gold necklace, was part of a composite figure. The finds date between 880 and 612 B.C.E.

44. Barnett, *Ancient Ivories,* pl. 46c.

45. Ibid. 47. For a catalogue, see Barnett, *Nimrud Ivories.*

46. Barnett, *Nimrud Ivories,* 190; for a color plate, see frontispiece.

47. See M. Mallowan and G. Herrmann, *Furniture From SW.7 Fort Shalmaneser* (London: British School of Archaeology in Iraq, 1974), 57–61; see also V. Karageorghis, *Salamis in Cyprus* (London: Thames and Hudson, 1969), and V. Karageorghis, "Die Elfenbein-Throne von Salamis, Zypern," in *Archaeologia Homerica: Die Denkmäler und das Frühgriechische Epos,* vol. 2, ed. S. Laser, Hausrat (Göttingen: Vandenhoeck and Ruprecht, 1968), 100–103. See also Barnett, *Ancient Ivories,* 49.

48. Mallowan and Herrmann, *Furniture,* 60.

49. See P. Amandry, "Statuette d'ivoire d'un dompteur de lion découverte à Delphes," *Syria* 24 (1944–45): 149–74, esp. 154. See also for further comparisons with the Delphi statuette, R. D. Barnett, "Early Greek and Oriental Ivories," *Journal of Hellenic Studies* 68 (1948): 1–25, esp. 17 and pl. XIIa–d.

50. D. G. Hogarth, *Excavations at Ephesus: The Archaic Artemisia* (London: British Museum, 1908); see especially chap. 9, "The Ivory Statuettes," by Cecil Smith, 155–98, pls. XXI–XLII.

51. See Hogarth, *Archaic Artemisia,* 171: "the uneven discolouration of some pieces suggests that parts of the surface were better protected than others; it is likely that the liquid mud which caused this discolouration in the ivory may have destroyed the traces of surface color." On 186 he states: "A great many of these objects are stained green, in some cases probably through the accidental proximity of oxidized bronze. . . . But in certain cases the green colour is obviously due to intentional tinting. Other pieces are stained brown or black." See, for example, the nude statuette, no. 7. A color photograph of one

of the green stained statuettes appears in E. Lessing and W. Oberleitner, *Ephesos: Weltstadt der Antike* (Vienna: Ueberreuter, 1978), pl. 99.

52. Lessing and Oberleitner, *Ephesos,* 4, 6 and pl. IIIc. See also H. Payne and T. J. Dunbabin, *Perachora: The Sanctuaries of Hera Akraia and Limenia,* vol. 2, (Oxford: Clarendon Press, 1962), 406 and pl. 173a–e.

53. See Barnett, "Early Greek and Oriental Ivories" (note 49 above), 18 and fig. 20 for a comparable head from Sardis dating to the 6th century, suggesting the type had Ionian origins. See also N. Stampolidis, "Four Ivory Heads from the Geometric/Archaic Cemetery at Eleutherna," in *Ivory in Greece and the Eastern Mediterranean from the Bronze Age to the Hellenistic Period,* 141–61, pls. 1 and 2, who describes inlaid eyes and red lips: "On the lips of E2 were traces of a reddish pigment at the time of excavation, though these have since faded" (142).

54. Minoan examples of ivory statuettes with gold ornament have also been called precursors of the chryselephantine statues.

55. P. Amandry, "Rapport préliminaire sur les statues chryséléphantines de Delphes," *BCH* 63 (1939): 86–119, esp. pls. XIX–XXXIV and figs. 7–9. See also *Guide de Delphes: Le Musée* (Paris: École française d'Athènes, Édition de Boccard, 1991), 206–19.

56. Amandry, "Rapport préliminaire," 98–99; cf. *Guide de Delphes,* 218: the three large heads are thought to belong to a triad of divinities, Apollo attended by his mother Leto and sister Artemis.

57. Amandry, "Rapport préliminaire," 116.

58. Ibid., 100–106.

59. Ibid., pls. XXXV, XXXVI; Barnett, *Ancient Ivories,* 60, pl. 63a–d, and Randall, *Masterpieces,* col. pl. 25.

60. See *Guide de Delphes,* 220–23 and figs. 37, 38: the subjects of these delicate *à jour* reliefs have been identified as the Boreades and Harpies, departure of a warrior, Calydonian boar hunt and a combat between Greeks and Amazons. Jane Burr Carter has suggested they were attached to a chest because they fit Pausanias's description of the chest of Cypselus at Olympia; she posits a Spartan artist: see "The Chests of Periander," *AJA* 93 (1989): 355–78.

61. Rare surviving fragments of a chryselephantine statue of the classical period are represented by a head and forearm in the Vatican Museum. Excavated in 1824, it is thought that they belonged to a statue of Athena 1.55 m tall. According to Albizzati, the features were highlighted by polychromy: "The lips were covered with cinnabar, the eyebrows were also painted; the eyes wrought in hard stone or enamel and the eyeball held in position by the stucco and by the lids; the conjunctive membrane was also painted." See C. Albizzati, "Two Ivory Fragments of a Statue of Athena," *JHS* 36 (1916): 373–402. He notes that the ivory would have cost not much less than the gold for these works (399). See also T. L. Shear, "The Campaign of 1936," *Hesperia* 6 (1937): 348–52, for an extraordinary figure of solid ivory representing a nude male that was excavated from a well in the vicinity of the Theseion in the Athenian Agora; this figure, 30 cm tall, survived in the mud, albeit in fragments, and has been reassembled. It is thought to reproduce a statue by Praxiteles of Apollo Lykeios. There is no trace of polychromy recorded.

62. See W. Schiering, *Die Werkstatt des Pheidias in Olympia,* vol. 2, *Werkstattfunde* (New York and Berlin: De Gruyter, 1991), 92–129, 159–60, 138–39, 145–46, 166–68. The pigments have been analyzed, with the following results: the blue is Egyptian Blue; yellow is kaolin; white is calcite; red is pure hematite and calcite mixed with hematite; rose is diluted calcite: See Wolf-Dieter Heilmeyer, "Antikewerkstättenfunde in Griechenland," *Archäologische Anzeiger* (1981): 440–53.

63. *Greek Gold: Jewelry of the Classical World,* ed. D. Williams and J. Ogden (New York: Harry N. Abrams, 1994).

64. See, for example, a sheet-gold decoration for a sword scabbard (ibid., cat. no. 112), or a bracelet with stags and griffins (cat. no. 86), or the rosettes or necklace pendants (cat. nos. 14, 15).

65. See, for example, ibid., cat. nos. 15, 18, 22, 76, and 87, just to name a few.

66. See M. Andronicos, *Vergina: The Royal Tombs* (Athens: Ekdotike Athenon, 1984), 122–33 for the couch, and 134–37 for the shield. For a vivid description of the discoveries, the large number of ivory objects in the tomb, and the sheer quantities of brightly colored objects and surfaces, see M. Andronicos, "Vergina: The Royal Graves in the Great Tumulus," *Archaiologika Analekta Ex Athenon* 10 (1977): 40–72.

67. For more on couch ornaments, see Dorothy Kent Hill, "Ivory Ornaments of Hellenistic Couches," *Hesperia* 32 (1963): 292–300.

68. After the sack of Gordion early in the 7th century, ivory craftsmen may have migrated from Phrygia and Lydia to Etruria in central Italy: See Barnett, *Ancient Ivories*, 61; this theory is based in part on the introduction of a Lydian letter into the Etruscan alphabet at this time.

69. Acc. no. 63.18; see S. S. Weinberg, "Etruscan Bone Mirror Handles," *Muse: Annual of the Museum of Art and Archaeology, University of Missouri-Columbia* 9 (1975): 25–33 and col. pl. front cover. I am indebted to Nancy DeGrummond for bringing this article to my attention.

70. Ibid., 25. Y. Huls mentions traces of color on Etruscan ivories in *Ivoires d'Etrurie* (Brussels and Rome: Palais des Académies, 1957), 77, 79, 81, 85, mostly red, sometimes blue, brown, and gilding, but does not discuss this feature of the pieces.

71. See Buitron, in *Ivory: The Sumptuous Art*, 15.

72. Randall, *Masterpieces*, 54–114, see esp. nos. 118, 134, 135, 152, 153 and col. pls. 43, 44.

73. Delbrueck, *Die Consulardiptychen*, 10–12.

74. Ibid., 21. Some diptychs were partly or completely colored purple, and traces of gold are recorded on many; black occurs on hair, in the pupils of the eyes, and sometimes the principal inscription was painted red. For an example in Trieste that retains almost all of its coloration, including red and blue backgrounds and gold on clothing of figures, see 21 and note 41.

75. See Delbrueck, *Die Consulardiptychen*, 230–32 and fig. 1 on p. 231; for a color plate of this *venatio*

diptych see Bank, *Byzantine Art*, col. pl. 30.

76. Delbrueck, *Die Consulardiptychen*, 191: the Barberini Diptych has a surviving inset pearl in the trappings of the horse and topazes in the diadem of the emperor, but clearly many more inset stones once were present. For a color plate of this piece see *Byzance*, 65.

77. Delbrueck, *Die Consulardiptychen*, 188: "Das Relief war bemalt, schon weil bei dem Barbarenhäuptling des mittleren Teilstücks das rechte Bein nicht plastisch ausgeführt ist."

78. "Die Polychromie muss ebenso vollständig gewesen sein wie z. B. bei den Sarkophagen, wenn auch nur geringe Reste da sind" (Delbrueck, *Die Consulardiptychen*, 21). He reproduces a watercolor sketch of a leaf of a consular diptych that is now lost but whose companion leaf still exists in Darmstadt, the Asturius Diptych (N 4 on pages 95–99): see col. pl. 2, opp. p. 94. Not only the familiar colors—gold, red, blue, and green—occur, but also light blue, light green, yellow, brown, and brownish red or purple.

79. Wood and ivory were in fact worked with the same kinds of tools and in the same workshops; see Winter, in *Ebla to Damascus*, 340, and Barnett, *Ancient Ivories*, 70–72. In Rome, ivory workers called *eborarii* became a clearly defined group of craft specialists in the second century C.E.; they shared their guild with the makers of citrus-wood tables, the *citriarii*, with whom they collaborated in making the feet and legs for chairs and tables. For special exemptions for Late Roman artisans working in wood and ivory, see *The Theodosian Code and Novels and the Sirmondian Constitutions*, ed. Clyde Pharr (Princeton: Princeton University Press, 1952), 390–91.

80. G. P. Stevens, "Remarks upon the Colossal Chryselephantine Statue of Athena in the Parthenon," *Hesperia* 24 (1955): 267–70; also J. Hurwit, "Beautiful Evil: Pandora and the Athena Parthenos," *AJA* 99 (1995): 171, note 2. Cutler remarks on the tendency of ivory to absorb moisture, but just as quickly to lose it, making a controlled humidity ideal for its preservation (*Craft of Ivory*, 14). See also Cut-

ler, *Hand of the Master,* 34, on color on ivory compared to wood.

81. See O. M. Dalton, *Ivory Carvings,* xlix–li. In addition to the tendency of the painted surface to flake or scale under changing climate conditions, heavy use surely played a part in the current appearance of ivories. If ivories were subjected to enough "wear and tear" and became irregular in appearance, there were several options available to a later owner: to remove as much as possible remaining traces of color, to repaint, or to do nothing. Judging from the consistency with which similar color traces reappear over and over again on the test group, it is highly unlikely that this was coincidentally the product of many individuals making similar decisions to repaint over a long period of time and in widely diverging circumstances and geographic locations.

82. See L. J. Matienzo and C. E. Snow, "The Chemical Effects of Hydrochloric Acid and Organic Solvents on the Surface of Ivory," *SCon* 31 (1986): 133–39: "Some standard conservation treatments cause changes in the composition of ivory on the top surface layers. . . . The effects of these solvents, and consolidant formulations using them, must be weighed against the effectiveness of our conservation treatments to preserve ancient and modern ivory objects."

83. See E. Cristoferi and C. Fiori, "Polishing Treatments on Ivory Materials in the National Museum in Ravenna," *SCon* 37 (1992): 259–66: "Finishing treatments were also necessary in order to prepare ivory and bone for painting and gilding" (260).

Chapter 4

1. Jane Burr Carter, *Greek Ivory-Carving in the Orientalizing and Archaic Periods* (New York: Garland, 1985); "Ivory in Homer" is discussed on pages 7–21. She distinguishes allusions to ivories that would apply to the Mycenaean age from those that would apply to Homer's own age, the early Geometric period of about four hundred years later (7).

2. In this chapter, the editions used for Homer are the *Iliad,* trans. Robert Fagles (New York: Pen-

guin, 1991), and the *Odyssey,* trans. Robert Fitzgerald (New York: Anchor Press/Doubleday, 1963). For the Greek and Latin editions, I use the Oxford Classical Texts when available, otherwise Loeb, or as indicated. Transliterations are provided in the text and in some notes to assist readers unfamiliar with Greek.

ἀκρότατον δ᾽ ἄρ᾽ ὀϊστὸς ἐπέγραψε χρόα φωτός·
αὐτίκα δ᾽ ἔρρεεν αἷμα κελαινεφὲς ἐξ ὠτειλῆς.

Ὡς δ᾽ ὅτε τίς τ᾽ ἐλέφαντα γυνὴ φοίνικι μιήνῃ
Μῃονὶς ἠὲ Κάειρα, παρήϊον ἔμμεναι ἵππων·
κεῖται δ᾽ ἐν θαλάμῳ, πολέες τέ μιν ἠρήσαντο
ἱππῆες φορέειν· βασιλῆϊ δὲ κεῖται ἄγαλμα,
ἀμφότερον κόσμος θ᾽ ἵππῳ ἐλατῆρί τε κῦδος·
τοῖοί τοι, Μενέλαε, μιάνθην αἵματι μηροὶ
εὐφυέες κνῆμαί τε ἰδὲ σφυρὰ κάλ᾽ ὑπένερθε
(*Il.* 4.139–47).

3. The color term, φοῖνιξ, the same as the term for a person who is a Phoenician (there are twelve different senses of the word in LSJ), refers to the source of painted and dyed objects, s.v. φοῖνιξ (B) LSJ: "purple or crimson, because the discovery and earliest use of this colour was ascribed to the Phoenicians." See E. Irwin, *Color Terms in Greek Poetry* (Toronto: Hakkert, 1974), 201: the red-yellow range is given terms from Homer on, while blues and greens are less well defined, and qualities such as gleaming or light take precedence over color.

4. It has been called to my attention by John Herington that the word μαίνω is used for "stain" or "dye," which would have a pejorative meaning of "pollute" or "befoul," and that a better translation might therefore be "discolor"; see G. S. Kirk in his commentary on *Iliad* I–IV (Cambridge: Cambridge University Press, 1985), 346, in which he says the usage is "virtually unparalleled," and "it must surely be determined by 'stained with blood' in the resumption at 146."

5. ἐκ δ᾽ ἄρα χειρῶν
ἡνία λεύκ᾽ ἐλέφαντι χαμαὶ πέσον ἐν κονίῃσιν
(*Il.* 5.582–83).

6. See J. Chadwick, *The Mycenaean World* (Cambridge: Cambridge University Press, 1976), 167 and 170, for Linear B texts recording horse trappings

with ivory inlay, some of which are painted red or vermilion, and chariot wheels with ivory borders.

7. For blinkers from Nimrud partially stained with red, see Carter, *Greek Ivory-Carving,* 12 and notes 5–7; see esp. J. J. Orchard, *Equestrian Bridle-Harness Ornaments, Ivories From Nimrud,* fasc. I, pt. 2 (Aberdeen: British School of Archaeology in Iraq, 1967), nos. 109–14.

8. χαλκοῦ τε στεροπὴν κὰδ δώματα ἠχήεντα,
χρυσοῦ τʼ ἠλέκτρου τε καὶ ἀργύρου ἠδʼ ἐλέφαντος.
Ζηνός που τοιήδε γʼ Ὀλυμπίου ἔνδοθεν αὐλή,
ὅσσα τάδʼ ἄσπετα πολλά· σέβας μʼ ἔχει εἰσορόωντα
(*Od.* 4.72–75).

9. Ἤλεκτρον can be either amber or electrum, according to LSJ. However, LSJ thinks it is the metal in this passage, because it is in a list with three other metals; ivory seems to have been a natural comparison to metals, perhaps because it was polished to have a comparable sheen. Amber can also shine, but tends to be more translucent than light-reflecting, and so is differentiated from the rest of the list.

10. For the meaning of ἠλέκτρον as amber here, see Alfred Heubeck et al., *A Commentary on Homer's Odyssey,* vol. 1 (Oxford: Clarendon Press and Oxford University Press, 1988).

11. This could be translated more literally as "awe grips me as I look on it" or simply "awesome!"

12. δώσω οἱ τόδʼ ἄορ παγχάλκεον, ᾧ ἔπι κώπη
ἀργυρέη, κολεὸν δὲ νεοπρίστου ἐλέφαντος
ἀμφιδεδίνηται· πολέος δέ οἱ ἄξιον ἔσται (*Od.* 8.403–5).
Neopristos is translated "newly sawn" because it is known through the technology of ivory production that tusks were sawn into workable pieces, and the ivory when newly cut or just after working was normally bright white.

13. For the use of saws in ivory working, see Arthur MacGregor, *Bone, Antler, Ivory, and Horn,* 55, and Cutler, *Craft of Ivory,* 41–42. See Chadwick, *The Mycenaean World* (note 6 above), 171, for Linear B tablets mentioning swords and daggers "bound with ivory."

14. κάλλεϊ μέν οἱ πρῶτα προσώπατα καλὰ κάθηρεν
ἀμβροσίῳ . . .

καί μιν μακροτέρην καὶ πάσσονα θῆκεν ἰδέσθαι,
λευκοτέρην δʼ ἄρα μιν θῆκε πριστοῦ ἐλέφαντος
(*Od.* 18.192–96).

15. δοιαὶ γάρ τε πύλαι ἀμενηνῶν εἰσὶν ὀνείρων·
αἱ μὲν γὰρ κεράεσσι τετεύχαται, αἱ δʼ ἐλέφαντι·
τῶν οἳ μέν κʼ ἔλθωσι διὰ πριστοῦ ἐλέφαντος,
οἵ ῥʼ ἐλεφαίρονται, ἔπεʼ ἀκράαντα φέροντες·
οἱ δὲ διὰ ξεστῶν κεράων ἔλθωσι θύραζε,
οἵ ῥʼ ἔτυμα κραίνουσι, βροτῶν ὅτε κέν τις ἴδηται
(*Od.* 19.562–67).

16. The plays on words, with horn (*keras*) described with the verb *kraino* (fulfill) and ivory (*elephantos*)with *elefairomai* (deceive), do not come across in translation. If the surface of ivory was regularly concealed or altered by painting or staining, this metaphor describing ivory as a glimmering illusion or a deception might be more comprehensible. But we do not know for sure if bone or horn was regularly painted too or was left its natural color. See also Patricia Cox Miller, *Dreams in Late Antiquity* (Princeton: Princeton University Press, 1994), 15–16, for further discussion of the meaning of the dreams coming through gates of horn and ivory. On passages in Homer mentioning horn and ivory, see A. Amory, "The Gates of Horn and Ivory," *Yale Classical Studies* 20 (1966): esp. 42–51.

17. The pun here, pointed out to me by Georgia Machemer, is important in that it reveals the *true* worth of substances that are comparable in their natural state with respect to origin and type of material. But when they are polished a different effect is achieved; they are truly the reverse of what they seem: one accomplishes, the other deceives.

18. καλὴν χαλκείην· κώπη δʼ ἐλέφαντος ἐπῆεν
(*Od.* 21.7).

19. For Penelope's chair: δινωτὴν ἐλέφαντι καὶ ἀργύρῳ· (*Od.* 19.56). For the bed: δαιδάλλων χρυσῷ τε καὶ ἀργύρῳ ἠδʼ ἐλέφαντι·
ἐν δʼ ἐτάνυσσʼ ἱμάντα βοὸς φοίνικι φαεινόν (*Od.* 23.200–201). To emphasize even further the multiplicity of colors, ox-hide thongs bright with red (*phoiniki phaeinon*) are included in the description of the bed. (These would probably not even be seen!)

The description of the thongs might be better translated as "shining brightly with crimson," with the alliterative language in the Greek drawing attention to the rich visual impression produced by the juxtaposition of media and colors. In Pindar the shoulder of Tantalus, newly replaced in ivory, is described as shining: ἐλέφαντι φαίδιμον (*Olympian Odes* 1.27). The weaving of wreaths described in Pindar's Nemean Ode (7.78–79) juxtaposes substances with similar bright colors: gold, ivory, and coral. For a discussion of the relation of the Homeric passages to finds from Mycenaean sites, see Carter, *Greek Ivory-Carving,* 18–20.

20. ¹⁸καὶ ἐποίησεν ὁ βασιλεὺς θρόνον ἐλεφάντινον μέγαν καὶ περιεχρύσωσεν αὐτὸν χρυσίῳ δοκίμῳ· ¹⁹ἐξ ἀναβαθμοὶ τῷ θρόνῳ, καὶ προτομαὶ μόσχων τῷ θρόνῳ ἐκ τῶν ὀπίσω αὐτοῦ καὶ χεῖρες ἔνθεν καὶ ἔνθεν ἐπὶ τοῦ τόπου τῆς καθέδρας, καὶ δύο λέοντες ἑστηκότες παρὰ τὰς χεῖρας, ²⁰καὶ δώδεκα λέοντες ἑστῶτες ἐπὶ τῶν ἐξ ἀναβαθμῶν ἔνθεν καὶ ἔνθεν· οὐ γέγονεν οὕτως πάσῃ βασιλείᾳ (Septuagint, 3 Kings 10.18–20). Revised Standard Edition (1 Kings), and Septuagint, ed. Alfred Rahlfs (Stuttgart: Deutsche Bibelgesellschaft, 1979). We might also cite in the Scriptures people "that lie upon beds of ivory" (Amos 6.4) or even "houses of ivory" (1 Kings 22.39 and Amos 3.15).

21. See Carter, *Greek Ivory-Carving,* 18–19, for further examples. A comparable couch to that found at Vergina is perhaps described in Theocritus, *Idyll* 15.123; for a commentary, see A.S.F. Gow, *Theocritus,* vol. 2 (Cambridge: Cambridge University Press, 1965), 298–300.

22. See Amory, "Gates of Horn and Ivory" (note 17 above), 3–57, esp. 43–50. "Ivory . . . appears only as a substance . . . and is, moreover, purely a decorative material, and an expensive one, associated primarily with royalty" (47); "Decorative descriptive passages were obviously part of the oral tradition, and the phrases of which these passages [referring to ivory] are composed may be almost wholly formulaic. Just as the poet of the *Iliad* has an array of phrases in which to describe arms and armor, so the poet of the

Odyssey must have drawn from a stock of expressions describing the furnishings of palaces" (49).

23. For the most complete list of references to ivory in the ancient sources see Pauly-Wissowa, s.v. "elfenbein."

24. For the best commentary, see J. G. Frazer, *Pausanias's Description of Greece,* 6 vols. (New York: G. Bell, 1898; Biblo and Tannen, 1965). For the English translations, I have used W.H.S. Jones and R. Wycherley, 5 vols. (Cambridge: Harvard University Press).

25. Kenneth Lepatin's dissertation, "Greek and Roman Chryselephantine Statuary" (Ph.D. diss., University of California, 1994), will contribute to our knowledge of these lost works and will appear soon in book form. I am indebted to him personally for suggesting several of the articles consulted in this chapter.

26. See A. Stewart, *Greek Sculpture: An Exploration,* vol. 1 (New Haven: Yale University Press, 1990), 36–42, for a description of the materials and methods thought to have been used in this art: "Of these 'radiant' media two, gold and ivory, held a privileged place. Prestigious and costly, they also evoked deeply held feelings about the gods (whom Homer regularly calls 'bright,' 'shining,' even 'gold-gleaming') in a way that bronze and marble, even silver, did not."

27. τότε δὲ ἐπιφανέντων αὐτῶν δεῖμα ἔλαβε Ῥωμαίους ἄλλο τι καὶ οὐ ζῷα εἶναι νομίσαντας. ἐλέφαντα γάρ, ὅσος μὲν ἐς ἔργα καὶ ἀνδρῶν χεῖρας, εἰσὶν ἐκ παλαιοῦ δῆλοι πάντες εἰδότες· αὐτὰ δὲ τὰ θηρία, πρὶν ἢ διαβῆναι Μακεδόνας ἐπὶ τὴν Ἀσίαν, οὐδὲ ἑωράκεσαν . . . δηλοῖ δὲ Ὅμηρος, ὃς βασιλεῦσι κλίνας μὲν καὶ οἰκίας τοῖς εὐδαιμονεστέροις αὐτῶν ἐλέφαντι ἐποίησε κεκοσμημένας, θηρίου δὲ ἐλέφαντος μνήμην οὐδεμίαν ἐποιήσατο (Paus. 1.12.3–4). The Greek writer Flavius Philostratus (c. 170–240 C.E.) describes elephants and their tusks: "but the best of all are the tusks of the elephants of the plain, for these are very large and very white and so pleasant to turn and carve that the hand can shape them into whatever it likes" (*Life of Apollonius* 2.13). His description confirms the ongoing awareness of the primacy and utility of the material.

28. φιλότιμοι δὲ ἐς τὰ μάλιστά μοι καὶ ἐς θεῶν τιμὴν οὐ φειδωλοὶ χρημάτων γενέσθαι δοκοῦσιν οἱ Ἕλληνες, οἷς γε παρὰ Ἰνδῶν ἤγετο καὶ ἐξ Αἰθιοπίας ἐλέφας ἐς ποίησιν ἀγαλμάτων (Paus. 5.12.3).

29. Μέτρα δὲ τοῦ ἐν Ὀλυμπίᾳ Διὸς ἐς ὕψος τε καὶ εὖρος ἐπιστάμενος γεγραμμένα οὐκ ἐν ἐπαίνῳ θήσομαι τοὺς μετρήσαντας, ἐπεὶ καὶ τὰ εἰρημένα αὐτοῖς μέτρα πολύ τι ἀποδέοντά ἐστιν ἢ τοῖς ἰδοῦσι παρέστηκεν ἐς τὸ ἄγαλμα δόξα (Paus. 5.11.9). Pausanias even adds to this a story of the thunderbolt as a sign of approval by Zeus of Phidias's statue.

30. LSJ. "ἄγαλμα" has a broad set of nuances: (1) glory, delight, honor; (2) pleasing gift, esp. for the gods; (3) statue in honor of a god; (4) statue; (5) image. Herodotus, among others, uses it specifically as a statue in honor of a god. For a study of this topic, see H. Bloesch, *Agalma: Kleinod, Weihgeschenk, Götterbild, Ein Beitrag zur fürhgriechischen Kultur* (Bern: Benteli, a. G., 1943).

31. For example in 7.20.2.

32. Καθέζεται μὲν δὴ ὁ θεὸς ἐν θρόνῳ χρυσοῦ πεποιημένος καὶ ἐλέφαντος· στέφανος δὲ ἐπίκειται οἱ τῇ κεφαλῇ μεμιμημένος ἐλαίας κλῶνας. ἐν μὲν δὴ τῇ δεξιᾷ φέρει Νίκην ἐξ ἐλέφαντος καὶ ταύτην καὶ χρυσοῦ, ταινίαν τε ἔχουσαν καὶ ἐπὶ τῇ κεφαλῇ στέφανον· τῇ δὲ ἀριστερᾷ τοῦ θεοῦ χειρὶ ἔνεστι σκῆπτρον μετάλλοις τοῖς πᾶσιν ἠνθισμένον, ὁ δὲ ὄρνις ὁ ἐπὶ τῷ σκήπτρῳ καθήμενός ἐστιν ὁ ἀετός. χρυσοῦ δὲ καὶ τὰ ὑποδήματα τῷ θεῷ καὶ ἱμάτιον ὡσαύτως ἐστί· τῷ δὲ ἱματίῳ ζῴδιά τε καὶ τῶν ἀνθῶν τὰ κρίνα ἐστὶν ἐμπεποιημένα. ὁ δὲ θρόνος ποικίλος μὲν χρυσῷ καὶ λίθοις, ποικίλος δὲ καὶ ἐβένῳ τε καὶ ἐλέφαντί ἐστι· καὶ ζῷά τε ἐπ᾽ αὐτοῦ γραφῇ μεμιμημένα καὶ ἀγάλματά ἐστιν εἰργασμένα (Paus. 5.11.1–2).

33. Cf. Paus. 5.11.7. LSJ prefers to translate γράφω as "to scratch, draw, or delineate" and secondarily as "to paint."

34. ποικίλος is defined in LSJ, vol. 2, as "wrought in various colours" or "of metalwork, cunningly worked."

35. τῶν δὲ ἐκ τοῦ θρόνου μεταξὺ ποδῶν τέσσαρες κανόνες εἰσίν, ἐκ ποδὸς ἐς πόδα ἕτερον διήκων ἕκαστος. τῷ μὲν δὴ κατ᾽ εὐθὺ τῆς ἐσόδου κανόνι,

ἑπτά ἐστιν . . . ἐπὶ δὲ τῶν κανόνων τοῖς λοιποῖς ὁ λόχος ἐστὶν ὁ σὺν Ἡρακλεῖ μαχόμενος πρὸς Ἀμαζόνας· ἀριθμὸς μὲν δὴ συναμφοτέρων ἐς ἐννέα ἐστὶ καὶ εἴκοσι (Paus. 5.11.3–4).

36. ἐν Ὀλυμπίᾳ δὲ ἐρύματα τρόπον τοίχων πεποιημένα τὰ ἀπείργοντά ἐστι. τούτων τῶν ἐρυμάτων ὅσον μὲν ἀπαντικρὺ τῶν θυρῶν ἐστιν, ἀλήλιπται κυάνῳ μόνον, τὰ δὲ λοιπὰ αὐτῶν παρέχεται Παναίνου γραφάς. . . . Πάναινος μὲν δὴ οὗτος ἀδελφός τε ἦν φειδίου καὶ αὐτοῦ καὶ Ἀθήνησιν ἐν Ποικίλῃ τὸ Μαραθῶνι ἔργον ἐστὶ γεγραμμένον (Paus. 5.11.4–6).

37. I am indebted to John Herington for this interpretation of the passage.

38. cum et Phidian ipsum initio pictorem fuisse tradatur clipeumque Athenis ab eo pictum, praeterea in confesso sit LXXX tertia fuisse fratrem eius Panaenum, qui clipeum intus pinxit Elide Minervae, quam fecerat Colotes, discipulus Phidiae et ei in faciendo Iove Olympio adiutor. . . . Panaenus quidem frater Phidiae etiam proelium Atheniensium adversus Persas apud Marathona factum pinxit. adeo iam colorum usus increbruerat adeoque ars perfecta erat . . . (*N.H.* 35.34.54–57).

39. A. Mallwitz and W. Schiering, *Die Werkstatt des Pheidias in Olympia. Olympische Forschungen 5* (Berlin: De Gruyter, 1964). See also Stewart, *Greek Sculpture,* 40.

40. For an example of an "archaic panel picture of Artemis at Ephesus" see the reference in Pliny, *N.H.* 35.40.147.

41. τὸ ὑπόθημα δὲ τὸ ὑπὸ τοῦ Διὸς τοῖς ποσίν, ὑπὸ τῶν ἐν τῇ Ἀττικῇ καλούμενον θρανίον, λέοντάς τε χρυσοῦς καὶ Θησέως ἐπειργασμένην ἔχει μάχην τὴν πρὸς Ἀμαζόνας . . . ἐπὶ δὲ τοῦ βάθρου τοῦ τὸν θρόνον τε ἀνέχοντος καὶ ὅσος ἄλλος κόσμος περὶ τὸν Δία, ἐπὶ τούτου τοῦ βάθρου χρυσᾶ ποιήματα, ἀναβεβηκὼς ἐπὶ ἅρμα Ἥλιος καὶ Ζεύς τέ ἐστι καὶ Ἥρα . . . ἐπείργασται δὲ καὶ Ἀπόλλων σὺν Ἀρτέμιδι Ἀθηνᾶ τε καὶ Ἡρακλῆς, καὶ ἤδη τοῦ βάθρου πρὸς τῷ πέρατι Ἀμφιτρίτη καὶ Ποσειδῶν (Paus. 5.11.7–8).

42. In *Greek Sculpture,* 40, Stewart comments on the overall effect, including the use of gilded glass: "This virtuoso display of sculptural technique must

have been quite startling, even disturbing, in its strident attempt to make present the scintillating glory of the Olympians."

43. See Carter, *Greek Ivory-Carving*, 166. See also *Guide de Delphes*, 206–19, and P. Amandry, "Rapport préliminaire," 103–6. The greatest surviving ivory throne is the throne of Maximian in the Archiepiscopal Palace in Ravenna. A Carolingian throne of the mid-9th century associated with the Liuthard group of ivories utilizes for revetment ivory plaques depicting the Labors of Heracles; this so-called Cathedra Petri in the Vatican reuses Late Antique ivory plaques. Gold leaf was used to overlay the reliefs, while decorative details were colored green and red. See K. Weitzmann, "The Heracles Plaques of St. Peter's Cathedra," *AB* 55 (1973): 1–37, esp. 18–25, and fig. 2. See also L. Nees, *A Tainted Mantle: Hercules and the Classical Tradition at the Carolingian Court* (Philadelphia: University of Pennsylvania Press, 1991), 192–201. For an excellent color plate of an ivory panel from the throne, see Danielle Gaborit-Chopin, *Ivoires du Moyen Age* (Fribourg: Office du Livre, 1978), pl. 94 opp. p. 74. Parallels between these plaques, the Heracles reliefs described by Pausanias on the thone of Zeus, and the Delphi reliefs merit further investigation.

44. Ὅσον δὲ τοῦ ἐδάφους ἐστὶν ἔμπροσθεν τοῦ ἀγάλματος, τοῦτο οὐ λευκῷ, μέλανι δὲ κατεσκεύασται τῷ λίθῳ· περιθεῖ δὲ ἐν κύκλῳ τὸν μέλανα λίθον Παρίου κρηπίς, ἔρυμα εἶναι τῷ ἐλαίῳ τῷ ἐκχεομένῳ. ἔλαιον γὰρ τῷ ἀγάλματί ἐστιν ἐν Ὀλυμπίᾳ συμφέρον, καὶ ἔλαιόν ἐστι τὸ ἀπεῖργον μὴ γίνεσθαι τῷ ἐλέφαντι βλάβος διὰ τὸ ἑλῶδες τῆς Ἄλτεως (Paus. 5.11.10).

45. Pliny describes similar techniques used in Rome for the preservation of ivory; a substance called *elaeomeli* imported from Syria was used to preserve ivory for "the interior of a statue of Saturn in Rome was filled with this oil" (*intus oleo repletum est*) (*N.H.* 15.32).

46. See Stewart, *Greek Sculpture*, 41–42, on painting of sculpture, including chryselephantine works.

47. ταύτῃ τῃ Ἐργάνῃ καὶ οἱ ἀπόγονοι Φειδίου, καλούμενοι δὲ φαιδρυνταί, γέρας παρὰ Ἠλείων εἰλ-

ηφότες τοῦ Διὸς τὸ ἄγαλμα ἀπὸ τῶν προσιζανόντων καθαίρειν, οὗτοι θύουσιν ἐνταῦθα πρὶν ἢ λαμπρύνειν τὸ ἄγαλμα ἄρχονται (Paus. 5.14.5). Maintenance of ivory through polishing was practiced by the Romans with two techniques mentioned by Pliny. Aquatic animals covered with rough skin that can be used for polishing wood and ivory (*qua lignum et ebora poliumtur*) are mentioned in *N.H.* 9.12.40. In a discussion of the multiple utility of radishes, he adds, "and they can be used for polishing ivory" (*Ebora certe poliunt*) (*N.H.* 19.26.87).

48. See H. Blümner, *Technologie und Terminologie der Gewerbe und Künste bei Griechen und Römern*, II (Leipzig: B. G. Teubner, 1897; repr. Hildesheim: Georg Olms Verlagsbuchhandlung, 1969), 372: "es ist aber, da ja auch an Marmorstatuen gewisse Theile des Gesichtes, wie Lippen und Augenbrauen, in der Regel durch Farbe hervorgehoben wurden, wahrscheinlich, dass man auch beim Elfenbein ein ähnliches Verfahren befolgte"; also note 5.

49. At si qui subtilior fuerit et voluerit expolitionem miniaciam suum colorem retinere, cum paries expolitus et aridus est, ceram punicam igni liquefactam paulo oleo temperatam saeta inducat; deinde postea carbonibus in ferreo vase compositis eam ceram a primo cum pariete calfaciundo sudare cogat fiatque, ut peraequetur; deinde tunc candela linteisque puris subigat, uti signa marmorea nuda curantur (haec autem *ganosis* graece dicitur): ita obstans cerae punicae lorica non patitur nec lunae splendorem nec solis radios lambendo eripere his politionibus colorem (Vitruvius, *De arch,* 7.9.3–4). See also G. Richter, "Were the Nude Parts in Greek Marble Sculpture Painted?" *Metropolitan Museum Studies* I (1928–29), 25–31.

50. Painting the flesh parts of statues of Jupiter with red pigment (cinnabar) is alluded to in a passage in Pliny, who attributes the practice to an ancient tradition: "Verrius gives a list of writers of unquestionable authority who say that on holidays it was the custom for the face of the statue of Jupiter himself to be coloured with cinnabar, as well as the bodies of persons going in a triumphal procession

... one of the first duties of the Censors was to place a contract for painting Jupiter with cinnabar" (*N.H.* 33.36.111–12). Is there a possible connection between this custom and that of polishing and maintaining the chryselephantine Zeus at Olympia?

51. See Stewart, *Greek Sculpture,* 40, on modulation of flesh tones of chryselephantine statues by tinting. Bronze statues had eyes, lips, and other features rendered in appropriate metals or other substances to achieve a more naturalistic appearance as well.

52. The Romans had acquired a taste for chryselephantine statues, as we learn from Pausanias: "Before the entrance to the sanctuary of Olympian Zeus, Hadrian the Roman emperor dedicated the temple and the statue, one worth seeing, which in size exceeds all other statues save the colossi at Rhodes and Rome, and is made of ivory and gold with an artistic skill which is remarkable when the size is taken into account" (Paus. 1.12.6). There was also an ivory statue of Jupiter in Rome, mentioned by Pliny as the work of a native of Magna Graecia named Pasiteles, who received Roman citizenship: "The ivory Jupiter in the temple of Metellus at the approaches to the Campus Martius is his work" (*N.H.* 36.4.41–42). The craft of making ivory statues was apparently brought to Rome by migrant Greek artists, but it did not stop the Romans from importing them from Greece. See Philostratus, *Life of Apollonius*, 5.20, in which he laments the export of chryselephantine statues of the gods from the Piraeus.

53. George Cedrenus, *Synopsis Historion* (Bonn: E. Weber, 1838), 564.

54. See C. Mango, M. Vickers, and E. D. Francis, "The Palace of Lausus at Constantinople and Its Collection of Ancient Statues," *Journal of the History of Collections* 4 (1992): 89–98, for a discussion of the textual evidence for the chryselephantine statue of Zeus from Olympia in Constantinople in the 5th century, with references by Cedrenus to the "ivory Zeus by Phidias, whom Pericles dedicated at the temple of the Olympians" (91); see also M. Vickers, "Phidias' Olympian Zeus and Its Fortuna," in *Ivory in Greece and the Eastern Mediterranean from the Bronze Age to*

the Hellenistic Period, 217–25; he emphasizes that the gold had been stripped from the Olympian Zeus long before it was acquired by Lausus, and therefore that the statue must be imagined as being of ivory mounted on a wooden framework.

55. καὶ ὁ Φειδίου ἐλεφάντινος Ζεύς, ὃν Περικλῆς ἀνέθηκεν εἰς νεὼν Ὀλυμπίων (Cedrenus, *Synopsis Historion* [note 53 above], 564).

56. For a discussion of the texts see Mango, Vickers, and Francis, "Palace of Lausus," 89–91.

57. Vickers, "Olympian Zeus," 219; Mango, Vickers, and Francis, "Palace of Lausus," 94; and Thucydides, *History of the Peloponnesian War* 2.13.

58. See Paus. 1.24.5–7 in which the statue is simply described as "made of ivory and gold": ἐλέφαντος τὸ ἄγαλμα καὶ χρυσοῦ πεποίηται; and the head of Medusa on her tunic is simply "made of ivory."

59. ἅτε δὲ ἀσπίδας ἐξ ἀκροπόλεως καθελὼν χρυσᾶς καὶ αὐτὸ τῆς Ἀθηνᾶς τὸ ἄγαλμα τὸν περιαιρετὸν ἀποδύσας κόσμον . . . (Paus. 1.25.7).

60. See G. P. Stevens, "How the Parthenos Was Made," *Hesperia* 26 (1957): 351–61, deals with the question of the material of the core and the means of attaching the gold sheets, but not with how the ivory parts were prepared. See Athenaeus, *Deipnosophistai* 9.405 for a reference to the Lachares event in which Athena is left bare. See also, for the detachability of the gold, a contemporary witness, Thucydides (*History of the Peloponnesian War* 2.13).

61. οὐκ ἀεὶ Δία Φειδίας ἔπλαττεν, οὔτε σὺν ὅπλοις τὴν Ἀθηνᾶν ἐχαλκεύετο, ἀλλὰ καὶ εἰς ἄλλους θεοὺς ἀφῆκε τὴν τέχνην καὶ τὴν Παρθένον ἐκόσμησεν, ἐρύθημα καταχέας τῆς παρείας, ἵνα ἀντὶ κράνους ὑπὸ τούτου τῆς θεοῦ τὸ κάλλος κρύπτοιτο (Himerius, *Or.* 21.4). Hugh Plommer concludes from this passage that the ivory cheeks of the Athena Parthenos were colored pink or red: see "Himerius and Athena," *CR* 9 (1959): 206–7: "Again, the colouring of ivory was a time-honoured craft, as we know from the famous simile of *Iliad* iv.141ff. It was not, perhaps, so long a step technically from the cheek-pieces of horses to the coloured cheeks of the Parthenos."

62. Ὅπου γὰρ ὕλη μὲν ἦν λίθος, χαλκός,

ἐλέφας, χρυσός, ἔβενος, κυπάρισσος, αἱ δὲ ταύτην
ἐκπονοῦσαι καὶ κατεργαξόμεναι τέχναι, τέκτονες,
πλάσται, χαλκοτύποι, λιθουργοί, βαφεῖς, χρυσοῦ
μαλακτῆρες [καὶ*] ἐλέφαντος, ζωγράφοι, ποικιλ-
ταί, τορευταί, πομποὶ δὲ τούτων καὶ κομιστῆρες
(*Per.* 12.7–13). (The Teubner edition was used: Karl
Sintenis, 1895.)

63. See P. A. Stadter, *A Commentary on Plutarch's
Pericles* (Chapel Hill: University of North Carolina
Press, 1989), for clarification of the materials and
techniques mentioned here, including the *malakteres
elephantos* ("ivory softeners"), in a practice of shaping
and bending ivory (158–60).

64. It is worth noting that in Elis alone there
were 14 chryselephantine statues recorded by
Pausanias.

65. παρείχετο δὲ ἡ Αἴγειρα ἐς συγγραφὴν ἱερὸν
Διὸς καὶ ἄγαλμα καθήμενον λίθου τοῦ Πεντελησίου . . .
ἐν τούτῳ τῷ ἱερῷ καὶ Ἀθηνᾶς ἄγαλμα ἔστηκε·
πρόσωπόν τε καὶ ἄκραι χεῖρες ἐλέφαντος καὶ οἱ
πόδες, τὸ δὲ ἄλλο ξόανον χρυσῷ τε ἐπιπολῆς
διηνθισμένον ἐστὶ καὶ φαρμάκοις (Paus. 7.26.4).

66. τῷ δὲ ἀγάλματι τοῦ Διὸς πρόσωπον ἐλέφαντος
καὶ χρυσοῦ, τὰ δὲ λοιπὰ πηλοῦ τέ ἐστι καὶ γύψου· . . .
ὄπισθε δὲ τοῦ ναοῦ κεῖται ξύλα ἡμίεργα· ταῦτα
ἔμελλεν ὁ Θεόκοσμος ἐλέφαντι καὶ χρυσῷ κοσμήσας
τὸ ἄγαλμα ἐκτελέσειν τοῦ Διός (Paus. 1.40.4).

67. Like any highly crafted object, ivory must be
associated with political and ideological contexts: see
M. W. Helms, *Craft and the Kingly Ideal: Art, Trade,
and Power* (Austin: University of Texas Press, 1993),
16–17, 23–25.

68. Encausto pingendi duo fuere antiquitus gen-
era, cera et in ebore cestro, id est uericulo, donec
classes pingi coepere. hoc tertium accessit resolutis
igni ceris penicillo utendi, . . . (*N.H.* 35.41). See
note *a* in the Loeb edition, vol. 9, by H. Rackham
(Cambridge, Mass., 1961), 370, on the interpretation
of this passage.

69. Examples of the technique described here by
Pliny may be seen in the collection of ancient ivories
at the Walters Art Gallery in Baltimore. Bone revet-
ment for boxes or other objects has been engraved or

hollowed out to receive encaustic in dark green, red,
and black, some of which survives. See Randall, *Mas-
terpieces*, 91–95 and col. pls. 43, 44; see esp. nos. 135,
151–53.

70. Indum sanguineo ueluti uiolauerit ostro
si quis ebur, aut mixta rubent ubi lilia multa
alba rosa, talis uirgo dabat ore colores (Virgil, *Aen.*
12.67–69, trans. A. Mandelbaum [New York, 1981]).
The vast number of allusions to the *Iliad* and the
Odyssey in Virgil's *Aeneid* would have been part of the
pleasure of reading the poem.

71. restitit Aeneas claraque in luce refulsit
os umerosque deo similis; namque ipsa decoram
caesariem nato genetrix lumenque iuuentae
purpureum et laetos oculis adflarat honores:
quale manus addunt ebori decus, aut ubi flauo
argentum Pariusue lapis circumdatur auro
(*Aen.* 1.588–93).

72. interea niueum mira feliciter arte
sculpsit ebur formamque dedit, qua femina nasci
nulla potest, operisque sui concepit amorem.
virginis est uerae facies, quam uiuere credas,
et, si non obstet reuerentia, uelle moueri:
ars adeo latet arte sua. miratur et haurit
pectore Pygmalion simulati corporis ignes.
saepe manus operi temptantes admouet, an sit
corpus an illud ebur, nec adhuc ebur esse fatetur
(*Met.* 10.247–55 [Loeb edition]).

73. Nothing precludes the tinting of the statue
with color to resemble rouge or eye color to help
achieve this illusion, although Ovid praises only the
beauty of the "snowy" ivory.

74. at illi
conscia purpureus uenit in ora pudor.
quale coloratum Tithoni coniuge caelum
subrubet, aut sponso uisa puella nouo;
quale rosae fulgent inter sua lilia mixtae
aut, ubi cantatis, Luna, laborat equis;
aut quod, ne longis flauescere possit ab annis,
Maeonis Assyrium femina tinxit ebur:
his erat aut alicui color ille simillimus horum, . . .
(Ovid, *Amores* 2.5.33–41).

75. Here Ovid, in his allusions to Homer, like Vir-

gil in his, would have invited the educated reader to compare Homer's treatment of a given topic with his own.

76. See below, note 77, on Propertius and the environment for retaining the whiteness of ivory.

77. "et numquam Herculeo numine pallet ebur" (Propertius, *Elegies* 4.82).

78. A Byzantine text of the 6th century, a contemporary description of the materials of the ambo of Hagia Sophia written by Paul the Silentiary, speaks of colors of stone changing according to the light at different times during the day. After comparing the colors of the stones to the softened color of washed beeswax, the author adds: "So, too, does ivory, tinged by the passage of long years, turn its silvery color to quince-yellow" (*De ambonis* 80). See Cyril Mango, *The Art of the Byzantine Empire, 312–1453*, ed. H. W. Janson (1972; repr. Toronto: University of Toronto Press, 1986), 92, and, for the Greek, Paul Friedländer, *Johannes von Gaza und Paulus Silentiarius* (Leipzig, 1912), 246.

79. pueri rubor ora notavit;
nescit, enim, quid amor; sed et erubuisse decebat:
hic color aprica pendentibus arbore pomis
aut ebori tincto est aut sub candore rubenti,
cum frustra resonant aera auxiliaria, lunae (Ovid, *Met.* 4.329–33).

80. deserit et niveos infecit purpura vultus
per liquidas succensa genas castaeque pudoris
inluxere faces: non sic decus ardet eburnum,
Lydia Sidonio quod femina tinxerit ostro (Claudian, *Rape of Proserpine* 1.272–75).

81. The source of this dye, known to the Greeks, was the purple-fish or πορφύρα. The Latin name for the fish was *murex purpureus,* but πορφύρα and *purpura* are both used to describe blood, or the color we would call red rather than purple; the dye is called *ostro.*

82. *Purpureus* clearly covered a wide range of shades, from blood-red to reddish-blue, or what we would call purple or violet; these colors were not distinguished by separate terms in antiquity as they are in today's usage. Indeed, the range of colors called *porphyrios* or *purpureus* in antiquity was descriptive of

the dye derived from a mollusk and could range from a deep bluish-red to a bright crimson like blood. John Herington has called to my attention that *purpureus* could be used even more broadly, and that Horace wrote of a *purpureus olor,* a purple swan. One may thus deduce that the word did not so much convey color in our sense as much as the eye-catching quality or brilliance of a whole variety of color-shades.

83. Iaia Cyzicena, perpetua virgo, M. Varronis iuventa Romae et penicillo pinxit et cestro in ebore imagines mulierum maxime et Neapoli anum in grandi tabula, suam quoque imaginem ad speculum. nec ullius velocior in pictura manus fuit, artis vero tantum, ut multum manipretiis antecederet celeberrimos eadem aetate imaginum pictores Sopolim et Dionysium, quorum tabulae pinacothecas inplent (*N.H.* 35.40.147).

84. Nec satis, coepere tingui animalium cornua, dentes secari lignumque ebore distingui, mox operiri (*N.H.* 16.232).

85. In Pliny, *N.H.* 8.10.31, ivory is cited as being vastly expensive and therefore appropriate for statues of gods; he also indicates that large tusks were kept in the temples. An ivory throne (φρόνον ἐλεφάντι-voν) is listed as one of the royal insignia of the Tyrrhenians in Dionysius of Halicarnassus, *Roman Antiquities* 3.61.1. A couch of ivory (*lectus eburneus*) with coverlets of purple and gold in a gilded shrine was set up on the rostra at the time of the funeral of Julius Caesar, according to Suetonius, *The Lives of the Caesars,* I, *The Deified Julius* LXXXIV.1. Such a couch of ivory might resemble that discovered in the royal tombs at Vergina (discussed above in chapter 3).

86. See T. F. Mathews, *The Clash of Gods: A Reinterpretation of Early Christian Art* (Princeton: Princeton University Press, 1993), 104–7 and figs. 76–81.

87. Livy, *History of Rome,* 42.14: Cum sella curuli atque eburneo scipione.

88. Ibid., 31.11.12: Cum eburneo scipione et toga praetexta cum curuli sella.

89. Ibid., 30.15.12: Sella curuli et scipione eburneo.

90. See C. Daremberg and E. Saglio, *Dictionnaire*

des antiquités grècques et romaines d'après les textes et les monuments (1877–1919), s.v. "*sella*" for the forms of these chairs with various types of ornament on them. For a discussion of the appearance of the *sella curulis* in coin types and in ivories depicting examples, see Mathews, *The Clash of Gods* (note 86 above), 104–8. The Leo Scepter, an ivory scepter of the Middle Byzantine period, survives in Berlin (see p. 17–18 above); it was found on examination to have numerous traces of red and gold stain and pigment.

91. Ἐπὶ τὸν ἐλεφάντινον δίφρον: Athenaeus, *Deipnosophistai*: 5.193.

92. haec altas eboris decoravit honore curules et princeps Tyrio vestem praetexuit ostro (Silius Italicus, *Punica* 8.486–87). The meaning of *altas* is more likely to be "exalted" than "high up," as in a high-backed or tall chair.

93. Ovid, *Fasti*, 5.51 and 1.82.

94. Paris, Cabinet des Médailles, inv. 55, no. 296 and cat. no. 3267: see *Byzance*: no. 15, 54–55 and no. 16, 56–57.

95. τά τε θυρώματα τοῦ ναοῦ θαυμαστὰς ἔχει τὰς κατασκευὰς ἐξ ἀργύρου καὶ χρυσοῦ καὶ ἐλέφαντος, ἔτι δὲ θύας δεδημιουργημένας (Diodorus Siculus 5.46.6). See A. Oliver Jr., "Ivory Temple Doors," in *Ivory in Greece and the Eastern Mediterranean from the Bronze Age to the Hellenistic Period.*

96. Iam vero quid ego de valvis illius templi commemorem? . . . Confirmare hoc liquido, iudices, possum, valvas magnificentiores, ex auro atque ebore perfectiores, nullas umquam ullo in templo fuisse. Incredibile dictu est quam multi Graeci de harum valvarum pulchritudine scriptum reliquerint. . . . Ex ebore diligentissime perfecta argumenta erant in valvis; ea detrahenda curavit omnia. Gorgonis os pulcherrimum cinctum anguibus revellit atque abstulit, et tamen indicavit se non solum artificio sed etiam pretio quaestuque duci; nam bullas aureas omnis ex iis valvis, quae erant multae et graves, non dubitavit auferre; quarum iste non opere delectabatur sed pondere (Cicero, *In Verrem* 2.4.56/124).

97. Virgil, *Georgics* 3.26–29.

98. The somewhat whimsical description of Hagia Sophia in Constantinople found in the *Narratio de S. Sophia* includes ivory doors (ch. 18; see Mango, *Art of the Byzantine Empire,* 99–100); two groups of three ivory doors were found in the esonarthex, and according to this translation, they were gilded. The *De ceremoniis* of Constantine Porphyrogenitus also mentions an ivory door on the Pharos Church within the imperial palace: see A. Vogt, *Le livre des cérémonies* (Paris: Société d'édition "Les Belles Lettres," 1967), vol. 1, chap. 40/31, 159.

99. See W. F. Volbach, *Early Christian Art* (New York: Abrams, n.d.), plate 92; see also the ivory panel dated to c. 420 showing the empty sepulcher in the British Museum in London (BM, M&La 56.6-23.6) in *Byzantium: Treasures of Byzantine Art and Culture from British Collections,* ed. D. Buckton (London: British Museum, 1994), no. 45, 58–59 and fig. 45.

100. Ibid., pls. 103–5. Eighteen of the original 28 carved panels survive.

101. Ibid., pls. 226–35. For a discussion of its strongly antique style see John Beckwith, *Early Christian and Byzantine Art,* Pelican History of Art (New York: Penguin, 1979), 116–18. Beckwith mentions the destruction of the surface of the ivory due to inept cleaning; one wonders what the original surface might have been like. This is another case in which it would be interesting to observe the throne closely to see if any color traces can be detected. See also E. Cristoferi and C. Fiori, "Polishing Treatments on Ivory Materials in the National Museum in Ravenna," *SCon* 37 (1992): 259–66. In this study of treatments of artifacts made of bone and ivory, the chair of Maximian is referred to as having been subjected to bleaching, which has given the surface a "dry and chalk-like appearance" (260).

102. ac ne quis me temere Graecorum alicui Latinorumve aestimet credidisse, habet in Bibliotheca Ulpia in armario sexto librum elephantinum, in quo hoc senatus consultum perscriptum est, cui Tacitus ipse manu sua subscripsit. nam diu haec senatus consulta quae ad principes pertinebant in libris elephantinis scribebantur (*Scriptores Historiae Augustae*: Tacitus 8.1–2).

103. See J. B. Bury, *The Imperial Administrative System in the Ninth Century* (London, 1911; repr. New York: Burt Franklin, n. d.). See also N. Oikonomides, *Les listes de préséance byzantines du IXe et Xe siècle* (Paris: Editions du Centre National de la Recherche Scientifique, 1972). Many of the titles and practices are thought to go back to Constantine the Great and Justinian; see Bury, *Administrative System,* 11.

104. (*Kletorologion* 710, from Bury, *Administrative System,* 134–35): πλάκες ἐλεφάντιναι κεκοσμημέναι σὺν κωδικέλλοις ἐγγεγραμμένοις εἰς τύπον τοῦ νόμου, ἐκ βασιλικῆς χειρὸς ἐπιδίδονται. See Oikonomides, *Les listes,* 92–97, for discussions of the difficulties of translating the terms on these lists. Conferring of codicils dates at least from the 4th century and, according to Oikonomides, had not changed since then. Furthermore, he states: "Les codicilles se présentaient comme un quaternion, . . . souvent enfermé entre des plaques d'ivoire; c'est le sens que me semble suggérer ici l'emploi d' ἐγγεγραμμένοις (au lieu de γεγραμμένοις) par Philothée" (93, note 41). For the ceremony of conferral of this award described in the *Book of Ceremonies* of Constantine Porphyrogenitus (mid-10th century), see Vogt, *Le livre des cérémonies,* vol. 2, 51–57: chap. 57; this elaborate ceremony describes the *patrikios* receiving only "plaques from the emperor" (τὰς πλάκας ἀπὸ τοῦ βασιλέως) (54) and "carrying the plaques" (βαστάζων τὰς πλάκας) (56), rather than specifically ivory plaques.

105. Philotheos, *Kletorologion,* 710, from Bury, *Administrative System,* 135: κωδίκελλοι ἁλουργοειδεῖς γεγραμμένοι. See Oikonomides, *Les listes,* 94, note 44.

106. Philotheos, *Kletorologion,* 711, from Bury, *Administrative System,* 135: πλάκες ἐλεφάντιναι ὁμοίως τοῖς πατρικίοις; see also Bury's comments on this office (33). See also Oikonomides, *Les listes,* 96, note 47. The *Book of Ceremonies* specifies that these ivory plaques were accompanied by codicils (τὰς πλάκας υετὰ τῶν κωδικέλλων), showing that this award really was like that of the *patrikios* (chap. 59 [50], R. 259.30 [= Vogt, vol. 2, p. 64]). See also Anton von

Premerstein, "Anicia Iuliana im Wiener Dioskorides-Kodex," *Jahrbuch der Kunsthistorischen Sammlungen des Allerhöchsten Kaiserhauses* 24 (1903): 106–24, esp. 115. He identifies the scene on the dedication page of the Vienna Dioscorides (*De mat. med.*, Vindobonensis med. gr. 1, fol. 6v) as Anicia Juliana enthroned and holding in her left hand the codicils indicating that she has obtained the title of *zoste patrikia* in her own right. If von Premerstein is correct, then we have represented in the miniature a 6th-century example of the *plakes elephantinai.*

107. Bury, *Administrative System,* 121 and 143.

108. See ibid., 21.

109. The emperor's signature appears in red (purple) ink on charters, or *chrysobulls.* We should remember that red and purple could be the same color, but that purple, when named according to the precious dyestuff *halourgis,* was more prestigious than red, *kokkinos,* which could have been made from madder or some other red dye.

110. See G.W.H. Lampe, *A Patristic Greek Lexikon* (Oxford: Oxford University Press, 1961), s.v. κωδίκελλος: (1) a writing tablet; (2) writing of emperor confirming privilege; (3) diploma or testamentary order, codicil.

111. See *ODB,* s.v. "Insignia" (A. Kazhdan) and "Diptych" (A. Cutler).

112. See Bury, *Administrative System,* 133–34.

113. See ibid., 135.

114. Weitzmann proposes this as an example of a *codicillus*; see K. Weitzmann, *Late Antique and Early Christian Book Illumination* (New York, 1977), 61 and col. pl. 15. See also von Premerstein's argument that she is holding the *plakes elephantinai kekosmemenai* of the office of *zoste patricia* (above note 106). The diptych held by Anicia Juliana conforms in shape to consular diptychs, and a lozenge-shaped design is also found on several of them, such as the Diptych of Philoxenus (Dumbarton Oaks acc. no. 35.4). See Weitzmann, *Byzantine and Early Medieval Antiquities,* vol. 3, 28–29 and pls. XIV, XV.

115. Unfortunately the consular diptychs have not so far been analyzed for the chemical makeup of this

red; taking a sample for testing may be difficult because the red often appears as a stain permeating the ivory.

116. Acc. no. 37.18; see Weitzmann, *Byzantine and Early Medieval Antiquities,* no. 24, 55–58 and pls. XXXII–XXXV. The emperor has been tentatively identified as Romanus II (959–963), the son of Constantine Porphyrogenitus.

117. For this discussion see ibid., 57.

118. See Goldschmidt and Weitzmann, *Reliefs,* nos. 65, 66 and pls. XXV, XXVI.

119. See *Theophilus: De Diversis Artibus,* 166–67.

120. Est etiam herba rubrica dicta, cuius radix est longa, gracilis et rubicunda, quae effossa sole siccatur atque in mortario pila tunditur, et sic lexiua perfusa in olla rudi coquitur. Cui cum bene bulluerit, os elephantis seu piscis uel cerui impositum rubeum fit. Possunt etiam ex his ossibus uel cornibus tornatili opere fieri nodi in baculis episcoporum et abbatum, atque minores noduli diuersis utensilibus apti (Chapter 94: *Theophilus: De Diversis Artibus,* 168).

121. On the evidence for the use of madder in antiquity, see Marie Farnsworth, "Second Century B.C. Rose Madder from Corinth and Athens," *AJA* 55 (1951): 236–39.

122. For examples of this long tradition see "Experimenta de Coloribus" in Merrifield, *Original Treatises on the Arts of Painting,* vol. 1, 47–111.

123. See ibid., vol. 1, 192:
De petula auri, quomodo in ebore mittatur.
Sculpturas eboris auri petulis decorabis
Quo tamen ipsa tibi res ordine congruat audi.
Quære tibi piscem qui dicitur usa liquentem
Vesicam tamen serva cum flumine coctam
Inde locum petulam cui vis componere signa
Sic ebori facile poteris ipsam consolidare.

124. See ibid., vol. 1, 224:
Quomodo dirigitur et ornatur ebur. — Quod si volueris ebur dirigere et ornare, in hac supradicta confectione mittatur tribus diebus et tribus noctibus. Hoc facto, cavabis lignum quali modo volueris; deinde, posito ebore in cavatura, diriges illud, et plicabis ad placitum.

125. See ibid., vol. 1, 314:
A faire une couleur qui est appelée posc pour faire le nus de ymages. — Mettez avec simple membrane un poi de cynobre et un poi de mine, et vous avez la dicte couleur posc, de laquelle vous rougirez dens, naselles, bouche, mains, col par dessoubs, et les fronces du front, et les tremples, et les articles et les autres membres en tous nus dimages pourtraictes et rondes.

126. See ibid., vol. 2, 820:
Sur l'yvoire il faut que se soit avec l'eau qui se trouve sous le fumier de cheval, car on n'y peut peindre autrement; les couleurs n'y pouvant estre appliquées que par ce secret et invention.

Chapter 5

1. See, in general, *Byzantium and the Classical Tradition,* University of Birmingham Thirteenth Spring Symposium of Byzantine Studies (Birmingham: Centre for Byzantine Studies, University of Birmingham, 1979), ed. M. Mullett and R. Scott.

2. For a stimulating analysis of ancient polychromy in theory, philology, and archaeology see John Gage, *Colour and Culture: Practice and Meaning from Antiquity to Abstraction* (London: Thames and Hudson, 1993), 11–27.

3. Irwin, *Colour Terms in Greek Poetry,* 24–27.

4. Ibid., 79.

5. Ibid., 157.

6. Ibid., 193.

7. Ibid., 202–3.

8. See G.M.A. Richter, "Polychromy in Greek Sculpture," *AJA* 48 (1944): 321–33; see esp. 321, note 2, for her selected bibliography on polychromy in Greek and Roman sculpture.

9. G.M.A. Richter, "Polychromy in Greek Sculpture," *Metropolitan Museum Bulletin* (1944): 233–40; Richter, "Polychromy in Greek Sculpture," esp. 322.

10. P. Dimitriou, *The Polychromy of Greek Sculpture: To the Beginning of the Hellenistic Period,* unpublished Columbia University dissertation, New York, 1947 (UMI Series). Dimitriou's catalogue (225–83)

records color traces on 312 examples of Archaic and classical sculpture.

11. See Dimitriou, *Polychromy,* 273–74. For example, she records with remarkable thoroughness the observations of various viewers, as in the following:

> On slab of frieze with part of procession of maidens brought to Paris by Choiseul-Gouffier, Louvre 758: remains of blue on background, gilt on hair and other parts of figures (Millin); remains of color on frieze slab while still unpacked in Louvre (de Quincy); clear traces of pigments on frieze (Choiseul-Gouffier); Foucherot and Fauvel quoted by de Quincy: red on background and other colors, especially green on figures (Paccard quoted by Hittorff); no color traces noted on frieze by Penrose or on later examination of frieze or on slabs in London and Paris. Cursorily sculptured and missing parts indicate extensive painting on frieze. Many details on pediment sculptures, metopes and frieze were originally added in metal.

12. See the color plates, for example, in *The Greek Museums,* ed. M. Andronicos, M. Chatzidakis, and V. Karageorghis (New York: Ekdotike Athenon and Caratzas Brothers, 1977): the pedimental sculptures from 6th-century temples on the Athenian Acropolis (pp. 130–31; nos. 13, 14), the Acropolis korai with their red hair, red lips, and green garments (pp. 136–39, 141; nos. 22–28), and the preserved friezes from the Siphnian Treasury at Delphi with traces of red (pp. 166–67; nos. 9–12).

13. See Dimitriou, *Polychromy,* ii.

14. Dimitriou, *Polychromy,* 206.

15. Ibid., 216. For a pioneering study of polychromy on sculpture see G.M.A. Richter, "Were the Nude Parts in Greek Marble Sculpture Painted?" *Metropolitan Museum Studies* I (1928–29): 25–31. See also Richter, "Polychromy in Greek Sculpture," *AJA* 48 (1944): 325, for the evidence from the limestone pediments on the Acropolis and other evidence of the painting of male flesh a rose color. The flesh color was transparent rather than opaque, and was only preserved through the application of protective *ganosis* (327–29). From the 4th century B.C.E. on, however, female flesh was also tinted a light pinkish hue (333).

16. Dimitriou, *Polychromy,* 218–19; see also B. Ashmole, *Architect and Sculptor in Classical Greece* (New York: New York University Press, 1972), 26, where he describes the original appearance of the pedimental sculpture of the Temple of Zeus at Olympia: "All the sculptures were fully coloured, not in imitation of, but by analogy with nature, the colours bolder and simpler; and the figures stood out sharp and clear, in a way that we can hardly imagine, against a coloured background."

17. Dimitriou, *Polychromy,* 196.

18. Ibid., 199–200.

19. Ibid., 183. Scholars have noted that the throne of the chryselephantine Zeus at Olympia was admired by Pausanias for its decorations of painted figures, carved statues, and the combination of rich materials, of which the principal were ivory, ebony, and gold.

20. There is evidence that male figures on stone sculpture had flesh painted brown or brownish-red, and female ones a rosy hue; see, for example, M. Stieber, "Aeschylus' *Theoroi* and Realism in Greek Art," *Transactions of the American Philological Association* 124 (1994): III, where she mentions the marble kore Acropolis 683, "Once she had a burnished olive-toned complexion, but that is lost to viewers today." Cf. M. S. Brouskari, *The Acropolis Museum. A Descriptive Catalogue* (Athens: Commercial Bank of Greece, 1974), 81.

21. See Stieber, "Aeschylus' *Theoroi*" (note 20 above), 121 and 176–79, on the evidence of painted nude parts. We have already seen in chapter 4 above that *ganosis* was a technique applied to stone sculptures and probably also to ivory statues. The ancients clearly went to great lengths to preserve the colored surfaces of statuary, for the painting of ancient sculpture was an important part of the medium's expressive power. Ivory was no exception; in fact, it was the prime example of the rule.

22. Dimitriou, *Polychromy,* 122.

23. "It is hoped that this review of ancient poly-chromy will end any remaining skepticism concerning polychromatic classical sculpture by proving sufficiently that the taste for colorless sculpture and architecture arose in erroneous interpretations of classical art by the classic revivalists in the Renaissance and was perpetuated by later Puritanism and moralism . . . color should be considered as a major criterion of the classical style" (ibid., vi).

24. The ivory reliefs from Delphi and Vergina dealt with in chapter 3 above are examples of small-scale sculpture that was gilded and probably painted or stained as well (see pp. 40–43 above).

25. Although we do not take up the case of terra-cottas in this study, the evidence of their coloring confronts us in every museum where they are displayed. The colors preserved on terracottas, however, tend more to pastel shades than those of stone sculpture. See also R. A. Higgins, *Greek Terracottas* (London: Methuen, 1967).

26. Ibid., 221.

27. Ibid., 222.

28. Ibid., 223–24. The polychromy on Roman sculpture and architecture needs further study along the lines of Dimitriou's work on Greek sculpture. For example, the recent book by Diana E. E. Kleiner, *Roman Sculpture* (New Haven: Yale University Press, 1992), makes no mention of polychromy on Roman sculpture. See in general Patrik Reutersward, *Studien zur Polychromie der Plastik: Griechenland und Rom* (Stockholm: Almquist and Wiksell, 1958). The study on Trajan's column, *La Colonna Traiana,* by S. Settis, A. La Regina, G. Agosti, and V. Farinella (Torino: Giulio Einaudi, 1988) includes on p. 597 a brief discussion on the polychromy of the reliefs on the column. See color plates 91 and 92 for a reconstruction of the colors: blue backgrounds, yellow city walls, brown and ocher for shields, dark tunics, and armor of horses and men, blue water.

29. Substantial remains of painting can be seen on the capitals and templon barriers in both churches at Hosios Loukas in Greece. Blue can still be seen in the carved moldings of the 10th-century church of Constantine Lips in Constantinople.

30. See R. M. Harrison, *Excavations at Saraçhane in Istanbul,* vol. 1 (Princeton: Princeton University Press and Dumbarton Oaks, 1986), 119, 121, 123. Also, on the peacock niches, in R. M. Harrison, *A Temple For Byzantium* (Austin: University of Texas Press, 1989): "The marble was probably richly painted, not only in blue, but also in red, green and gold, and a chain may have been suspended from the beak" (121).

31. See Volbach, *Early Christian Art,* col. pl. 164.

32. See, for example, in C. L. Connor, *Art and Miracles in Medieval Byzantium: The Crypt at Hosios Loukas and Its Frescoes* (Princeton: Princeton University Press, 1991), 42 and col. pl. 10, figs. 91, 92.

33. See Mango, *Art of the Byzantine Empire,* 76 (Procopius, *De aedificiis,* I).

34. C. Mango, "Antique Statuary and the Byzantine Beholder," *DOP* 17 (1963): 55–75, see esp. 67.

35. Dimitriou, *Polychromy,* 71–91.

36. Ibid., 100.

37. See Liz James, *Light and Colour in Byzantine Art* (Oxford: Clarendon Press, 1996). I am greatly indebted to her for showing me her manuscript prior to publication; her work provided me with many important insights which were particularly useful for this part of my study.

38. For the history of the connotations of purple starting in the second millenium B.C.E., see M. Reinhold, *History of Purple as a Status Symbol in Antiquity, Latomus: Revue d'études latines* (Brussels, 1970). For the mythical origins of sea-purple, see 11 and note 2, where King Phoenix obtained a purple cloak from Heracles, making Phoenix the first to wear purple as a royal symbol.

39. We have seen in chapter 2 the difficulty of distinguishing terms such as *purpur, phoinikes,* and *halourgis.*

40. Bury, *Administrative System,* 135.

41. Ibid., 134–35. References to other colors in Philotheos's list of Orders include red wands, jeweled gold whips, white gold-embroidered tunic, mantle, and belt (22). We have discussed (above p.

59, note 82) the difficulty of determining exactly what range of shades of red, blue, or violet actually were represented by *halourgidos* and *kokkinos*.

42. "The Embassy to Constantinople," chaps. LIV–LV in *The Works of Liudprand of Cremona: Antapodosis liber de rebus gestis Ottonis relatio de legatione Constantinopolitana,* ed. F. A. Wright (London: Routledge and Sons, 1930), 268–69.

43. See, for example, the mosaic lunette in the inner narthex of the church of Kariye Djami in Istanbul depicting the Virgin Receiving the Skein of Purple Wool. While the term *porphyroun* is used in the inscription, it is apparent that the mosaic shows the skein as red, not purple (see Paul Underwood, *The Kariye Djami* [New York: Bollingen Foundation, 1966], vol. 1, 76–78; vol. 2, pl. 94).

44. Nicholaos Mesarites, *Description of the Church of the Holy Apostles at Constantinople,* ed., trans., and com. by Glanville Downey (Philadelphia: American Philosophical Society, 1957), XIV.8 on p. 870.

45. Gervase Mathew, *Byzantine Aesthetics* (London: J. Murray, 1963 and Viking Press, 1964), 118–19.

46. *Saint John of Damascus: Writings,* trans. Frederic H. Chase (New York: The Fathers of the Church, 1958), 242.

47. See Liz James, "Colour and the Byzantine Rainbow," *Byzantine and Modern Greek Studies* 15 (1991): 84.

48. James, *Light and Colour,* 2.

49. See E. Diez and O. Demus, *Byzantine Mosaics in Greece: Daphni and Hosios Lucas* (Cambridge, Mass.: Harvard University Press, 1931), chapter on "The Colour," 88ff. Connections through color of mosaics with other media—like miniature painting, enamel work, and textiles—are pointed out by the authors.

50. *The Homilies of Photius, Patriarch of Constantinople,* trans. and com. Cyril Mango (Cambridge, Mass.: Harvard University Press, 1958), 187–88.

51. Ibid., 187.

52. See Irwin, *Color Terms,* 24.

53. Mango, *Homilies* (note 50 above), 290–94.

54. Ibid., 292.

55. *Digenis Akritas: The Two-Blood Border Lord. The Grottaferrata Version,* trans. Denison B. Hull (Athens: University of Ohio Press, 1972).

56. L. James, *Light and Colour,* 85–90, esp. 88: "Weapons, horses and armaments, the important things in life, are all given colour descriptions." She also compares color terms in Psellus's *Chronographia* with *Digenes Akrites,* pointing out the use of classical terms alongside a new vernacular set of terms which form the basis for modern Greek terms. See 72–74 and 91–109 for glossaries of color terms.

57. Mesarites, *Holy Apostles,* 868, 901.

58. Mesarites, *Holy Apostles,* XV (Downey 870). The mystical theology of Dionysius the Areopagite (5th–6th century) or the light symbolism of Hesychasm, a religious movement of the 14th and 15th centuries, demonstrates the culture's inclination toward such theological visions involving light.

59. James, *Light and Colour,* 80.

60. Ibid., 9; also chapter 7 on "The Perception of Colour in Byzantium" (125–40): "the concept of 'colour' in Byzantium had an importance and a significance which has been hardly grasped by art historians . . ." (125).

61. See *The Treasury of San Marco, Venice,* exh. cat., Metropolitan Museum of Art (Milan: Olivetti, 1984), nos. 8–20, 109–76 and introduction on 109–14 by Margaret Frazer.

62. See ibid., the Pala d'Oro panels on 45, 49, 57, 59, etc.

63. See ibid., 121 and 172, among many other examples.

64. To separate ivories from works created with colors simply reveals an outdated art historical bias against combining sculpture and painting. See Cutler, *Hand of the Master,* 146–47: "To equate such treatment of plaques with the impulse behind the brilliance of Byzantine enamels and textiles is naive. In these media color was an intrinsic part of the material before it was worked; on ivory pigment is, by definition, an addition to the dentine after it had been carved." In my opinion, however, covering the surface of carved ivory with valuable pigments is

comparable to applying enamels to a gilt silver book cover or painting the white surface of finely carved Proconnesian marble with bright colors; the philosophical and aesthetic principle is the same: the more colorful and contrasting, the more precious, bold, and beautiful. To color or not to color was not a random decision, it was integral to the art.

65. See Cutler, *Hand of the Master,* 142, 144.

66. See Mango, *The Art of the Byzantine Empire,* 99.

67. See, for example, in K. Weitzmann and G. Galavaris, *The Monastery of Saint Catherine at Mount Sinai: The Illuminated Greek Manuscripts,* vol. 1, *From the Ninth to the Twelfth Century* (Princeton: Princeton University Press, 1990), col. pls. IV, V, XV.

68. See ibid., col. pl. XV, fol. 2v. The manuscript's provenance is Constantinople. The pages of this manuscript measure 36 cm in height, making individual registers approximately the same size as the pictorial scenes in the ivory panels.

69. See, for example, the silk textiles with roundels in which are depicted the Annunciation and the Nativity, in the Museo Sacro Cristiano in the Vatican, dated to the late 8th or 9th century (see Beckwith, *Early Christian and Byzantine Art,* 176–77, figs. 147, 148).

70. For icons, see K. Weitzmann, *The Monastery of Saint Catherine at Mount Sinai: The Icons,* vol. 1, *From the Sixth to the Tenth Century* (Princeton: Princeton University Press, 1976), for example, nos. B33, B36, B50, B52 (pls. XXIV, XXV, XXXII, XXXIII), in which backgrounds are blue or gold, frames are red, and figures are modeled in a variety of colors including bright reds and blues.

For steatites, see *Byzance,* 268–75, nos. 175–77, 182: "Stéatite, traces de dorure, de rouge et de bleu." Much of the color on steatites is readily visible to the naked eye, and therefore it is even more surprising that while it has been regularly noted, color has not been taken into account in this study. Also see I. Kalavrezou-Maxeiner, *Byzantine Icons in Steatite* (Vienna: Verlag der Osterreichischen Akademie der Wissenschaften, 1985), in which polychromy is asso-

ciated with low quality: "Especially bright or primary colors against the green are unpleasant to the eye. Traces of color other than gilding are uncommon. More polychrome [sic] appears on pieces of lower quality, so that it might reflect a more popular taste. However, it is difficult to determine whether polychrome remains such as the red and blue traces on the Annunciation plaque in the Benaki Museum (no. 104) are original. In my opinion, these remains are predominantly later additions" (31).

71. M. B. Hall, *Color and Meaning: Practice and Theory in Renaissance Painting* (Cambridge and New York: Cambridge University Press, 1992), 15.

72. Ibid., 27.

Conclusion

1. When possible, it makes a fascinating study to trace the provenance of certain pieces, but this approach can unfortunately rarely be applied because of the difficulty of recovering the process of transmission of ivories from one ownership to another through the centuries. In any case, even if one could discover histories of individual pieces, this would unfortunately not amount to a substantial enough body of evidence for statistical analysis, even if it was suspected that coloring had been applied or reapplied at some point along the way. See Alessandra Melucco Vaccaro, "'Hierosolimam adiit { . . . } Tabulas eburneas optimas secum deportavit,'" *Arte Medievale,* 2d series, 7 (1993): 1–19.

2. Gervase Mathew, in *Byzantine Aesthetics,* reserved judgment on the original appearance of ivories, one of the premier art forms of the Macedonian Renaissance:

The age of the Amorian and Macedonian emperors coincided with the climax in ivory-work as well as in enamels. But it is far harder to reconstruct the art standards by which carved ivory would be judged. Clearly the material was costly, since like silk before the late 6th century it was necessarily an import, but it has not yet been de-

termined to what extent it was imported from India or from East Africa and the Sudan. It is not yet clear how far the ivories were gilded or painted, but it seems unlikely that they were pure monochrome (130).

3. James, *Light and Colour,* 275.

4. For example, the fashionable look of faded southwest American colonial furniture has recently been shown to be a misconception. See Sandra Blakeslee, "Study Says True Santa Fe Style is Bold, Not Faded," *New York Times,* Sunday, Oct. 9, 1994: "the Santa Fe Style—that rough-hewn, faintly tinted, gently dilapidated look that has exploded over that last decade . . . is based on fantasy rather than fact . . . the bare wood tables, chairs and chests were originally painted in the garish, eyesearing colors of modern Mexican folk art: Prussian blue, vermilion, chrome yellow."

5. As in Thomas Kuhn's *The Structure of Scientific Revolutions* (Chicago: University of Chicago Press, 1974), the need for constant reevaluation of existing knowledge is what gives vitality to research. Scientific paradigms are developed over time, but they should not be seen as final solutions, rather as stages that require constant reevaluating and challenging. Puzzle-solving where new phenomena or anomalies are encountered results in paradigm change (52).

Bibliography

Primary Sources

For standard texts, editions are cited in the endnotes.

Cennini, Cennino D'Andrea. *The Craftsman's Handbook: The Italian "Il libro dell'arte."* Trans. D. V. Thompson, Jr. New York: Dover Publications, 1933.

Constantine Porphyrogenitus. *Le Livre des cérémonies.* Ed. Albert Vogt. Paris: Société d'édition "Les Belles Lettres," 1967.

The Kletorologion of Philotheos. Ed. and trans. in J. B. Bury, *The Imperial Administrative System in the Ninth Century.* London, 1911; reprint, New York: Burt Franklin, n.d.

Nicholaos Mesarites. *The Description of the Church of the Holy Apostles at Constantinople.* Ed., trans., com. Glanville Downey. *Transactions of the American Philosophical Society,* n.s., vol. 47, pt. 6 (1957): 859–918. Philadelphia: American Philosophical Society, 1957.

The "Painter's Manual" of Dionysius of Fourna. Trans. Paul Hetherington. England: The Sagittarius Press, 1981. Reprint, Redondo Beach, Cal.: Oakwood Publications, 1989.

Theophilus, De Diversis Artibus: The Various Arts. Trans. C. R. Dodwell. London: Thomas Nelson and Sons Ltd., 1961.

Theophrastus On Stones. Introduction, Greek text, English translation, and commentary by E. R. Caley and J.F.C. Richards. Columbus: Ohio State University Press, 1956.

Lexica

Harpers' Latin Dictionary. Ed. E. A. Andrews. New York: Harper and Brothers, 1895.

Lampe, G.W.H. *A Patristic Greek Lexicon.* Oxford: Oxford University Press, 1961.

The Oxford Dictionary of Byzantium. 3 vols. Ed. A. P. Kazhdan et al. New York: Oxford University Press, 1991.

Pauly-Wissova: *Paulys Real-Encyclopädie der classischen Altertumswissenschaft,* herausgegeben von Georg Wissova. Stuttgart: J. B. Metzlerscher Verlag, 1894.

Selected Bibliography of Secondary Sources

Amandry, Pierre. "Rapport préliminaire sur les statues chryséléphantines de Delphes." *BCH* 63 (1939): 86–119.

Andronicos, Manolis. *Vergina: The Royal Tombs.* Athens: Ekdotike Athenon, 1984.

Augusti, Selim. *I colori pompeiani.* Rome: De Lucca, 1967.

Bank, Alice V. *Byzantine Art in the Collections of Soviet Museums.* Leningrad: Aurora Art Publishers, 1985.

Barnett, Richard D. *Ancient Ivories in the Middle East.* QEDEM Monographs. Jerusalem: Institute of Archaeology of the Hebrew University of Jerusalem, 1982.

———. *A Catalogue of the Nimrud Ivories in the British Museum.* London: Trustees of the British Museum, 1957.

Beckwith, John. *Early Christian and Byzantine Art.* Pelican History of Art. New York: Penguin, 1979.

Blümner, H. *Technologie und Terminologie der Gewerbe und Künste die Griechen und Römern,* vol. 2. Leipzig: G. Olms, 1897.

Bourgeois, B. "An Approach to Anatolian Techniques of Ivory Carving during the Second Millennium B.C." In *Ivory in Greece and the Eastern Mediterranean from the Bronze Age to the Hellenistic Period,* 61–66.

Bury, J. B. *The Imperial Administrative System in the Ninth Century, with a Revised Text of The Kletorologion of Philotheos.* London, 1911; New York: Burt Franklin, n.d.

Byzance: l'art byzantin dans les collections publiques françaises. Musée du Louvre. Paris: Editions de la Réunion des Musées Nationaux, 1992.

Carter, Jane Burr. *Greek Ivory-Carving in the Orientalizing and Archaic Periods.* New York: Garland, 1985.

Connor, Carolyn. "New Perspectives on Byzantine Ivories." *Gesta* 30 (1991): 100–111.

Cutler, Anthony. *The Craft of Ivory: Sources, Techniques, and Uses in the Mediterranean World: A.D. 200–1400.* Washington, D.C.: Dumbarton Oaks, 1985.

———. *The Hand of the Master: Craftsmanship, Ivory, and Society in Byzantium (9th–11th Centuries).* Princeton: Princeton University Press, 1994.

Dalton, O. M. *Catalogue of the Ivory Carvings of the Christian Era in the British Museum.* London: The British Museum, 1909.

Delbrueck, Richard. *Die Consulardiptychen und verwandte Denkmäler.* Leipzig and Berlin: W. de Gruyter, 1929.

Dimitriou, P. *The Polychromy of Greek Sculpture: To the Beginning of the Hellenistic Period.* New York: Unpublished Columbia University Dissertation, UMI Series, 1947.

Effenberger, Arne, and Hans-Georg Severin. *Das Museum für Spätantike und Byzantinische Kunst Berlin.* Mainz: Verlag Philipp von Zabern, 1992.

Evans, Sir Arthur. *The Palace of Minos at Knossos,* vol. 3. London: Macmillan and Co., 1930.

Gaborit-Chopin, Danielle. *Ivoires du Moyen Age.* Freibourg: Office du livre, 1978.

Gage, John. *Colour and Culture: Practice and Meaning from Antiquity to Abstraction.* London: Thames and Hudson, 1993.

Gettens, Rutherford J., Robert L. Feller, and W. T. Chase. "Vermilion and Cinnabar." *SCon* 17 (1972): 45–69.

Gibson, Margaret. *The Liverpool Ivories: Late Antique and Medieval Ivory and Bone Carving in Liverpool Museum and the Walker Art Gallery.* London: HMSO, 1994.

The Glory of Byzantium: Art and Culture of the Middle Byzantine Era, A.D. 843–1261. Exh. cat., The Metropolitan Museum of Art. Ed. H. Evans and W. Wixom. New York: The Metropolitan Museum of Art and Harry N. Abrams, 1997.

Goldschmidt, Adolf J., and Kurt Weitzmann. *Die byzantinischen Elfenbeinskulpturen des X.–XIII. Jahrhunderts. Vol. 1, Kästen. Vol. 2, Reliefs.* Berlin: B. Cassirer, 1930–34.

Guide de Delphes: Le Musée. Paris: Ecole française d'Athènes, Edition de Boccard, 1991.

Hogarth, D. G. *Excavations at Ephesus: The Archaic Artemisia.* London: British Museum, 1908.

Irwin, Eleanor. *Colour Terms in Greek Poetry.* Toronto: Hakkert, 1974.

Ivory in Greece and the Eastern Mediterranean from the Bronze Age to the Hellenistic Period. Edited by J. L. Fitton. *British Museum Occasional Papers* 85. London: The British Museum, 1992.

Ivory: The Sumptuous Art. Exh. cat., The Walters Art Gallery. Baltimore: The Walters Art Gallery, 1983.

James, Liz. *Light and Colour in Byzantine Art.* Oxford: Clarendon Press, 1996.

MacGregor, A. *Bone, Antler, Ivory, and Horn: The Technology of Skeletal Materials since the Roman*

Period. Beckenham, Kent: Barnes and Noble, 1985.

Mallowan, M., and G. Herrmann. *Furniture From SW.7 Fort Shalmaneser*. London: British School of Archaeology in Iraq, 1974.

Mallwitz, Alfred, and Wolfgang Schiering. *Die Werkstatt des Pheidias in Olympia. Olympische Forschungen* 5. Berlin: De Gruyter, 1964.

Mango, Cyril. *The Art of the Byzantine Empire, 312–1453*. Ed. H. W. Janson. New York: Prentice Hall, 1972. Reprint Toronto: University of Toronto Press, 1986.

Mango, Cyril, M. Vickers, and E. D. Francis. "The Palace of Lausus at Constantinople and Its Collection of Ancient Statues." *Journal of the History of Collections* 4 (1992): 89–98.

Maskell, Alfred O. *Ivories*. London: C. E. Tuttle Co., 1905. Reprint, Rutland, Vt., 1966.

Maskell, W. *Ivories: Ancient and Medieval*. London: Chapman and Hall, 1875.

Mathew, Gervase. *Byzantine Aesthetics*. London: J. Murray, 1963, and Viking Press, 1964.

McLaren, K. *The Colour Science of Dyes and Pigments*. Bristol: A. Hilger, 1983.

Merrifield, Mary P. *Original Treatises on the Arts of Painting*. New York, 1849. Reprint, New York: Dover Publications, 1967.

Oikonomides, N. *Les listes de préséance byzantines du IXe et Xe siècle*. Paris: Editions du Centre national de la recherche scientifique, 1972.

Parker, Elizabeth C., and Charles T. Little. *The Cloisters Cross: Its Art and Meaning*. New York: The Metropolitan Museum of Art, 1994.

Plesters, J. "Ultramarine Blue, Natural and Artificial." *Studies in Conservation* 11 (1966): 62–91.

Poursat, J.-C. *Les ivoires mycéniens: essai sur la formation d'un art mycénien*. Paris: Ecole française d'Athènes, Boccard, 1977.

Randall, Richard H. *Masterpieces of Ivory from the Walters Art Gallery*. New York: Hudson Hills Press, 1985.

Richter, Gisela M. A. "Polychromy in Greek Sculpture." *American Journal of Archaeology* 48 (1944): 321–33.

Schiering, W. *Die Werkstatt des Pheidias in Olympia*. Vol. 2, *Werkstattfunde*. New York and Berlin: De Gruyter, 1991.

Stewart, Andrew. *Greek Sculpture: An Exploration*. Vol. 1. New Haven: Yale University Press, 1990.

Thompson, Daniel V., Jr. "Artificial Vermilion in the Middle Ages." *Technical Studies in the Field of the Fine Arts* 2 (1933): 62–71.

——. *The Materials of Medieval Painting*. London: George Allen and Unwin Ltd., 1936.

Vickers, M. "Phidias' Olympian Zeus and Its Fortuna." In *Ivory in Greece and the Eastern Mediterranean from the Bronze Age to the Hellenistic Period*, 217–25.

Volbach, W. F. *Elfenbeinarbeiten der Spätantike und des frühen Mittelalters*. Mainz: Verlag des Römisch-Germanischen Zentralmuseums, 1952.

——. *Early Christian Art*. New York: Harry N. Abrams, n.d.

Weitzmann, Kurt. *Catalogue of the Byzantine and Early Medieval Antiquities in the Dumbarton Oaks Collection. Vol 3, Ivories and Steatites*. Washington, D.C.: Dumbarton Oaks, 1972.

Williamson, P., and L. Webster. "The Coloured Decoration of Anglo-Saxon Ivory Carvings." in *Early Medieval Wall Painting and Painted Sculpture in England*, ed. S. Cather, D. Park, and P. Williamson. B.A.R. British Series 216. London: B.A.R., 1990.

Winter, Irene J. "Ivory Carving." In *Ebla to Damascus: Art and Archaeology of Ancient Syria,* ed. Harvey Weiss. Washington, D.C.: Smithsonian Institution Traveling Exhibition Service, 1985.

Index